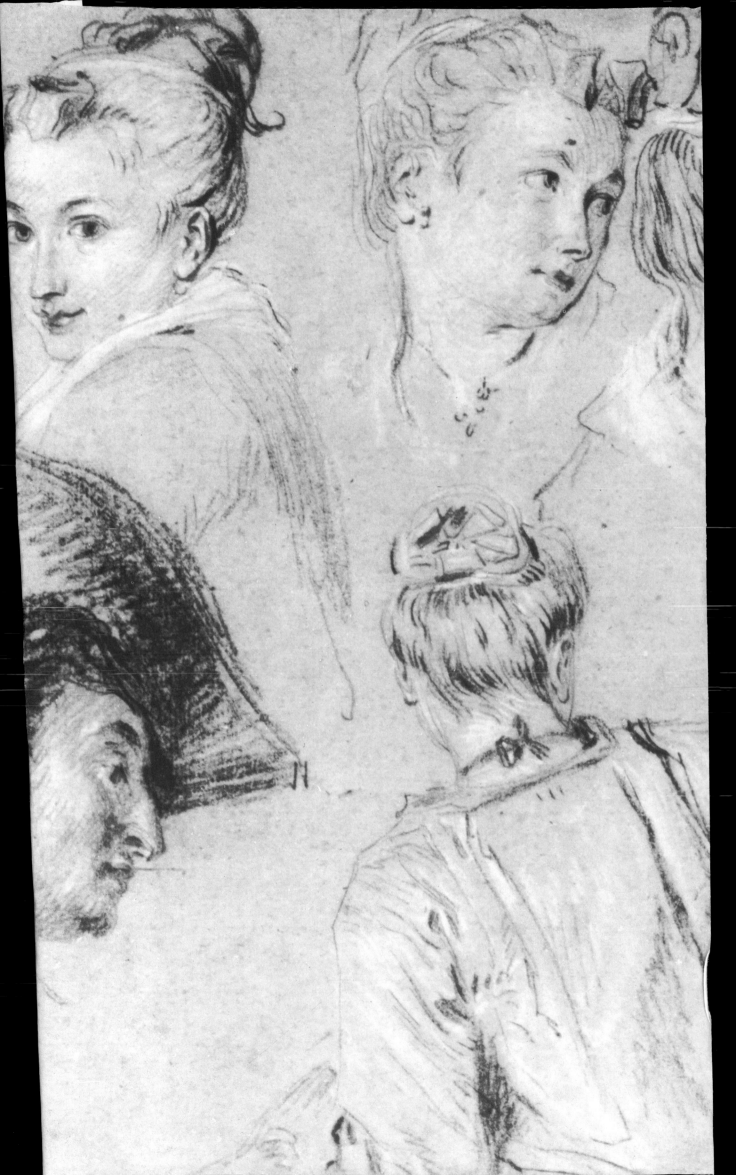

The Drawings of Watteau

The Drawings of Watteau

Malcolm Cormack

Hamlyn London/New York/Sydney/Toronto

Acknowledgments

Plate 78 is reproduced by Gracious Permission of Her Majesty the Queen. The other drawings and paintings by Watteau and other artists in this volume are reproduced by kind permission of the following collections, galleries and museums to which they belong: Art Institute of Chicago: The Joseph and Helen Regenstein Foundation (Plate 32); Ashmolean Museum, Oxford (Plates 28, 36, 52, 96, 107, 113); Walter C. Baker Collection, New York (Plate 42); P. Bordeaux-Groult, Paris (Plates 50, 101, 114); Trustees of the British Museum, London (Plates 2, 3, 17, 21, 24, 29, 35, 38, 45, 46, 55, 58, 62, 63, 66, 71, 72, 90, 92, 94, 99, 102, 103, 105, 111); Cabinet des Dessins, Musée du Louvre, Paris (Plates 31, 39, 40, 44, 51, 61, 70, 77, 91, 104, 110, 124, 130); Ecole des Beaux-Arts, Paris (Plate 108); Syndics of the Fitzwilliam Museum, Cambridge (Plates 7, 12, 13, 19, 26, 27, 33, 75, 85, 93, 98, 115, 122, 123, 126); Galleria degli Uffizi, Florence (Plates 16, 125, 127); Gemäldegalerie, Berlin-Dahlem (Plates 117, 120); Graphische Sammlung Albertina, Vienna (Plates 109, 129); Mr and Mrs Eliot Hodgkin, London (Plate 4); Kupferstichkabinett, Berlin (Plates 11, 56, 95); Metropolitan Museum of Art, New York: Gift of Cornelius Vanderbilt, 1880 (Plate 37); Musée des Arts Décoratifs, Paris (Plate 23); Musée des Beaux-Arts, Angers (Plate 118); Musée des Beaux-Arts, Besançon (Plate 54); Musée Bonnat, Bayonne (Plates 53, 65); Musée Cognacq-Jay, Paris (Plates 22, 41, 83); Musée Condé, Chantilly (Plates 69, 73, 121); Musée du Louvre, Paris (Plate 119); Musée du Petit Palais, Paris (Plates 20, 60); Museum Boymans-van Beuningen, Rotterdam (Plates 5, 10, 14, 15, 25, 88, 131, 132); National Gallery of Scotland, Edinburgh (Plate 112); Nationalmuseum, Stockholm (Plate 6); Pierpont Morgan Library, New York (Plates 47, 81, 82); Private Collections, London (Plates 1, 64, 67, 97); Rijksprentenkabinet, Amsterdam (Plates 57, 68, 74, 76, 79, 89, 106); Count Antoine Seilern Collection, London (Plates 9, 18, 30, 43, 84); Staedelsches Kunstinstitut, Frankfurt (Plates 100, 128); Teylers Museum, Haarlem (Plates 34, 48, 59, 86, 87); Victoria and Albert Museum, London (Plate 49). The following photographs were supplied by Roger Chuzeville, Paris (Plates 31, 39, 40, 44, 50, 51, 61, 70, 77, 91, 101, 104, 110, 114, 124, 130); Jean-Pierre Durel, Paris (Plates 22, 41); R. B. Fleming, London (Plate 4); John Freeman, London (Plate 64); Giraudon, Paris (Plates 69, 73, 108, 119, 121); Michael Holford, London (Plate 1); National Gallery, London (Plate 116). Plate 8 is reproduced from K. T. Parker and J. Mathey *Antoine Watteau, catalogue complet de son œuvre dessiné*, Paris, 1957.

Published by the Hamlyn Publishing Group Limited
London, New York, Sydney, Toronto
Hamlyn House, Feltham, Middlesex, England
Copyright © The Hamlyn Publishing Group Limited, 1970
I SBN 0 600 02557 8
Phototypeset by Filmtype Services, Scarborough
Printed in Hong Kong by Lee Fung

Antoine Watteau

1684-1721

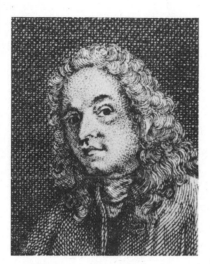

Detail of Plate 123

'As for his drawings, when they are of his best period, that is to say, after he had left M. Crozat, there is nothing superior to them in their kind; subtlety, grace, lightness, correctness, facility, expression, they are not wanting in any quality, and he will always be considered as one of the greatest and best draughtsmen that France has ever produced.'
(E. F. Gersaint, *Catalogue de feu M. Quentin de Lorangère*, 1744)

Gersaint, one of Watteau's closest friends, thought more highly of Watteau's drawings than his paintings and argued elsewhere that 'Watteau was of the same opinion in this respect. He was more satisfied with his drawings than with his paintings and I may say with assurance that in this matter, he was not blinded by self-esteem to any of his defects. He found it a greater pleasure to draw than to paint. I have often seen him out of temper with himself because he was unable to convey in painting the truth and brilliance that he could express with his pencil.'
(*Preface to Catalogue of the Collection of Augran de Fonspertius*, 1747–8)

Gersaint was not the only contemporary admirer of Watteau to prefer his drawings. Their importance for a true understanding of the artist was realised during his lifetime and immediately after his death, when another close friend, Jean de Jullienne, gathered together 351 etchings after the drawings: *Figures de différents Caractères, de Paysages et d'Etudes*, which was published in two volumes in 1726 and 1728.

This work gives, even today, an idea of the scope and variety of his drawings as well as providing an infallible test for authenticity. Jullienne was concerned to show Watteau at his best: 'It has rarely occurred to any-one to have engravings made from a painter's studies. . . . It is hoped, however, that the drawings of the celebrated Watteau presented here will receive the favourable regard of the public. They are in a new manner and their charms are so intimately related to the personality of their author that they may justly be considered as inimitable. . . .'

Jullienne, however, was not in the 1720s pleading a lost cause. Watteau's paintings and particularly his drawings were popular and among his admirers were a number of knowledgeable connoisseurs. Even those whose taste was for the grand and heroic style of art, such as the Comte de Caylus and Mariette, the great collector, admitted the excellencies of his draughtsmanship. Although the Comte de Caylus (1692–1765) was an upholder of the academic classical tradition to which Watteau's art was opposed, he could, nevertheless, point to Watteau's industry as a draughtsman: 'Such moments of freedom as he enjoyed — public holidays, even the nights — were devoted to drawing from nature. He set an example whose value to the young could hardly be over-emphasised . . .' and again: 'The exercise of drawing had infinite charms for him and although sometimes the figure on which he happened to be at work was not a study undertaken with any particular purpose in view, he had the greatest imaginable difficulty in tearing himself away from it.'

Equally, the famous connoisseur P. J. Mariette (1694–1774) recognised his qualities: 'The touch of his brush, as with his pencil, is the most lively, the placing of his figures the most agreeable, their expressions somewhat common but graceful, his execution rapid' *(Abecedario)*. As with Reynolds's appreciation of Gainsborough, who seemed to stand against everything he held most dear, the weightier minds of the eighteenth century admired Watteau's drawings in spite of themselves. It was left to the nineteenth century with the rehabiliation of Watteau's reputation by above all the de Goncourt brothers to catch in words his inimitable style: 'What draughtsman has given to his rapid and spontaneous drawings that indefinable quality that Watteau achieves? Whose

pencil moves with more acid grace? Who captures with such witty skill a *profile perdu*, the tip of a nose, a hand? ... All those portraits of men and women, see the way the pencil quivers as it goes over the stumping, with scoring slashes, tiny double strokes, blunt accents, figures swelling along the curve of a muscle, trifles and felicities of art which are everything — a whole quantity of little effects full of verve and inspiration, evoked by the model itself, animating the drawing with a thousand details of nature, bringing almost to life the flat tones of the flat paper with the relief and thickness as if of paint. ... It is a red chalk shot with purple, a black crayon of incomparable smoothness, and chalk added with all the artist's wit and skill, to form upon the paper the colour of chamois, the pink and white of flesh. ...'

Watteau's drawings, then, have always been generally appreciated. And, certainly, it has always been understood that they stand at the heart of his style, that they would, perhaps, explain his art. In them we think we see the moment of creation. Through them we can follow his development, judge his borrowings and categorise his interests.

Yet they remain something of an enigma. It is impossible to be too precise about their chronology. Certain fixed points remain within a relatively short time span, but unlike many Italian masters of the preceding century only rarely were studies executed on the spot for a particular end. As Caylus complained, he drew for no particular purpose other than the pleasure of drawing, and, in this, he could be compared to those northern artists with whom he has often been linked. His drawings stand alone and their dating is difficult.

Nevertheless, though they can be considered as independent creations and were eagerly sought after as such during his own lifetime, they were carefully kept by Watteau in bound books for use, often years later, in his painted compositions. Unlike Annibale Carracci, who would use a drawing to clean his frying pan, and the medieval artist with a pattern book for the studio's use, Watteau looked upon his drawings both as tools and as independent works of art and from a rich gallery of prototypes he was able to produce works of great virtuosity.

It is, perhaps, the element of virtuosity, among other characteristics, which confirms him as an eighteenth-century artist. With a reshuffling of recognisable elements, something new emerged which revealed his creativity and astonished his spectators. This method of drawing and using drawings could be compared to eighteenth-century musicians providing variations on a theme. His drawings from life, albeit a special-ised and rather selective life, are the themes; his pictures are the variations in which a spontaneous pose, gesture and richness of costume are, as the de Goncourts saw, manipulated to provide a harmony of their own.

To our modern eyes, persuaded by the Romantic movement that an individual act of artistic creation should preferably be unique, such a reasonable attitude on Watteau's part, that drawings should be used again and again where appropriate, is rather suspect and seems to suggest that his invention was lacking. Caylus, too, with his more pompous approach, thought the same. However, Watteau's skill in arranging his compositions and inventing an ideal world from such a realistic basis can be understood best by a study of his drawings.

He was, moreover, not entirely a man of his time. Though his subject matter might be inspired by a backward look at sixteenth and seventeenth-century art, his intentions and effects were revolutionary. He broke the canons of academic criticism by creating a new type of art: the *fête galante*, as the minutes of the Academy record. He was admitted into the French Royal Academy against all the rules, a fact which Caylus

perceived. In the hierarchy of eighteenth-century styles such 'French Gallantries', as Reynolds described them, came very low, even though Reynolds could privately remark that 'Watteau is a master I adore'.

As a personality, too, Watteau is elusive. His studio was open to the world yet he was impatient of the public's demands. 'His dispostion was anxious and changeable; he was self-willed; he had a wanton truant wit but his conduct was virtuous'. Gersaint knew him as a good though difficult friend. His drawings help us to find the real man yet it is not possible to arrange them in an exact sequence. Instead it is only possible to examine the various categories of drawings which have survived and which can then be examined in relation to his own paintings and the works of others, in the hope of penetrating the mystery of his moods.

One further general point needs to be emphasised. We are dealing, in effect, with the early maturity of an artist who died relatively young, at the age of thirty-seven. If undue emphasis seems to have been placed on his influences, if the unravelling of his co-operation with other artists seems somewhat confusing, it is because, for the major part of his short life, he was undergoing a subtle process of assimilation and only in the last few years does he seem to break through to a fully independent style. His merit at all times shines forth, as a cursory glance at his drawings reveals, but time spent in following him down what appear to be blind alleys, is, perhaps, the only way to get closer to his own development and to grasp what we can of his own interests and triumphs. We may not fully explain — with a major artist this is probably impossible — but we hope to comprehend. For this Watteau's drawings are invaluable.

Jean-Antoine Watteau was born in 1684 in Valenciennes. He thus came from an area that had once been Flemish and his drawings have something in common with northern artists in subject matter and realistic outlook. The influence of Rubens was not far away from his own background and it was to be intensified during his stay in Paris, where he arrived in 1702. His earliest beginnings are unknown, at least no drawings are identifiable. He had been apprenticed to a little-known local painter, Gérin, and then to the equally unknown Metayer, who brought him to Paris, only to leave him there. At this time Watteau seems to have worked as a hack, producing copies after old masters or religious pictures for private sale. Gersaint stresses the mediocrity of such tasks but emphasises that Watteau was very good at them: 'His rendering of St Nicholas, a saint much in demand, was so felicitous that commissions for this subject were specially reserved for him. "I knew St Nicholas by heart", he told me one day, "and had no need of the original".'

He then came into contact with Claude Gillot (1673–1722), who was to provide him with an important contact with the world of the theatre. It is, perhaps, no exaggeration to say that Gillot formed Watteau's style, or at least provided him with subject matter for the rest of his life. Gillot had already produced several paintings and drawings of the Italian Comedy. The drawing by Gillot reproduced here (Plate 124) shows a scene of a comedy produced in 1694 at the centre for the Italian Comedy, the Hôtel de Bourgogne. The Italian Comedy, the stock world of Harlequin, Pierrot and Pantaleone, was particularly well received in Paris during the latter half of the seventeenth century and Gillot acted, in the way Zoffany did later for Garrick in England, as its artistic propagandist. Even when the Italian troupe was banished in 1697, not to return until 1716, its memory and popularity remained through the fairs and marionette theatres. Watteau, too, was drawn into this world and it became a constant theme. His two later pictures *L'Amour au Théâtre français* and *L'Amour au Théâtre italien*

Detail of Plate 124

(Brookner, Plates 22 and 23), possibly painted on the return of the Italian actors to Paris in 1716, seem to show Watteau's preference in the contrast between the two rival groups.

Not only, then, was Gillot important for the introduction he gave Watteau to the world of the theatre but in style, his drawings were a source for Watteau's development. The scene from the *False Coquette* has the same elegance of pose and slightly elongated figures, tapering to their extremities and with a nervous energy about their heads, which occur in Watteau's earliest known drawings. The drawing of a group of figures, one bearing a standard, by Watteau (Plate 2), has very much the same character, though Watteau does not use the pen, Indian ink and wash which Gillot favoured, and already is less wooden. Another early drawing of actors in the Italian Comedy, in Rotterdam (Plate 5), engraved by Caylus and certainly by Watteau, shows his wit, elegance and an intricate feeling for light and space, in contrast to the four-square, cruder drawings of Gillot.

Gillot, however, was not alone in furnishing the young Watteau with an example of theatrical subject matter and an elegant style. An earlier artist, who also made a brilliant record of his contemporary scene and whose drawings and designs were known through his prints, was Jacques Callot (1594–1635). As well as making a sharp, individual comment on events, he too had drawn scenes from the Italian Comedy and his drawings were to become popular among collectors at the beginning of the eighteenth century, among them two later friends and patrons of Watteau: Jullienne and Crozat. Mariette, a third, owned one hundred and seventy drawings at the end of his life, all certainly from Callot's hand. Gersaint, too, in his catalogue of Quentin de la Lorangère testifies to the admiration his circle felt for Callot. The drawing of the standing figure by Callot (Plate 125) was just the sort of drawing which reinforced his interest in an elegant, slightly theatrical world — a single figure placed, like many of Watteau's early drawings, casually yet precisely on the page, so that the style of the drawing with its expressive accents gives a hint of the style of the man. We do not know whether Watteau saw this particular drawing and as it is still in Florence and dates from Callot's Florentine period (1611–21), it is rather doubtful. Yet the type of influence remains — if only until Watteau came into contact with Crozat and his collection — through Callot's enormous number of prints, for example the *Balli di Sfassania* (Lieure, 379) from the Commedia dell'Arte or the elegant cavaliers of *La Noblesse Lorraine* (Lieure 549–560).

It is not known how long Watteau stayed with Gillot. According to Jullienne, Gillot, after seeing and admiring examples of Watteau's drawing and painting, invited him to come and live with him, probably in about 1703. But in about 1707 or 1708 he seems to have left Gillot for reasons not entirely clear. Caylus explains Gillot's part in it: 'Whether his motive was the jealousy which has often been imputed to him or whether, in the end he frankly and justly admitted that his pupil had surpassed him, we do not know'. But what is certain, according to Gersaint, is that 'they parted with at least as much satisfaction as had previously united them'. Caylus went on, 'on leaving Gillot he was received as a pupil by Claude Audran, Concierge of the Luxembourg, an estimable character and a skilful decorator who in this latter capacity worthily upheld the reputation of the family which has provided your Academy with so many gifted members'. Caylus expresses well what Watteau could learn from Claude III Audran (1658–1734): 'He was, moreover, a man of natural taste. Ornamentation had been his principal study, ornamentation of the kind that was used by Raphael at the Vatican and elsewhere by his pupils, of the kind also that Primaticcio employed at Fontainebleau, Audran revived the fashion of

the latter's compositions, and it was due to his activities that the heavy and oppressive taste of his own predecessors was forgotten. His works were designed by the reservation of blank spaces, for the reception of figure and other subjects in accordance with the wishes of the various patrons whom he had inspired with a desire to have walls and ceilings decorated in this manner; it was thus that artists in differing genres found employment in his studio. . . .'

Audran, through his work as a decorator, thus gave Watteau an entrance to the new decorative style at the end of the reign of Louis XIV. It has been considered, as it was by Caylus, using the dismissive hindsight of the immediately succeeding generation, that this style was heavy, dedicated only to the pompous glorification of Le Roi Soleil. Since the beginning of century, however, and the Peace of Rijswick, there had been a resumption of what might be called 'the works of peace'. Fiske Kimball's fundamental book 'The Creation of the Rococo' and a recent exhibition have convincingly shown that the slightly older artists of the reign of Louis XIV, such as Oudry, Parrocel, Van Loo, Nattier, Lemoyne, Jouvenet, de Troy, La Fosse, Rigaud and, above all, Antoine Coypel, moulded the generation of Watteau and influenced the Art of the Regency in France. Their subject matter of mythological gallantry and genre and the many decorative projects also taking place for the King under Pierre Lepautre (c. 1648–1716), who was appointed Dessinateur des Bâtiments in 1699, were bound up in the emergence of the rococo style. Watteau, at work in Audran's studio together with Huillot, Charles Huet, Simpol, Oudry and Pater, was in contact with the new decorative revolution instigated by Lepautre, Jean Bérain and Audran. Lepautre incidentally was the son of Jean Lepautre (1618–1682) best known as an engraver mainly in the official style of Le Brun but who had also illustrated theatrical scenes such as the peasant dance from *La Noce de Village,* which provided a further connection with the genre of Callot and was to be developed further in Watteau's own painting *The Village Bride* (Sir John Soane's Museum, London).

Watteau was thus influenced by the Lepautres, father and son, mainly through the mediation of Audran, but Gillot, too, had been responsible for some decorative work. The arabesques and ornaments of Audran were developed by Watteau and he soon became an independent creator in his own right. His designs are mainly known through the posthumous engravings of Huquier but a few independent drawings survive. From 1707 to 1709, when Watteau was in Audran's studio, work was being produced for arabesque patterns at the Château Neuf at Meudon and in 1709 Audran produced for the royal Château of Marly his famous design with monkeys at the table, the first of many such designs. It would appear that, for reasons of style, the drawing of the *Arabesque with monkeys* at Stockholm (Plate 6) is by Watteau, though he follows Audran's example, whose own drawing is also at Stockholm (Brookner Fig. 7). Watteau's livelier combination of figures within a surrounding decoration distinguishes him from his master. In *Le Berceau* (Plate 7) he passes to a more involved style and then to other designs which are much more naturalistic. 'Such plates', as Kimball remarked, 'are merely scenes of figures in landscape within an outer frame of arabesque or cartouche elements, reduced to the greatest attenuation and wreathed or branching with leafy sprays.' As he had with Gillot, Watteau quickly equalled and soon surpassed the example of his master in another form of art.

What exactly Watteau did as a decorator with Audran has never been fully resolved and another mystery of his period as a designer which must be considered concerns a series of drawings for extravagant baroque fountains, many of which are in Stockholm (Plate 126). For a long time they

9

were attributed to Gilles-Marie Oppenort (1672-1742), who was to become the architect and designer to the Regent, the Duke of Orleans. Then they were given by Parker and Mathey to Watteau himself. A recent article, however, (by M. P. Eidelberg), convincingly shows that these designs which, admittedly, belonged to Watteau in 1715, are rightly attributed to Oppenort and in fact the engravings by Huquier in 1737 say so. One lesser-known drawing is reproduced here as an example of Watteau's contact with Oppenort, who was also from a Flemish background. Both of them were part of the revolution in design and Oppenort, in turn, owned two paintings by Watteau and knew and admired his work. It may be that Watteau copied one or two of Oppenort's designs; one of the Stockholm drawings in particular does seem superior of handling. On the whole, however, the series compare equally well with Oppenort's known drawings and the contemporary evidence of the Swedish count Carl Gustaf Tessin, who was shown them by Watteau himself in 1715, as being by Oppenort, seems conclusive. They are more baroque in style, extravagant fantasies probably never intended to be built, and as such closer to Oppenort's known predeliction for the baroque, a tendency which Watteau never fully endorsed. Even when he uses large baroque details in his paintings they are not quite the same, though some of the actual fountains do occur in the work of Watteau's followers, Lancret and Pater.

Oppenort was probably the originator of these but Watteau admired them and may have seen their possible use as props to create an ideal setting in some rich park, with elaborate sculpture and its graceful play of water, echoing the playful mood of the painting; but his own fountains are rather different and it was left to his followers to exploit these designs.

Nevertheless, it was undoubtedly through Audran and his studio that Watteau's draughtsmanship was allowed to develop in this direction. Whether he was the creator or only the follower, he was now emerging into the main stream of the new developments of eighteenth-century art and shows how in his drawings the decorative arts could help to create a new form of independent painting. Seriousness of purpose could be reconciled by Watteau with apparently flippant decorative details.

There is no mystery surrounding his interest in genre. We have seen how in his decorative work for Audran he introduces genre details. He had begun his career by copying the painter Gerard Dou but an interest in Flemish art was by no means unusual. In 1709, for example, the Cabinet de Royal contained pictures by, among others, Teniers, Mieris and Brueghel. The Regent, the Duke of Orleans, an important arbiter of taste, also owned Flemish pictures. Lip service may have been paid to the Grand Style but collectors still bought pictures which showed them, at one remove, how people lived. The development of Watteau's art is unthinkable without this interest in genre, and his revolutionary development of the *fête galante* may be taken as a sophisticated arrangement of genre elements.

Audran was able, in his other role as caretaker of the Luxembourg Palace, to introduce Watteau to the great cycle of paintings by the greatest Fleming of them all, Rubens. The cycle of the Life of Marie de' Medici, then in the Luxembourg, revealed for Watteau a rich, luxurious world idealising real events. *La Kermesse*, also in the royal collection, could be plundered not only for genre details for his pictures, for example *A Man stealing a kiss* (Plate 23) but he could also see how such genre elements could be transformed from a vulgar orgy into a bold and lively frolic of elegance and poetry. When de Piles was elected *Conseiller* of the Academy in 1699 and published his *Abrégé de la vie des peintres*, the triumph of Rubénisme was assured. Colour rather than design, what has been described as Flemish exuberance rather than classical restraint, the

new rather than the old, were to be the tendencies of even official French painting and Watteau was caught up in this enthusiasm.

We can see what Watteau learned from Rubens through his drawings. *Hercules wrestling with the Nemean Lion* was copied directly by Watteau (Lugt Collection). The baroque power and expressive masses of the original were fully caught by Watteau in red chalk and his drawings were never to be the same again. He could also catch the rich sensual mood of the *Garden of Love* by Rubens which made manifest Watteau's own longings and which he refined for his own similar paintings of Arcadian romance.

He also studied other Flemings, such as Van Dyck, and in the *Portrait of Adam de Coster* (Plate 27) we can see how the more elegant Flemish portraitist gives a personal hint to Watteau's own development.

Rubens and colour, though important, were not to be enough. The world of the common man: genre; the world of the theatre: the Italian Comedy; the world of interior decoration: arabesques and *rocaille* fountains; the world of Rubens in *Kermesse;* the world of Van Dyck in his aristocratic portraits; all were to be subtly changed in Watteau's own drawings and paintings so that he could strike out in an independent world of his own. Three further stages, however, were necessary in his development before these aspects were successfully coalesced.

The desire for change, which was part of Watteau's restless nature, then led him to another branch of painting which marked a curious new departure for Watteau. He actually left Paris for his native Valenciennes where he remained for about seven months, possibly to demonstrate his independence. All his contemporary biographers are agreed that his military subjects which he began in 1709 were a new venture. Not only was the subject different from the decorative work he had been doing but the way in which he painted them was against the accepted mode. In the seventeenth century, the painting of battle scenes had, with artists such as Salvator Rosa and Jacques Courtois (Cortese), known as 'Il Borgognone', been the excuse for a baroque display of power, smoke and thunder. Watteau chose to concentrate on the more humdrum character of military life as it was in the campaigns in the Netherlands, with soldiers and their camp followers at rest, lying about, taking their ease or occasionally marching off to war, rather than the full-blooded reality of the battle itself.

To some extent the records of the campaigns of Louis XIV, made by the Fleming Adam Frans van der Meulen (1632–90), or the elegant military genre of Pieter van Bloemen (1657–1720), also a Fleming, provide a near contemporary analogue to Watteau's scenes. Watteau's military paintings, however, are closer in mood and arrangement to an earlier Flemish artist, Jan Brueghel I (1568–1625), nicknamed Velvet Brueghel. His landscapes and street scenes, with their quiet, naturalistic air, tumbled space, clusters of figures going about their daily routine and scattered over open foregrounds, are closest to the military scenes of Watteau. The difference is that in the latter, soldiers have been substituted for peasants and their carts, and the arrangement of the figures is more complex. Watteau's military subjects can, accordingly, be best understood as an extension of his interest in genre, his soldiers considered as slightly more exotic, popular types. It is interesting to note that both Crozat and Mariette admired and possessed large numbers of drawings by Jan Brueghel.

There is also a difficulty concerning the exact chronology of these scenes. Gersaint describes the events as follows: 'He painted one while still in Paris showing the departure of a group of soldiers . . . the picture is one of those engraved by the elder Cochin.' This he sold to the dealer Sirois, who was also Gersaint's father-in-law. 'This transaction marked the beginning of my father-in-law's life-long acquaintance with the painter, and he was

so satisfied with the picture that he begged its author to paint him a companion piece which was duly executed and sent to him from Valenciennes. This was the second piece engraved by the Sieur Cochin; it represents the halt of a regiment, the whole painted from nature. . . .' It has previously been argued that these two pictures, the first of a series, were the *Recruits going to join the Regiment*, previously in the collection of Edmond de Rothschild and *The Halt of a Detachment*. These two simple paintings are a pair for size but the *Recruits going to join the Regiment* was engraved by Thomassin, not Cochin as Gersaint states. Mariette also wrote, after the event, that Watteau painted a second pair after he had returned from Valenciennes to Paris, both also engraved by Cochin, *Retour de Campagne* (Col. E. W. Edwards, U.S.A.) and *Camp Volant* (Hermitage, Leningrad). He then added an enigmatic note that 'It had been painted the first'. It would appear that these two may well be considered as the first of the series. They are a pair for size and the subjects fit Gersaint's description in general terms, one showing soldiers departing, the other showing them at rest. The actual names given to Watteau's pictures varied in his own lifetime — though it must be conceded that the prints were first published between 1727–30 (that is, before Gersaint wrote) with these titles. What is most important, however, is that the *Retour de Campagne* and the *Camp Volant* were both engraved by Cochin, which the others were not.

It might be argued, then, that Watteau's earliest drawings are those connected with these two pictures and in style they seem to coincide. Such drawings as the *Standing Cook* (P. & M. 257) or the *Kneeling Soldier tending a Fire* (P. & M. 256) are in his earlier manner, drawn with a nervous outline, seen whole and tapering towards the extremities. Of the drawings reproduced here, and over thirty-eight are known to have existed, the *Three Soldiers in Capes* (Plate 9) seems to be the earliest in style. They are seen full face and in profile, like others in the series (P. & M. 239), almost as if Watteau wanted to make sure he had fully mastered the new models, before he arranged them in more casual poses. A drawing exists, in fact, (P. & M. 244) where Watteau appears to be depicting successive stages in ordering arms; the figures are numbered as if from a seventeenth-century manual of arms, a reminder that then as now such a procedure was done by numbers.

His figures quickly lose this static appearance. Their arrangement in the paintings becomes less awkward, the space broader, the conventional framework of trees (as in Jan Brueghel) disappears and the landscape becomes softer. The general mood is more romantic. The drawings also reflect this change. The soldier at the right of the *Three Studies* (Plate 11) has been connected with the painting of the *Recruits going to join the Regiment* which was considered his earliest painting. But again the style of the drawing is different, and it probably dates from a little later.

The third sheet reproduced here (Plate 10) has four studies of soldiers which occur in the painting *The Diversions of War* (Hermitage, Leningrad) (Plate 115), one of a pair, the other being *The Hardships of War*, also in Leningrad. Dates suggested for these two pictures range from 1711–1715, which would make them relatively later variations on his military themes. Certainly the mood is much more expansive, the spatial grouping more flowing and the light and shade more subtly divided. The landscape is frothier and more elegant. The drawings too reflect the greater breadth of handling. They were, however, probably done sometime before and used later — a fact of his working which makes a convincing arrangement of all these military drawings rather difficult. The figure of the woman seen from the rear on the sheet of drawings occurs in another painting of *The Halt* which probably dates from the Valenciennes period. The landscape in this

Detail of Plate 10

picture does, however, bear some resemblance to the *Diversions of War*. It may be that Watteau found a market for this sort of picture on his return from Valenciennes to Paris. There was, in any case, not much demand for pictures of any sort in Valenciennes which is probably why he left, and why he produced the two in Leningrad for the dealers in Paris. It is significant that they belonged to Antoine la Roque, whom he had met about 1714 through Crozat. The greater assurance of the landscape may have been due to contact with Crozat which will be discussed shortly.

One certain point remains: the extreme difficulty of dating paintings and particular drawings from stylistic evidence. Even the contemporary evidence is in conflict. It says much for the attempt to analyse Watteau's works if agreement cannot be reached over such a homogeneous group of paintings with thirty-eight connected designs. Stylistic analysis, contemporary documents, all the accoutrements of an art historical campaign have not provided a quick solution.

The more domestic aspect of his Valenciennes military pictures can be contrasted with a small group of drawings which reveal another aspect both of Watteau's education and of his progress as an independent artist. Some time before 1710 according to the publisher's address, and it may even have been before he left for Valenciennes, a number of his drawings were engraved as *Figures de Modes*. The drawings connected with these prints, which are mostly of single figures, elegantly posed and dressed in the height of fashion, were clearly done about 1710 (Plates 12, 13). Essentially they are fashion plates which may have inspired him with the idea. By taking another popular art form he lays down the foundation of his later elegant assemblies. The ruffles of expensive clothes give him the excuse to enrich these relatively simple drawings with a variety of accents, to develop the play of light and widen his vocabulary of forms and poses. Very few of them, in the way of fashion plates, give the appearance of being drawn exactly from life and the introduction of studio landscape backgrounds, like Victorian photographs, complete the artificial effect. The success of the sale of prints encouraged him to extend the series which was engraved as *Figures françaises et comiques* and in which actors and singers also appear. They all become more elegant as the divorce from reality increases. He was now able to make a smooth transition from high fashion to humble life, from decoration to reality.

But while he was obviously impressed by the elegancies of the social scene he could also look quite objectively at the lower classes — although it was a particular sub-strata of the lower classes. From time immemorial the inhabitants of the mountainous Duchy of Savoy had visited France either with peep shows, magic lanterns and performing marmots, or as menial shoe-blacks. This great migration took place every winter, as a result of the economic hardship in their own country. Like many present-day immigrants they were exploited in their adopted country and maintained families at home with the money they earned. Their filial piety was later treated by Greuze as the excuse for paintings with a moral. Watteau, however, draws no moral, makes no comment, except to produce a series of brilliantly observed realistic figures, which make bold use of black and red chalk to set off their distinctive traditional costume and curious paraphernalia (Plates 14–17). They were probably executed around 1710 and like the *Figures de Modes* are single figures. They, too, can be connected with a popular art form — the various sets of popular types, generally called *Cris de Paris*. The later eighteenth-century *Cries of London* by Francis Wheatley are still popular with print sellers.

On a wider and more public front, however, the three years from 1709 and 1712 were important for Watteau. He finally achieved a measure of public

Detail of Plate 14

success as an independent painter, he was accepted into the Academy and he met Crozat, the millionaire whose patronage provided him with shelter, work and introductions and whose extensive collection acted as a finishing school for Watteau's artistic education. In August 1709, Watteau entered for the Academy's Rome prize, the subject of which was *David granting Nabal's pardon to Abigail* (I Samuel 25). He came second, which was not good enough to earn him a trip to Rome. So, like Rembrandt, his experience of Italy and its art remained second-hand, through the not inconsiderable works of art he saw in Parisian collections. Watteau's painting, his first and last in this vein, was a typical historical subject, which Sebastiano Ricci (1659–1734) might well have enjoyed, or his French contemporaries, Charles de la Fosse (1636–1716) or Antoine Coypel (1661–1722) laboriously worked over. The painting is now lost and, strangely, no drawings survive, although there are a number surviving for every other major project of his. It is as if he had later wished to obliterate all trace of his venture in the grand style and preserve the characteristics of his art as we now know it.

For he was to achieve official honours not by conventional history painting but by leaving two of his pictures lying about in the Academy where they were seen by de la Fosse who supported his acceptance by the Academy as an associate with a presentation picture which could be a subject of his own choice. This casual achievement, probably by means of his military subjects, confirmed that Watteau was to advance by 'the originality and novelty of his style', as Caylus described it, rather than by the grand style. This new venture also brought with it more commissions than he was willing or able to deal with, which presumes some change in contemporary art taste. Certainly, Watteau's friends and patrons felt it necessary to make allowances for Watteau, as someone outside normal rules for painting or behaviour. The last eight years of his life were spent in producing a large number of works to fulfil the demand for his new subject the *fête galante*. The drawings of his last period are mostly of this sort — studies of women, musicians, actors, children 'exactly observed from nature', which he arranged in his finished pictures with increasing subtlety and psychological insight. But before this there was one final period of self-education which he experienced during his stay with Crozat.

Pierre Crozat (1665–1740), nicknamed 'poor Crozat', was one of the richest men of his time. He acted as patron and intermediary for living artists, host for like-minded amateurs, and collector of works of art of all periods on a grand scale. The opportunity to live in his town house was not one which Watteau could easily have refused. Crozat gave him the commission to redecorate the dining room of his house in the rue de Richelieu with four panels of *The Seasons*, only one of which now survives but which we can recreate through the drawings and engravings after his works (Plates 39–43). Tragically, the long lost *Spring* (Plate 116), recently rediscovered, was even more recently destroyed by fire, so that only *Summer* remains. Tradition has it that Charles de la Fosse, ever appreciative of Watteau's art, had a hand in the designs but fairly careful preliminary designs by Watteau which exist would suggest that he was also concerned with their inception. At any rate, de la Fosse was dead by 1716 and may have handed on the work to Watteau, as he had introduced him to Crozat.

The four works are an interesting attempt by Watteau to come more into line with a contemporary allegorical work and have much of the flavour of old masters about them. Rather unusually for Watteau, he drew from the life specifically for the project rather than use already existing drawings — he probably would not have had a Bacchus or Ceres to hand — and this may have been the result of the connoisseurship he imbibed in the Crozat household. While with Crozat he also seems to have painted another

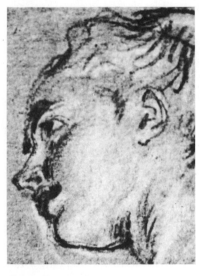

Detail of Plate 39

Detail of Plate 118

similar mythological picture of *Jupiter and Antiope* for which nude studies also exist (Plate 44), though for this he also borrowed from Van Dyck.

His debt to Rubens, through Audran, has already been mentioned but Crozat's wonderful collection enabled him not only to look again at Rubens and Van Dyck but also to flavour his art with the experience of Italy, and in particular Venice. His mythological works with their worldly nudes and what were later called his *Fêtes Vénétiennes* were based on an appreciation of the splendour of sixteenth-century Venetian drawing and painting. Like Tiepolo in Italy, Watteau looked backwards to the world of richness, elegance and ceremony which Veronese seemed to express, with its impressive honeyed architecture and regal pomp. But he also looked at other Venetians. The earlier *poésies* of Giorgione and his followers, at the beginning of the sixteenth-century, such as the famous *Fête champêtre* which was thought to be by him, had figures in a landscape, making music, to complete an allegory of the senses. Watteau used music in exactly the same way (Plate 118) as part of love making. The great Venetian triumvirate of Veronese, Titian and Giorgione are important for an understanding of the sources of Watteau's style.

Another important aspect of Venetian painting which he could experience through the Crozat collection was, of course, landscape. We have seen how in the Luxembourg Gardens during his time with Audran he drew incessantly from nature, as well as from Rubens' own landscapes. When at the end of 1715, Crozat returned to France with a large collection of Venetian landscape drawings which included the marvellous series by the Bassano family, Domenico Campagnola, Titian and others, we know how impressed Watteau was from the number of copies which he made. He could learn from their breadth, luminous atmosphere, the collocation of peasant buildings and mountainous landscapes which bordered on the fantastic and which were echoed in Watteau's own works (Plate 32).

But his interest in landscape did not receive its only impetus through Crozat's collection of Venetian drawings. It may be, if the number of copies which exist by Watteau after Venetian drawings are considered, that he copied Venetian drawings before his contact with Crozat. Some are less unreal and closer to the genre of Jacopo Bassano, while some, because of the inscriptions which they bear, have even been considered to have been drawn on the spot in Italy, though this is unlikely.

He was indeed interested in landscape drawing out of doors and in the same way as his figure drawings vary between the artificially elegant and the realistic detail, so his landscape drawings could give him details of trees and greenery (Plates 35, 36) as well as more leafiness and atmospheric effect for the backgrounds of his pictures. The landscapes he drew in what was the market garden area called the *Porcherons*, now part of Montmartre, were used to provide realistic settings. He also drew out of doors at Crozat's country house, Montmorency, near Enghien. At the very end of his life at Nogent he was engaged on similar pursuits with Mme de Jullienne. As the de Goncourt brothers put it, 'with this mixture of authentic nature with artificiality of operatic scenery . . . Watteau has conjured up a nature more beautiful than nature . . . he paints (and draws) landscapes which by the force of poetry acquire a supernatural air'.

Nevertheless, the Crozat Collection gave him the authority of the Venetians for the poetry of his courtly allegory combined with genre-like detail. Sometimes the setting was dark, as with Jacopo Bassano, and imbued, too, with a richness of texture and colour which add to the pleasure of the senses. This was to be his final aim. His drawings of women, for example (Plate 65), come very close to similar works by Veronese.

There was, however, one other northern master, also collected by Crozat,

from whom he could learn: the Dutch artist Abraham Bloemaert (1564–1651). During his long career which brought an elegant mannered art to Utrecht, Bloemaert produced for his own studio sheets of studies of heads, hands and animals which were used to make up his compositions. These were gathered together by his son Frederik Bloemaert and engraved as a Drawing Book (*Het Konstrijk Tekenboek . . .*) of prototypes in 1740, though these plates seem to have been known in the seventeenth century. Watteau's own procedure, with many heads on one sheet, came very close and his drawings, though in chalk rather than pen and ink, are sometimes similar in execution. The subjects also comprised arrangements of cupids and romantically posed single figures of peasants which also influenced Watteau and later French artists such as Boucher.

In many ways, then, Watteau's stay with Crozat was a culmination of his education, and he received confirmation of the validity of the aims which he had already set himself. As to his final few years, we do know a little more which can be briefly related. They were dominated by two major works for which we have, luckily, both the connected drawings and finished paintings. His restlessness made him leave Crozat for temporary lodgings in the Quai de Conti (June 1715). He became a full member of the Academy with his painting the *Embarkation from the Island of Cythera* finally presented in August 1717. He was then lodging again with Sirois. In 1718 he stayed for a time with his Flemish compatriot Nicolas Vleughels (1668–1737). Then in 1720 as his consumption grew worse he made a mistaken journey to London apparently to consult the famous Dr Mead but probably to earn money and make good his losses in the financial crash of 1720 (Plate 113). After a disastrous winter in London he returned to Paris in 1720, this time staying with Gersaint, Sirois' son-in-law, for whom he painted his sign, *L'Enseigne de Gersaint* (Plate 120). As his condition worsened he moved to Nogent producing a few landscapes and a religious picture of Christ on the Cross, finally dying there in July 1721 at the age of thirty-seven in the arms of Gersaint. Just before his death he seems, in a fit of remorse, to have destroyed a number of works which he considered indecent. Though the erotic overtones of some of his works cannot be denied the effect may well have been exaggerated to his last repentant gaze. Like the works of Turner destroyed by Ruskin for similar reasons, they may well have been nude studies, slightly more intimate than those which did survive.

His reception piece for the Academy had been delayed but with his new maturity he confidently presented to the Academy his famous *Embarkation*. This was, not surprisingly, quite revolutionary for the Academy but its liberality enabled it to realise that he had created a new form of contemporary history painting 'concerned not with heroism but with passion', the *fête galante*. A recent brilliant analysis by Michael Levey has established its genesis in the world of theatre and explained its motive. It represents, in fact, the return of the masquerade pilgrims from the island of love, not the departure for the island as had long been thought. All of Watteau's nuances of feeling and arrangement can be found but the drawings which remain show how concerned he was to have a firm basis for his chain reaction of sexual love. He drew from the life the two figures who reluctantly leave the shrine of Venus (Plate 111). The painting marks the glorious apotheosis for which his drawings were a preparation. Venetian *poésie*, groups of elegant courtiers in a sixteenth-century landscape seen from a high viewpoint, his own decorative training, all these traits are fused in one perfect ensemble, quite rightly compared to a musical composition. 'In every way, the picture is imbued with a poignant sense of the losing battle love fights against the reality of time. Sunset marks the end of love's day,

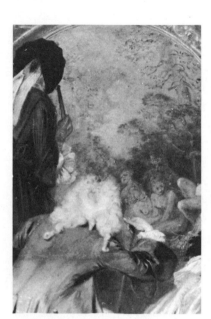

Detail of Plate 120

along with the end of the pilgrimage and intimations of dispersal set everyone in motion except the pair seated under the statue's spell' (Michael Levey).

Watteau was to paint a further perhaps more explicit variant for his friend Jullienne which is now in Berlin. He was to produce other pictures which echo the mood but in none is the combination of reality and dream so magically combined. He painted larger but never so evocatively again. The direction of his art seems to have taken a more realistic turn.

On his return to France at the beginning of 1721, he asked Gersaint the dealer for permission to paint a sign board 'to take the chill off his fingers'. Gersaint allowed him to proceed and the 'success of the painting is well known; the whole was executed from nature and the attitudes were so lifelike and easy, the arrangement so natural and the grouping so well conceived that it fascinated the attention of passers-by . . . it represented only eight days' work . . . it is the only example of his work that in any way stimulated his self-esteem. . . .' What Gersaint excusably ignores is that it most certainly did not represent Gersaint's shop as it really was. The stock, for example, is excessively grand but it is, nevertheless, an earthier development of *The Embarkation* which deals on this occasion with the commerce of art and society rather than elegant love. The bias is more realistic and, again, specific drawings were made for the various precise functions of the action, particularly in the men packing the crate with a portrait of Louis XIV (Plate 22), a reference to the full title of Gersaint's shop *A L'Enseigne du Grand Monarque*, Pont Notre-Dame. This revival of his interest in genre may well have been developed had he lived, as it was by later eighteenth-century French artists.

He rightly saw in his drawings the essence of his whole development, and he divided them among his friends, Jullienne, Henin, Gersaint, Caylus and the Abbé Haranger. This at first made it difficult for other collectors to obtain his drawings which were in demand but Mariette, for example, managed to acquire about twenty-three. As he described them 'they are of a new mode; they have those graces so much connected with the spirit of the artist that one can say that they are inimitable. Each figure which comes from the hand of that excellent man has a character so true and so natural that they attract attention all alone without having to be sustained by the composition of a grand subject.'

The Goncourt brothers testified to their legacy in the eighteenth century, to Pater, Lancret, to Boucher, to Gabriele de St-Aubin for example, who exhibited landscapes with 'figures in the manner of Watteau and finally there appeared a certain Portail, a draughtsman in the manner of Watteau to fix and paint the expiring graces of the century with the same three chalks used by the illustrious artist of the Régence.'

Through Jullienne's collection of prints his graces and attitudes spread throughout the rest of Europe, in England, for example, to Hayman and Gainsborough particularly, whose *Musidora* was based on Aveline's print after Watteau's *Diana*. Watteau's intense observation of nature seen through a temperament was to be taken up by the Romantic movement and the distinction between the sketch and finished work, already seen by Mariette to be non-existent in his work, was to be finally abandoned in the nineteenth-century. It is his sketches in three chalks, 'painted drawings,' as the de Goncourt called them, which break through the hierarchy of academic subject matter and fully reveal this new shift in emphasis to stand as works of art in their own right. As Reynolds reluctantly conceded in discussing Gainsborough, a very similar artist to Watteau, 'we have the sanction of all mankind in preferring genius in a lower rank of art to feebleness and insipidity in the highest.'

Notes on the Plates

ABBREVIATIONS

Adhémar: Hélène Adhémar, *Watteau, sa vie et son œuvre*, Paris, 1951.
Brookner: Anita Brookner, *Watteau*, The Colour Library of Art, Paul Hamlyn, London, 1967.
D.V.: E. Dacier and A. Vuaflart, *Jean de Jullienne et les graveurs de Watteau au XVIIIe siècle*, Paris, 1922–9.
P. & M.: K. T. Parker and J. Mathey, *Antoine Watteau, catalogue complet de son œuvre dessiné*, Paris, 1957.

TECHNICAL NOTE

The French term *sanguine* has been used throughout to describe the various grades of red chalk which Watteau used, ranging from a deep crimson to an earthy red. He also used black and white chalk, which he sometimes moistened with his fingers to create a pink or grey slashing wash or accent. The three used in combination gave a rich, painterly effect known simply as *aux trois crayons* ('with three chalks') which has also been used in the following notes. He very rarely used pen and ink, though occasionally a wash produced with the brush can be found. He apparently preferred a white paper with a very smooth surface which, often through age and the effect of light, has darkened to cream or even pale brown. In all measurements height precedes width.

Plate 1 Self-Portrait. Sanguine and black chalk. $3\frac{5}{8} \times 3$ in. (9.3×7.3 cm.). Private Collection, London.

This little known self-portrait is similar to a full-face self-portrait previously in the collection of Otto Gutekunst (P. & M. 915) and can be compared with known engraved portraits of the artist, such as that which appeared in *Livre de différents caractères de têtes inventées par Watteau* in 1752 by Filloeul, Plates 4 and 7. These were probably drawn on the same occasion and show the artist apparently in good health. He seems to have retained slightly fleshy jowls right until the end, even though an emaciated appearance would be expected. This particular example is unusual for a self-portrait in that it shows the artist in profile and must have been executed with the aid of a double mirror.

Plate 2 Three studies of a man, one bearing a standard. Sanguine. $7\frac{1}{4} \times 9\frac{3}{8}$ in. (18.3×23.8 cm.). British Museum, London.

These sharply observed studies of young men, holding basins and carrying a standard, arranged like actors dressed in the costume of apothecaries with soft, close-fitting hats, were used in Watteau's satirical painting *Qu'ai-je fait, Assassins maudits. . . .* ('What have I done, clumsy murderers. . . .' D. V. 150, Adhémar 9, Plate 5). In his salty comment on the medical profession, of which he was to have grim experience, the careful study of the man pilloried in the horse's collar is changed into a fat, obviously stupid and well-to-do doctor, while the central figure of the man holding a basin is turned more to his right. The man with a standard appears as if from a troupe of comedians. Only occasionally does Watteau allow himself a sly even bucolic comment on the world around him, though in the work of Gillot, the humour was similarly direct. The drawing, however, is more neutral. Another sheet of studies exists for the painting with the models seen from different angles and carrying wicked-looking syringes (P. & M. 37), whose use is suggested to good effect in the finished painting. This early study, however, has a characteristic refinement and attenuation of limbs with part of one figure faintly drawn in. Already can be seen his close observation of the bulk of cloth over limbs, together with isolated studies of hands, which he drew again and again throughout his career for their importance in gesture and composition. The sheet belonged to Watteau's first great patron, the great collector Crozat. The standard-bearer and collared head were engraved by J. C. François.

Plate 3 Two figures dancing and a study of an old man with a stick. Sanguine. $6\frac{7}{8} \times 9$ in.
(17·5 × 22·8 cm.). British Museum, London.
The two figures dancing their rustic dance appear in his painting *Le Contrat de mariage* (Prado, Madrid, D.V. 116) and all three occur in his early arrangement of a country wedding, *L'Accordée de village* (The Village Bride), Sir John Soane's Museum, London (Brookner Plate 8). The old man, with his flaxen locks, appears to be a direct portrait of the actor La Thorillière, and he can be found in other studies. Again the figures are not finished throughout. The heads are given expression by the merest details of eyes and nose, touched in with the chalk, and the gracefulness of line and pose distract the eye from noticing the deficiencies of proportion, particularly the arm of the man on the left. The drawing is an early example of his lifelong interest in the Arcadian world of country folk, an interest which can be traced back to the beginning of the seventeenth century with the Carracci in Italy and Northerners drawing similar peasant dances.

Plate 4 Studies of two young men and seated woman. Sanguine. $6\frac{1}{4} \times 7\frac{1}{8}$ in. (16·0 × 19·5 cm.). Mr and Mrs Eliot Hodgkin Collection, London.
The seated woman, turned as if in response to a question, was used by Watteau in his painting *Pierrot content* (D. V. 180). The elegant figure of the man in the centre was used again by Watteau in one of his *Figures de modes* but with the head turned away from the spectator and the right arm lowered (P. & M. 173). This last drawing, less alive and without the immediacy of the present example, was engraved by J. Audran for the series of plates. Even though it is thus an early drawing with occasional hesitancies, Watteau has moved from rustic simplicity to a more elegant world, as his interest in the details of the costumes reveals. The verso of the drawing shows Watteau's current interest (*c*. 1709) in the different subject matter of his military pictures.

Plate 5 Pierrot playing a guitar with a figure from the Italian Comedy. Sanguine. $5\frac{3}{8} \times 6\frac{3}{16}$ in. (13·6 × 15·7 cm.). Museum Boymans-van Beuningen, Rotterdam.
Watteau has seized a spontaneous moment from the Commedia dell' Arte and characterised with rapidity its humour and charm. The comedians stand rather nervously, as if giggling to the strumming of the guitar, against a conventional background of trees. Their slight awkwardness and simplified details place the drawing early in his career. Watteau had been introduced to the Italian Comedy by Gillot but his deft summary of the Pierrot's costume, the false nose, their poses and their awareness of the spectator contrast with Gillot's cruder and more pedestrian approach which can be seen in a drawing in the Louvre, *La Fausse Coquette* (reproduced here, Plate 124).
A landscape with buildings has recently been discovered on the back, drawn probably not much later, which testifies to Watteau's early interest in landscape, admittedly of a slightly artificial type. The small sketch was originally on a larger piece of paper and the Italianate buildings on the verso, which have been cut, were used in his painting *La Promenade sur les Ramparts*. The two figures were engraved, as from Watteau's hand, by Caylus, who also admired Gillot's theatrical scenes.

Plate 6 An arabesque with monkeys. Sanguine and plumbago. $27\frac{1}{2} \times 19\frac{1}{2}$ in. (69·7 × 49·5 cm.). Nationalmuseum, Stockholm.
While Watteau was in Audran's shop he developed a highly competent style of arabesque decoration. The present drawing was once considered to be by Audran, but when it is compared to a similar design by Audran at Stockholm Watteau's superiority is evident. Instead of a series of isolated decorative elements seen flat on the wall, Watteau has drawn a subtly arranged genre scene in depth, with monkeys instead of humans, framed by an elaborate but airy structure with a greater three-dimensional quality. The conceit of showing monkeys behaving as humans gave an added spice to the luxurious surroundings at Marly for which it was intended.

Plate 7 Le Berceau (The Arbour). Etching with some engraving by Huquier after Watteau. 16 × 10¾ in. (45 × 27 cm.). Fitzwilliam Museum, Cambridge. Watteau's most elaborate arabesque design, given its title when engraved by Huquier (D.V.25). The original Sanguine drawing was formerly in the Groult Collection (P. & M. 192). In contrast to the preceding drawing, this fine design, probably dating from the end of his period with Audran, breaks open the space and is less static. The decoration is even more elaborate and the arrangement of putti, nymphs and satyrs moves in and out of space in a confident way. Yet the mood is essentially light-hearted. The decoration creates a pagan, sensuous world and the heavier spatial manipulation of the Baroque period is translated in terms of the new Rococo.

Plate 8 A project for an arabesque with the head and shoulders of a woman. Sanguine. 7⅜ × 11⁵⁄₁₆ in. (18·8 × 28·8 cm.). Formerly Museum Boymans-van Beuningen, Rotterdam.
Watteau's individual creation of a style of arabesque decoration which consists basically of a scene framed by decorative elements can be seen here. Nevertheless, the grotesque head, the shell forms, the nude, and all the decorative details echo the curves of the design in a confident and three-dimensional manner. We have moved a long way from the stucco decorations by Primaticcio at Fontainebleau from which Watteau took his inspiration. The rapid and sensitive touch adds to the mood of the decoration. The isolated study of a woman's head emphasises the working nature of such a study, yet the combination of the two elements increases its charm.

Plate 9 Three studies of soldiers in capes. Sanguine. 5⅞ × 8⅝ in. (14·8 × 22 cm.). Count Antoine Seilern Collection, London.
Watteau's first independent paintings which established for him an individual form of subject matter were his series of military subjects done just before and during his return to Valenciennes in 1709. These three studies were used in his painting *La Porte de Valenciennes* (The Gate of Valenciennes) and were engraved by Audran as separate plates in his *Figures de différents Caractères* (241, 95 and 127). They are seen simply full face and in profile and are drawn with the tenuous line and elongated proportions which possibly denotes that they date from early in the series.

Plate 10 Four studies of soldiers with a woman seen from the back. Sanguine. 7⅛ × 7¾ in. (17·9 × 19·8 cm.). Museum Boymans-van Beuningen, Rotterdam.
The figure at the bottom resting his head on his hands was used in the *Escorte d'Equipage* (Baggage Train; Adhémar 39) and was used again in his later painting, *The Relaxations of War*, Hermitage, Leningrad (Adhémar 95), as were the other three soldiers. The woman was used in a military picture, *The Halt* (Adhémar 35) which probably came near the beginning of the series. She provides an early example of his liking for the fullness of the dress down a woman's back, but she has the nervous start of his early style.

Plate 11 Three studies of soldiers marching, seen from the back. Sanguine. 6⅞ × 7⅞ in. (17·4 × 20 cm.). Kupferstichkabinett, Berlin.
More confident in style than the preceding drawings, the present sheet is drawn with a greater attention to detail, movement and subtlety of pose. They also have certain similarities but are not exact with figures in his paintings *Recruits going to join their Regiment* (Adhémar 34), *The Departure of the Garrison* (D.V. 276) and the *Escorte d'Equipage* (Baggage Train, Adhémar 39) both lost but known from engravings. They may date from later in the series, perhaps even after his return to lodge with Sirois in 1710. The figures at the right and in the centre were engraved by Audran (*Figures de différents Caractères* 189 and 257).

Plate 12 Standing man. Sanguine. $4\frac{3}{8} \times 2\frac{7}{8}$ in. ($11 \cdot 3 \times 7 \cdot 4$ cm.). Fitzwilliam Museum, Cambridge.

The following two drawings were used by Watteau in a series of prints entitled *Figures de Modes*. From a publisher's address the prints must date from before 1710. The drawings consequently precede or are roughly contemporary with his military drawings at Valenciennes of about 1709 and like them mark a new departure for the artist. The figures are more supple and individual than the contemporary fashion plates which they resemble and enable Watteau to parade an inventive series of figures of high fashion who could be later found strolling in his *fêtes galantes*. The present drawing was etched by Watteau himself and the plate altered by Thomassin for the *Figures de Modes* (D. V. 49 and 51) and later engraved in reverse by J. Audran in *Figures de différents Caractères*, as was the following drawing.

Plate 13 A woman standing by a tree. Sanguine. $4\frac{5}{8} \times 2\frac{7}{8}$ in. ($11 \cdot 3 \times 7 \cdot 4$ cm.). Fitzwilliam Museum, Cambridge.

Both of these drawings are marked by the use of rich crimson chalk with the accents picked out in thicker, denser touches, a developing characteristic of his drawing style. They are posed against a conventional backdrop of landscape, but Watteau has slightly altered the women's hair styles from the high, structured creations of around 1710, to make his female figures softer and less formal.

Plate 14 Two studies of a young boy carrying a stool. Sanguine and black chalk. $9\frac{1}{8} \times 8\frac{7}{8}$ in. ($23 \times 22 \cdot 5$ cm.). Museum Boymans-van Beuningen, Rotterdam.

In contrast to his elegant figures are the studies of 'popular types', particularly the marvellously realistic studies of the Savoyards which he drew about 1709–10. They remind us that all French art of the seventeenth and eighteenth centuries was not exclusively artificial. With these drawings he could be compared not only to the Flemings but also to the great French masters of realism, Le Nain and Chardin. The following drawings can be seen as brilliant studies not of improvisation but as aspects of the people of Paris. Between the two sets of drawings, the *Figures de Modes* and these figures of the populace, there is not only a change of world but also a rapid development of style. Watteau used three chalks and immediately attained mastery of this painterly technique of drawing to express light, mass, mood and detail of these individuals of the streets. These two appealing and direct studies of a boy, who was possibly a shoe-black, show Watteau's skill with his new technique, accenting details of the hair and stool in black chalk. Caylus, who owned the drawing, engraved both figures, but the plate of the figure on the right was refused and one by Tremolières incorporated in the *Figures de différents Caractères* (38 and 170) and perhaps because he admired it so much he engraved a third plate of the right-hand figure in a slightly different pose.

Plate 15 Savoyard with a box of curiosities. Sanguine, black chalk and stump. $11\frac{7}{8} \times 8\frac{1}{4}$ in. ($30 \cdot 1 \times 20 \cdot 7$ cm.). Museum Boymans-van Beuningen, Rotterdam.

This magical drawing executed in red and black chalk with areas of shadow smudged with the stump shows a Savoyard with his 'box of curiosities', a peep-show opened up for the spectator, and the box for his performing marmot over his shoulder. The dishevelled appearance and characteristic hat have been powerfully suggested, but the detail has not been lost in the general effect. It was possibly one of nine drawings bequeathed by Watteau on his death to Crozat, in recognition of the debt he owed his patron. A counter-proof is in the Louvre (No. 3885) and a similar figure was engraved by Boucher as the title page for the second volume of *Figures de différents Caractères* (133).

Plate 16 Bearded Savoyard. Sanguine, black chalk and wash. $8\frac{7}{8} \times 6$ in. ($22 \cdot 4 \times 15 \cdot 1$ cm.). Galleria degli Uffizi, Florence.

The bold treatment of the chalk and wash admirably expresses the rough character of the stocky Savoyard, who sits with his marmot box on his lap and leans on his 'box of curiosities'. The box showed hand-coloured engravings of battles and dramatic events, arranged inside to give an illusion of perspective. The spectator looked through a lens at one end and the scenes were changed by strings hanging outside the box. The holes for the strings can be seen on the right-hand side.

The drawing was engraved by Jeaurat before 1715 as one of the *Figures françaises et comiques* and placed bizarrely among the *Figures de Modes*. It was later engraved by Caylus but not used by Jullienne in his *Figures de différents Caractères*. A counter-proof of the drawing is at Stockholm (2820).

Plate 17 Seated figure of an old Savoyarde. Sanguine and black chalk. $12 \times 7\frac{7}{8}$ in. ($30 \cdot 5 \times 20 \cdot 1$ cm.). British Museum, London.

The proud independence of the poverty-stricken Savoyards who left their families and wandered all over France is fiercely characterised by Watteau, not without a hint of the pathos of the old woman in spite of his basically stern realism.

Plate 18 A Friar (*Un Carme*). Red and black chalk. $13\frac{1}{8} \times 9\frac{1}{8}$ in. ($33 \cdot 2 \times 23$ cm.). Count Antoine Seilern Collection, London.

The mendicant is seen as another inhabitant of the streets, like the Savoyards, and makes a realistic single-figure study in his own right, though perhaps there is also an element of caricature. This sheet may date from *c.* 1712–14.

Plate 19 Two studies of a man carrying a basket. Sanguine. 6×15 in. ($15 \cdot 2 \times 12 \cdot 7$ cm.). Fitzwilliam Museum, Cambridge.

Though this drawing does not have the same immediacy as the series of Savoyards it is a charming study from the life of a working porter, carrying a basket on his back. The slightly elongated figure and slight accents probably indicate that it was drawn early in his career, *c.* 1710, 'lacking as yet the sovereign mastery of his later years, but yet firmly and crisply drawn and with the mannerisms of Gillot's teaching already fully replaced by a searching and sensitive observation of reality' (Parker). It can thus be associated with the time when his ideas were germinating for the larger series of popular types.

Plate 20 Studies of a man turned to the left and a seated gardener. 'Aux troix crayons' on grey-brown paper. $8\frac{7}{8} \times 14\frac{1}{4}$ in. ($22 \cdot 5 \times 36 \cdot 4$ cm.). Musée du Petit Palais, Paris.

The present drawing has been included here amongst Watteau's more realistic statements of people in action, although as an active gardener the figure on the right is not particularly convincing nor is he obviously involved in any struggle for existence. He is much closer in mood and luxuriously dressed, in spite of his working straw hat, to the idle women with whom he appears in *Le Concert champêtre* (Musée d'Angers; Plate 118). He is again more typically cast as the uncertain lover in *L'Amoureux timide* (National Palace, Madrid; Adhémar Plate 103). Nevertheless, he gives Watteau a glorious opportunity to suggest the shimmer of light on clothes and we can see his ability to search out his facts and re-use them imaginatively. Similar vine leaves are found in *L'Amour au Théâtre français* (D. V. 270). The figure at the top who obviously turns his back on a life of toil appears in *L'Isle enchantée* (D. V. 264). Both figures were engraved by Boucher in *Figures de différents Caractères* (153 and 282).

Plate 21 Half-length figure of a man looking up and holding a basket. 'Aux trois crayons' on light brown paper. 10×7 in. ($25 \cdot 5 \times 17 \cdot 8$ cm.). British Museum, London.

This impressionistic study of a Parisian working man holding a basket in his hands appears to have later additions in another hand. Watteau used similar hands and a basket in his *Champs Elysées* (D. V. 133).

Plate 22　Studies of men packing pictures. 'Aux trois crayons' on grey paper. $6\frac{5}{8} \times 9$ in. (17 × 22·8 cm.). Musée Cognacq-Jay, Paris.
One of the last drawings by Watteau, probably of September 1720, it shows the men energetically packing pictures in *L'Enseigne de Gersaint*, Berlin (Plate 120). Like many of his late drawings the figures are drawn with extreme rapidity and may have been posed specially for the picture, to help with a passage for which his albums could not provide a pose. The man on the left is packing a portrait of Louis XIV; Gersaint's shop was known as *Au Grand Monarque* (At the Sign of the Grand Monarch).

Plate 23　A man stealing a kiss, after Rubens. Sanguine. $9\frac{1}{4} \times 5\frac{3}{4}$ in. (23·3 × 14·7 cm.). Musée des Arts Décoratifs, Paris.
Watteau was impressed by the robust vitality of Rubens, to which he was introduced by Audran, and he carefully copied these two peasant figures from Rubens's painting, *La Kermesse*, then in the French royal collection, now in the Louvre. He later made use of the motif in his own painting *La Surprise* (D. V. 81) of which there is an old copy in Buckingham Palace.

Plate 24　Ariadne, Bacchus and Venus, after Rubens. Sanguine. $6\frac{3}{8} \times 7\frac{1}{4}$ in. (16·3 × 18·4 cm.). British Museum, London.
The major works by Rubens which Watteau saw in the Luxembourg Palace were the series devoted to the history of Marie de'Medici. From the grand pomp of *The Government of the Queen* (Louvre, Paris), Watteau has copied the sensuous details of the meeting of Bacchus and Ariadne, an allegorical forerunner for his own more earthly encounters, and the nude Venus, a languorous image of love which comes close to the mood of his own paintings.

Plate 25　Head of a young woman, after Rubens. Sanguine and black chalk. $12\frac{1}{4} \times 9$ in. (31 × 22·8 cm.). Museum Boymans-van Beuningen, Rotterdam.
Watteau looked to Rubens not only for robustness and vitality. This beautiful drawing was copied by Watteau from a drawing by Rubens, as Mariette, who owned Watteau's copy, said on his mount. Drawn mainly in black chalk with delicate touches of red, Watteau achieved that colouring and grace for which Rubens was admired at the beginning of the eighteenth century. Watteau was more than just a *Rubéniste*. He had a particular regard for his illustrious Flemish predecessor who, it can be said, changed his style, affecting his rendering of space, atmosphere and colouring. Even the type of woman bears a strong affinity to those favoured by Watteau. He probably saw the original drawing, not through Audran, as in the preceding drawings, but slightly later in the treasure house of Crozat and his copy may date from his residence there.

Plate 26　Isabella Brant, after Rubens. 'Aux trois crayons'. $7\frac{3}{4} \times 5$ in. (18·8 × 12·8 cm.). Fitzwilliam Museum, Cambridge.
A copy by Watteau after a painting by Rubens formerly in the collection of the Duke of Norfolk. Another version of the same painting is reproduced here: (Plate 127). The type of woman and the decorative costume accord well with Watteau's own ideal.

Plate 27　Portrait of Adam de Coster, after Van Dyck. Sanguine. $5\frac{7}{8} \times 3\frac{7}{8}$ in. (14·9 × 10 cm.). Fitzwilliam Museum, Cambridge.
Rubens was not the only Flemish artist whom Watteau admired. He learned a great deal from the refined and aristocratic world of Van Dyck. Also in Crozat's collection were drawings by Van Dyck which he admired. Watteau's copy can be compared to the original of Adam de Coster, now in Frankfurt (Plate 128); the sensitive fingers and fall of the hand, the casual but elegant pose of the head and the feeling for the texture of clothes, particularly on the sleeve, have all been captured by Watteau with a technique as sensitive as the original.

Plate 28 Vertumnus and Pomona, after Bloemaert. Sanguine. $10\frac{5}{8} \times 8\frac{1}{4}$ in. (26.8×21 cm.). Ashmolean Museum, Oxford.

In spite of Watteau's northern background and obvious affinities with the art of the Netherlands, he did not make many copies after northern artists. Abraham Bloemaert (1564–1651), the originator of this design, was an interesting choice for Watteau to copy. He has used an engraving after Bloemaert by J. Saenredam, an example of his wide knowledge of the graphic art of the seventeenth century. Bloemaert, during a long career, produced many pictures and designs for prints, ranging from extravagant mannerist designs to quieter, more classical pagan mythologies in the manner of Goltzius, whose painting of the same subject the print resembles and which doubtless accounts for the initials H. G. in the lower left-hand corner. The soft, classical subject was also treated by Watteau (Adhémar 180, Plate 106), apparently as a sign for a painter, but early on in his career when Watteau made this copy he was looking at the art of the past for hints. Sometimes he would copy a domestic detail but here he is dallying with a courtly art, with a subject of mythical love, expressed in the relationship of two figures in a landscape setting which he has observed very closely. He perhaps saw it as an extension of Venetian *poésie* and an alternative to Rubens' *Garden of Love*. His own art, though it would exploit the sensuousness, was not so concerned with legend. He did, however, explore other aspects of Bloemaert's work, for example, his groups of putti, his bucolic, tender landscapes and his method of drawing individual studies of heads and hands placed haphazardly on the page, which could be used as prototypes. We know that Crozat and Mariette collected drawings by Bloemaert which Watteau would have seen. Boucher was later to be influenced by them, engraving twelve plates after Bloemaert's designs. Watteau may also have known Frederik Bloemaert's engravings after his father's drawings, published as *Het Konstrijk Tekenboek* . . . in which there are many studies of hands and heads, similar to Watteau's own practice.

Plate 29 A seated woman and two studies after sculpture. Sanguine. $8\frac{3}{4} \times 15$ in. (22.2×37.6 cm.). British Museum, London.

Watteau's connection with Oppenort demonstrated his interest in Baroque sculpture of fountains. The present drawing reveals a development of that interest. The group at the right is close in appearance to a group by Jacques Sarazin (1592–1660) in the Louvre, of which Watteau's original may have been a pendant. Watteau then made use of the group in his picture *L'Assemblée dans un Parc*, Berlin (Adhémar Plate 116) and again in his work *La Cascade* (D. V. 28). From such copies, Watteau was to develop the importance of the sculpture in the background of his paintings, so that it became an integral part of the mood.

Plate 30 The mystic marriage of St Catherine and the Holy Family. Sanguine. $6\frac{3}{8} \times 11\frac{3}{8}$ in. (17.5×28.9 cm.). Count Antoine Seilern Collection, London.

Watteau received from the great Flemish artists an admiration for the richness and colour of the sixteenth-century Venetians, of whom Veronese was typical. The left-hand design on this sheet has been connected with a painting by Veronese of the same subject, now in Leningrad and known to have belonged to Crozat. It is not absolutely certain, however, whether this particular painting, or another like it, also by Veronese, for example *The Holy Family*, at Hampton Court, supplied Watteau with the components in reverse for his subtly related figure composition, focussed on St Catherine's hand. The rich variations which Venetian artists like Veronese made on the High Renaissance compositional problem of the Holy Family was obviously of interest to Watteau. The group on the right has been thought to be an attempt by Watteau at an original variant of his own and such a rapid sketch is a rarity in his work. It could also be seen, however, as an example of his constant debt to the Venetians, an aspect of his career which Delacroix later appreciated, for the motif of the Virgin nursing Christ with St Joseph in

attendance occurs frequently in Veronese's work and a painting attributed to him in the Ringling Museum, Sarasota, is very close in its arrangement of the principal figures.

What is also interesting is that Watteau uses the design in a painting which he represents hanging at the right of *L'Enseigne de Gersaint* (Plate 120). Furthermore the pose of the Virgin at the left of the present drawing is related to the woman seated at the counter in Gersaint's sign. It may be that the present drawing does not come from the first flurry of copies after Venetian masters done while he was with Crozat, *c.* 1712–15, but a little later, closer to the date of the finished picture, 1720. Certainly the rapid strokes can be compared to other late sketches, such as his studies of the men packing pictures (Plate 22) for the same painting; or his preliminary designs (P. & M. 875–876) for the *Comédiens Italiens* (Italian Players, Brookner 46), painted for Dr. Mead in London, 1720.

Plate 31 Two figures in a landscape, after Titian. Sanguine. $9\frac{1}{4} \times 9\frac{1}{8}$ in. ($23 \cdot 3 \times 23 \cdot 2$ cm.). Cabinet des Dessins, Musée du Louvre, Paris.
Watteau's debt to the Venetians also included landscape. This sensitive sheet copies in his favourite red chalk, *avec beaucoup d'esprit* as it was described, a drawing by Titian in pen and brown wash, now in the Albertina, Vienna (Plate 129), which once belonged to Crozat. Both copy and original later came into the collection of Mariette. Crozat had returned to Paris at the end of 1715 with a large number of Venetian drawings and of the 75 or so copies of landscapes by Watteau which are known over two thirds are after Italian masters. Watteau, as Caylus saw, 'was charmed by the fine buildings, the beautiful scenery and the naturalistic foliage which he saw in the work of Titian and Campagnola.' The copy emphasises the dream-like atmosphere of the original, with the ambiguous figures in the foreground and fantastic buildings behind and the success with which he captured and made use of the breadth and opulent harmony of Titian's landscapes can be seen in his own paintings after 1715.

Plate 32 Italian landscape. Sanguine. $9 \times 13\frac{1}{4}$ in. ($22 \cdot 9 \times 33 \cdot 6$ cm.). Art Institute of Chicago, Joseph and Helen Regenstein Collection.
Watteau's interest in the Venetian drawings he saw in the Crozat collection has already been noted. He was also able to make use of his copies in his own paintings. It has recently been pointed out by Dr Eidelberg that this drawing, a copy after an unknown sixteenth-century Venetian artist, was used for the background of his painting *La Leçon d'Amour*, now in the Nationalmuseum, Stockholm (Adhémar 138, Plate 70). Watteau has covered the landscape with a forest, but the buildings at the left with a tower and those at the right by the river are quite recognisable. Drawings such as this could complement the virtuoso artifice of his ideal world.

Plate 33 Italian landscape. Sanguine. $8\frac{5}{8} \times 13\frac{3}{4}$ in. ($22 \times 34 \cdot 9$ cm.). Fitzwilliam Museum, Cambridge.
Not all of Watteau's copies were made after works in the Crozat collection. This magnificent composition was almost certainly based on a drawing attributed to Titian, and since lost, which was engraved by Caylus as being in the royal collection. The mountainous distance, more romantic than Titian's native Cadore and the buildings with their curly roofs perched like houses from fairyland, would seem a fitting background to an enchanted isle by Watteau.

Plate 34 View of a village and a church. Sanguine and greenish-grey wash. $6\frac{1}{4} \times 8\frac{5}{8}$ in.
(16 × 22 cm.). Teylers Museum, Haarlem.
All Watteau's early biographers agree that as well as copying landscapes
after the old masters he also drew incessantly from nature. Caylus records that
he drew many landscapes in the grounds of the Luxembourg Palace. In addition
to copying ideal landscapes which he used for his romantic compositions
he also produced a series of more down-to-earth landscapes based on
actual scenery. He seems to have been working on these at about the same time
as he produced his realistic military scenes and his figures of popular types,
that is, c. 1709–12, as if he had to explore reality on a broad front.
In this view of a village church, largely drawn in ink wash, which is unusual
for him, he has put down the results of his careful observation with notes
about the light: *demi teinte grise et généralement les ombres grises* ('half shade grey
and the shadows generally grey'. Watteau was not an Impressionist). The tower
seems to have been at Gentilly on the Bièvre where he visited his friend
Jullienne at the Gobelins factory and he made use of it as the background of his
early picture of a Savoyard, *La Marmotte*, now in Leningrad. On the verso of
the drawing is a study of a hurdy-gurdy player and the old man with the
flaxen locks, the same person in the drawing at the British Museum
(reproduced here Plate 3), who appears in Watteau's early painting
L'Accordée de village (The Village Bride), Sir John Soane's Museum, London,
which seems to confirm the early date of the landscape.

Plate 35 Studies of plants. Black chalk with Indian ink wash. $7\frac{1}{4} \times 9\frac{3}{8}$ in. (18·3 × 23·8
cm.). British Museum, London.
The present careful study of leaves can be considered as part of the data he
gathered out of doors for the background of his paintings. Its direct
observation puts it firmly in the Netherlandish tradition. The rare use of an ink
wash can be compared with his view of a village church (Plate 34). This may
have been done at about the same time as the Haarlem drawing which has
studies on the other side of the sheet for *The Village Bride*, for it is drawn on
the back of a study of three figures (Plate 2) for *Qu'ai-je fait . . . assassins
maudits*, another early picture, possibly dating from c. 1708–11. The buildings
in the background are similar to those in a drawing of a quarry in the
Musée Bonnat, Bayonne (P. & M. 473), which like the present example also
belonged to Crozat and may have been drawn in the same neighbourhood
near Gentilly.
Constable's later criticism of French painters that they know nothing of nature
and 'make painfull *(sic)* studies of individual articles — leaves, rocks, stones
trees etc. etc., singly — so that they look cut out — without belonging to the
whole and they neglect the look of nature altogether under its various changes'
could be applied to some extent to Watteau's practice in the present
drawing. This was, of course, the creation of an ideal world from such realistic
details, and this puts him close to Gainsborough, who was equally indebted to
the Dutch School, very different from Constable's aim to make his art
entirely naturalistic.

Plate 36 Landscape. Black chalk. $3\frac{3}{8} \times 11\frac{1}{4}$ in. (8·5 × 28·5 cm.). Ashmolean Museum,
Oxford.
Far more typical of the realistic tendencies of his landscape are the two
drawings at the Ashmolean Museum, of which one is reproduced here. Instead
of effects of light, Watteau has carefully drawn the disposition of trees around a
farm house with the countryside beyond. They may have been drawn at
Valenciennes c. 1709 and are close to Dutch seventeenth-century tradition of
landscape drawing with hints of Esaias van de Velde (c. 1590–1630) and indeed
Rembrandt, with the elongated horizon and details seen from close to.

Plate 37 A landscape with a rural cottage (The Porcherons). Sanguine. $3\frac{1}{4} \times 5\frac{5}{8}$ in.
(8·4 × 14·3 cm.). Metropolitan Museum of Art, New York. Gift of Cornelius
Vanderbilt, 1880.
Similar in approach to the preceding drawing is a group which can also be
connected to identifiable scenes. According to Mariette, Watteau drew
landscapes in an area of Paris, then known as the *Porcherons*, which consisted
mainly of rural market gardens and in which Crozat owned land. This
atmospheric and subtly observed sketch has been correctly identified as one of
two preliminary drawings — the other is in a French private collection
(P. & M. 444) — for Watteau's painting *L'Abreuvoir* (The Watering Place),
known today from the engraving by Jacob (D. V. 137). The main details of the
house and fence are taken up in the painting which has added figures of women
washing clothes. It may well be that this small drawing was done on the spot
in a small sketch book which Watteau carried with him. Because of the
connection with Crozat a date of 1712 may be assumed.

Plate 38 Landscape with cottages and peasants. Sanguine. $6\frac{7}{8} \times 9\frac{3}{8}$ in. (16·7 × 23·9 cm.).
British Museum, London.
The present realistic sketch can also be connected with the *Porcherons* group.
It uses motifs but is not exactly analogous with a painting *Le Marais* (The
Market Garden), also known from an engraving by Jacob (D. V. 136), a
pendant to *L'Abreuvoir*. It is interesting to note that there is, in addition, a
small sketch similar to the preceding drawing, also in the Metropolitan
Museum, New York, which is closer to the finished painting than the present
drawing. Although both have the same tripod form of well-head, the New York
drawing is the same way round as the painting while the London drawing is
the same as the print, which is presumably in reverse. The New York drawing
was probably also drawn on the spot, whereas the British Museum one is larger,
more highly finished and with figures drawn in. The peasants and rustic
appearance of this drawing remind us that, though Watteau's primary concern
with this group of drawings was to note exactly the details of the countryside
for use later in his studio for his paintings, he also comes very close to a
previous conception of similar scenes by Abraham Blocmaert, an artist with
whom Watteau had other affinities.

Plate 39 A nude woman, study for *Flora*. Black chalk with touches of sanguine and
white. $12\frac{7}{8} \times 11\frac{1}{8}$ in. (32·6 × 28·3 cm.). Cabinet des Dessins, Musée du Louvre, Paris.
Caylus rather pedantically thought that Watteau did not draw very well from
the nude and certainly nude studies are not common in Watteau's œuvre. He
rarely worked in the academic manner which demanded preparatory studies
from the model for the major figures in a composition. Yet when he was
presented with the commission by Crozat to decorate the dining room of his
town house, he rose to the occasion with a magnificent series of drawings for
his four oval paintings of *The Seasons*. Unfortunately, only *Summer* now exists,
National Gallery of Art, Washington (Brookner Plate 11); *Spring*, recently
rediscovered, has even more recently been destroyed (Plate 116), while *Autumn*
and *Winter* are known only through the engravings (D. V. 105–8). It is very
likely that Charles de la Fosse, who was engaged on a large ceiling painting
for Crozat of the *Birth of Minerva*, was responsible for Crozat employing
Watteau and, according to Caylus, the preliminary studies were by de la Fosse.
If, however, this beautiful study from the life is compared to de la Fosse's
similar drawings (Plate 130), it can be seen that Watteau completely changed the
older artist's conception. The pose of *Flora* and her relationship to Zephyr
who can be faintly discerned at the left of the sheet, has been transformed
into the 'purest Watteau'. The sensuousness of the figure, expressed with his
magical technique of three chalks intermingled to render with superb effect
the luminosity of the flesh, gives the group a vitality which is perhaps lacking
in the other three designs. Michael Levey has described the gaze of Flora and
Zephyr as 'ardent yet veiled' and some hint of the tenderness of the finished
painting can be seen in the drawing.

Plate 40 A nude man, study for Bacchus. Sanguine and black chalk with touches of white. $11\frac{1}{8} \times 8$ in. ($28 \cdot 1 \times 20 \cdot 2$ cm.). Cabinet des Dessins, Musée du Louvre, Paris.

This impressive male nude was drawn from the life for the lolling pose of Bacchus in Watteau's painting of *Autumn*, for Crozat's *Seasons*, (engraved by Fessard, D. V. 107), a more complicated composition than *Spring*. Unlike countless academic male nudes of the eighteenth century, Watteau's drawing has a freshness and vigour due to his increasing mastery of the three-crayon technique. He is not particularly concerned with niceties of detail but with accents of light and dark which animate the contours and masses and accentuate the languid feeling of the pose.

Plate 41 A woman reclining, raising a glass. 'Aux trois crayons'. $6\frac{5}{8} \times 7\frac{5}{8}$ in. ($17 \times 19 \cdot 4$ cm.). Musée Cognacq-Jay, Paris.

The same feeling for the essential quality of the pose with the thrusting shoulder comes over in Watteau's study for the leaning Bacchante who raises her glass to Bacchus in *Autumn* (see preceding drawings). The pose is taken, however, from Titian's *Bacchanal of the Andrians* (Prado, Madrid). Watteau probably knew the print, as the original was in Spain, and he has joined together two reclining Bacchante figures to make up this one pose. It seems certain that he also borrowed from the same painting for the figure of Zephyr in *Spring* and also for the faun who fills Bacchus' glass (Plate 42). The painting of *Summer*, for which no preparatory drawings are known, seems to be indebted to Veronese. The Venetian influence comes over so strongly in these allegorical works by Watteau that although he may first have entered Crozat's household (*c.* 1712) after his entry to the Academy (both probably through the mediation of de la Fosse), the actual execution of *The Seasons* may date from 1715–16, when Crozat had returned to Paris from Venice with his large collection of Venetian drawings. A letter from Crozat to Rosalba of 1716 seems to hint that Watteau took a long time over his paintings.

Plate 42 Study of a nude man. Sanguine and black chalk. $10\frac{7}{8} \times 8\frac{7}{8}$ in. ($27 \cdot 7 \times 22 \cdot 6$ cm.). Walter C. Baker Collection, New York.

A preliminary idea for the faun filling Bacchus' cup in *Autumn*. This beautifully balanced and controlled drawing was replaced by the following study for the finished picture.

Plate 43 Study of a nude man. 'Aux trois crayons'. $11\frac{1}{2} \times 8\frac{1}{2}$ in. ($29 \cdot 2 \times 21 \cdot 6$ cm.). Count Antoine Seilern Collection, London.

The same model as the preceding drawing has been used but turned round and seen full face together with the addition of a beard and a suggestion of pointed ears, for the faun in Crozat's *Autumn* (see preceding drawings). The same vigorous accents as in the preceding drawings, particularly around the head and arms, mark a new maturity in Watteau's approach.

Plate 44 Study of a nude man. 'Aux trois crayons'. $9\frac{5}{8} \times 11\frac{5}{8}$ in. ($24 \cdot 4 \times 29 \cdot 7$ cm.). Cabinet des Dessins, Musée du Louvre, Paris.

A study from the model for Watteau's painting *Jupiter and Antiope*, Louvre (Adhémar Plate 108). The same model, the same mature directness and the same Venetian tendencies are to be found in the painting and drawing and enable the drawing to be connected with the Crozat *Seasons*, *c.* 1712–16. A sketchier variant for Jupiter is in the Lugt Collection, Institut Néerlandais (P. & M. 517). Though the Venetian basis for his mythological paintings has already been noted, the pose of Jupiter is also very similar to a figure in Van Dyck's *Christ carrying the Cross*, in Antwerp. The similarity is even more marked in Van Dyck's preparatory study in the Courtauld Institute (Crozat also owned a preparatory study for this painting), a reminder that in looking back to Van Dyck and Rubens, Watteau was also indirectly looking to the Venetians whom the Flemings also admired.

Plate 45 Seated nude woman taking off her chemise. Sanguine and black chalk on pale grey paper. $8\frac{7}{8} \times 10$ in. (22·5 × 25·4 cm.). British Museum, London.
Of the other nude drawings which survived Watteau's censorious selection, the remainder are mainly concerned not with allegory but with intimate studies from the life for use in his small paintings for private delectation. They are refreshingly direct without a hint of the grand manner but not without an occasional sense of contrivance. Only perhaps Rembrandt in the previous century and Degas in the next have drawn such engaging realistic studies. Watteau, however, is not so neutral. He was influenced by a pretty face. This series of models, half-dressed or preparing their toilette, are the forerunners for the later eighteenth-century charms of Boucher and Gabriel de St-Aubin who saw them more archly. The present drawing, with the model not too put out by the presence of the spectator, is a preliminary study for *La Toilette* (Wallace Collection, London; Brookner Plate 42). The painting may date from as late as 1720, though the drawings may date from *c.* 1717–20.

Plate 46 Semi-nude woman seated on a chaise longue, holding her foot. Sanguine and black chalk. $13\frac{3}{8} \times 8\frac{5}{8}$ in. (34·1 × 22·1 cm.). British Museum, London.
This series of drawings may have been done at one sitting. The model seems to be the same girl, she wears the same chemise and she is seated on the same chaise longue. The present example has a delicate feeling for light and spontaneity which is much less contrived than the previous drawing. As in his nude studies for the Crozat *Seasons*, the accents of thicker chalk, in this case black, reinforce the contour and articulate the forms without becoming predominant and destroying the delicate areas. The control of the tones of his chalk gives the study an exceptional luminosity.

Plate 47 Seated semi-nude woman, turned towards right. 'Aux trois crayons'. $6\frac{5}{8} \times 6\frac{1}{8}$ in. (17·1 × 15·4 cm.). Pierpont Morgan Library, New York.
The subtle use of three chalks enables Watteau to render the fall of light and softness of forms in this ravishing study. The attentive head gives the casually turned pose a psychological immediacy which is the basis for his poetry of love in his major work of about this time: *The Embarkation from the Isle of Cythère*.

Plate 48 Standing Persian servant. Sanguine and black chalk. $9\frac{7}{8} \times 6\frac{1}{4}$ in. (25·1 × 15·7 cm.). Teylers Museum, Haarlem.
A visit of a Persian embassy, headed by Mohammed Riza Bey, to Louis XIV at Versailles in 1715 enabled Watteau to indulge his interest in exotic types observed realistically, and incidentally provided one of the rare definite dates for his drawings. It may be that he thought these studies, of which another ten are known, would be useful for servant figures in a *fête galante*, in view of their romantic turbanned costume, or perhaps he thought they could be engraved as a series, like his single Savoyards. It was after all a period of a growing interest in exotic subject matter with rococo decoration and chinoiserie. They were not, however, used. Possibly he was reminded of similar engravings by Stefano della Bella and Jacques Callot, seventeenth-century artists whom he admired. The present simple drawing of a Persian servant holding a dish has a note on the back by Caylus showing that it was one of those he was bequeathed by Watteau. It later belonged to Mariette. It was also engraved by B. Audran for the *Figures de différents Caractères*, but the plate was rejected.

Plate 49 Seated Persian. Sanguine and black chalk. $11\frac{3}{8} \times 7\frac{5}{8}$ in. (29 × 19·5 cm.). Victoria and Albert Museum, London.
This large study was at one time attributed to Lancret, but it was engraved by Boucher among the *Figures de différents Caractères* (215). A counter-proof is in the Ashmolean Museum, Oxford. The modelling is bolder and less finished than the preceding example but it is not without some nice touches of the chalk around the eyes, nose and lips.

Plate 50 Seated Persian. Sanguine and black chalk. $11\frac{7}{8} \times 7\frac{7}{8}$ in. (30×20 cm.).
P. Bordeaux-Groult, Paris.
Perhaps the grandest of the Persian series, this figure was at one time thought
to represent Mohammed Riza himself who, however, was bearded. Watteau's
rapid strokes of chalk ripple over the turban and clothes so that the marks
have a life of their own as well as describing with precision the stout figure of
the Persian. The figure was also engraved by Boucher for the *Figures de
différents Caractères*.

Plate 51 Three studies of the head of a young negro. Sanguine (of two shades), black
chalk with touches of white and grey wash. $9\frac{5}{8} \times 10\frac{5}{8}$ in. ($24 \cdot 4 \times 27$ cm.).
Cabinet des Dessins, Musée du Louvre, Paris.
As part of the cult of the exotic it was fashionable at the beginning of the
eighteenth century to employ a negro servant. With his brilliant technique of
three chalks, Watteau was able not only to suggest the fall of light but also
the texture and colour of the skin. Mariette, who owned this drawing,
thought that such drawings were '*d'une vérité frappante*' ('of a striking
truthfulness'). Watteau's method of drawing separate studies of the same
head seen from different angles, which he could later use in his finished
compositions, can also be seen in this brilliant example. The head at the top
right appears in *Le Concert champêtre* (D. V. 72) and also in *Les Charmes de
la Vie* (D. V. 183).

Plate 52 Two studies of a spaniel. Sanguine. $6\frac{1}{4} \times 4\frac{1}{4}$ in. ($15 \cdot 9 \times 10 \cdot 9$ cm.). Ashmolean
Museum, Oxford.
About thirty animal studies are known and many more must have been made
if the number of animals which appear in the pictures is taken into account.
They were not thought so highly of by Jullienne and none were engraved.
Watteau, however, observed them with the same sympathetic realism as he did
the humans who amuse themselves in his *fêtes* and, indeed, the presence of a
pet is part of the playful mood, a fact which Titian, Rubens and Van Dyck
had realised and which Boucher and Fragonard were also to exploit. The
present charming slight study was not, however, actually used in a painting by
Watteau. It may well be an early work, *c.* 1708–9.

Plate 53 Studies of a cat and two studies of a man. Sanguine. $7\frac{1}{8} \times 9\frac{3}{8}$ in. (18×24 cm.).
Musée Bonnat, Bayonne.
The style of drawing for the figures suggests an early date, possibly when he
was producing the *Figures de Modes*, but the cats are observed with affection
and drawn with assurance. He shows how well his accents of chalk can suggest
form and texture, particularly the flank and belly of the cat lying on its side.

Plate 54 Study of a shell. Sanguine and black chalk. $8\frac{7}{8} \times 8\frac{1}{8}$ in. ($22 \cdot 5 \times 20 \cdot 8$ cm.).
Musée des Beaux-Arts, Besançon.
Since the end of the sixteenth century, connoisseurs with cabinets of
curiosities had prized their collections of shells, and Gersaint was most active
as a dealer in them, as well as his more normal trade of works of art. A series
of about seven careful studies by Watteau of these shells exists in which he has
obviously been fascinated by the complexity of forms. His training as an
arabesque decorator obviously enabled him to recognise their rococo
characteristics, for the world of rococo and the revolution in design at the
beginning of the eighteenth century is derived from the word *rocaille* (shell).
The particular example here is of *murex anguliferus*.

Plate 55 Three studies of hands. Sanguine, black chalk and pencil. $5\frac{3}{4} \times 8\frac{3}{4}$ in.
(14·8 × 22·5 cm.). British Museum, London.
The following nine drawings are a selection of the large number of typical
studies of hands and heads which Watteau made throughout his career and
which he would sometimes use in his painted compositions. Drawn casually
on the page, they have always been prized by collectors for what they reveal
of Watteau's essential spirit: his grace, his tactile sense, his charm and his
powers of observation. It is not possible to arrange them in a satisfactory
chronological sequence though they all probably date from the more mature
period of his career. The present example has a study of a man lifting a
curtain on the verso.

Plate 56 Studies of three hands, two holding masks. Sanguine. $3\frac{1}{2} \times 6\frac{3}{8}$ in. (8·9 × 16·1
cm.). Kupferstichkabinett, Berlin.
This precise and elegant rendering of a hand holding a mask also occurs in
another drawing (P. & M. 541), which was used in his painting *Coquettes qui
pour voir galants* . . . (D. V. 36) and in *La Sultane* (D. V. 214).

Plate 57 Sheet of studies with the hand of Crispin holding the handle of a sword, and
a head of a Mezzetin. Sanguine and black chalk. $7\frac{1}{8} \times 10\frac{1}{8}$ in. (17·9 × 25·5 cm.).
Rijksprentenkabinet, Rijksmuseum, Amsterdam.
Watteau used the brief gesture of the hand holding a sword in the figure of
Crispin in his painting *Harlequin, Pierrot and Scapin* in the collection of the
Earl Spencer, Althorp (Adhémar 163) and Boucher made a print of it for the
Figures de différents Caractères (57).

Plate 58 Two studies of the head of a young woman, in profile and full face. Sanguine
and black chalk. $6\frac{3}{4} \times 6\frac{1}{8}$ in. (17·3 × 15·6 cm.). British Museum, London.
Watteau used the contemplative study of the woman seen full face in his
painting *Le Concert champêtre* (D. V. 72). The atmospheric profile study was
engraved by L. Cars in *Figures de différents Caractères* (261).

Plate 59 Sheet with three heads of a woman and a hand. Sanguine, black chalk and
brown-grey wash. $10\frac{3}{8} \times 13\frac{5}{8}$ in. (26·3 × 34·5 cm.). Teylers Museum,
Haarlem.
The elegantly posed head at the top left of this large sheet was used in
Réunion en plein air (Open-air assembly) of about 1717–18 at Dresden
(Adhémar 185, Plate 112). He used the same head and hand in *La Leçon
d'Amour* (collection of Mrs Hugo Moser, New York; Adhémar 138). A
similar drawing of the head occurs on a sheet in the Rijksprentenkabinet,
Rijksmuseum, Amsterdam (P. & M. 745). The present sheet is notable for the
manner in which the wash is combined with the red and black chalks to give
the heads a delicate luminosity.

Plate 60 Studies of nine heads. 'Aux trois crayons' on yellow-grey paper.
$10\frac{5}{8} \times 16\frac{1}{2}$ in. (27 × 42 cm.). Musée du Petit Palais, Paris.
This large and vigorous sheet provided a valuable repertoire for many of his
paintings: the head of the man at the left in *L'Enchanteur* (D. V. 11), *La
Leçon d'amour* (D. V. 263) and, with changes, as the pilgrim on his knees in
The Embarkation from Cythère (Plate 119). The head of the man at the right was
used in *L'Aventurière* (D. V. 12) and the figure of a woman seen from the back
at the bottom of the sheet in *Le Concert champêtre* (Adhémar Plate 99). It is
noticeable that when a pose pleased Watteau he used it again and again. The
two male heads were engraved as full-length figures by Boucher (131) and
L. Cars (46) in the *Figures de différents Caractères*.

Plate 61 Three heads of women and three male heads. 'Trois Crayons' on grey-brown
 paper. $10\frac{5}{8} \times 15$ in. (27 × 38 cm.). Cabinet des Dessins, Musée du Louvre, Paris.
 The head of the woman at the top left of this rich and colourful sheet was used
 for *La Lorgneuse* (D.V. 13) and *Le Rendez-vous* (D.V. 174). The head of the
 man in the middle appears in *L'Accordée de village* (The Village Bride), Sir
 John Soane's Museum, London. The hats have a carnival air, and although the
 studies are of separate individuals, they appear to be taking part in some
 intimate *conversation galante*.

Plate 62 Two studies of a woman, one three-quarters from rear, one in profile.
 Sanguine and black chalk. $11\frac{3}{8} \times 6\frac{3}{4}$ in. (29·1 × 17·1 cm.). British Museum, London.
 Because of the watermark of the arms of the City of London the present
 drawing has been connected with Watteau's stay in England, *c.* 1719–20. The
 girl with her white cap was probably a servant girl and the same model is used
 for a drawing at Darmstadt (P. & M. 784). His handling of the two chalks is
 rapid but assured, giving a marvellous impression of half light.

Plate 63 Four studies of the head of a young woman. Sanguine of two shades, black and
 white chalk. $13 \times 9\frac{3}{8}$ in. (33·1 × 23·8 cm.). British Museum, London.
 Also probably drawn in his London period. The head at the top left is the same
 model as on a sheet in the collection of P. Bordeaux-Groult (P. & M. 783)
 which continues the music of the heads. The chalks moistened with a finger
 produce the effect of watercolour and add to the delicacy of pose with the
 nervous tilt of the heads.

Plate 64 Seated lady. Sanguine. $7\frac{3}{4} \times 5\frac{1}{2}$ in. (19·6 × 13·9 cm.). Private Collection, London.
 With the following group of drawings we come to the essence of Watteau's
 art — those drawings which have been most universally admired. His studies
 of women, whose presence was vital to the creation of his ideal world, are not so
 much portrait studies as a series of statements of a theme. This is probably an
 early study in view of the touches for eyes, nose and mouth but already his
 thicker accents of chalk are able to express the fall of drapery and movement of
 the pose. A similar figure occurs in the *Partie quarrée* (D. V. 169) and the
 Plaisirs du Bal, Dulwich College (Brookner Plate 20) and may be connected
 with a group of three similar studies on the same sheet (P. & M. 574–6).

Plate 65 Standing woman. 'Aux trois crayons'. $12\frac{7}{8} \times 7\frac{5}{8}$ in. (32·5 × 19·5 cm.). Musée
 Bonnat, Bayonne.
 Perhaps such magnificent drawings have been best described by the de
 Goncourt brothers: 'All the fascination of women in repose: the languor, the
 idleness, the abandonment, the mutual leanings upon one another, the
 outstretched limbs, the indolence, the harmony of attitudes, the delightful air
 of a profile bowed over a lute, studying the notes of some *gamme d'amour*, the
 breasts receding, elusive contours, the meanderings, the undulations, the
 pliancies of a woman's body; the play of slender fingers upon the handle of a
 fan, the indiscretion of high heels peeping below the skirt, the chance
 felicities of demeanour, the coquetry of gesture, the manoeuvring of shoulders,
 and all that erudition, that mime of grace, which the women of the preceding
 century acquired from their mirrors; all this, with its particular intensity of
 tone, its special lustre, lives on in Watteau. . . .' The present figure was
 engraved in *Figures françaises et comiques* (178).

Plate 66 Studies of half-length figures of a woman, a man playing a flageolet, and a
 standing figure of a servant holding a flacon and tazza. Sanguine. $7\frac{1}{4} \times 9\frac{1}{4}$ in.
 (18·4 × 23·5 cm.). British Museum, London.
 In this early drawing all three aspects of Watteau's art appear: a modest
 femininity, an elegant world of servants and dalliance, united by music. These
 studies were used in *Là Conservation* (D. V. 151) but the head of a negro which
 appears on a drawing in the Louvre (P. & M. 729) was substituted for the
 servant. The verso has a study of a tree (P. & M. 456).

Plate 67 Woman on a swing. Sanguine and black chalk. $6\frac{1}{2} \times 5\frac{1}{4}$ in. ($16 \cdot 5 \times 13 \cdot 3$ cm.).
Private Collection, London.
This fragile study, delicately poised, was used in *Le Plaisir pastoral* (D. V. 209)
and for *Les Bergers* at Potsdam (Adhémar Plate 75).

Plate 68 Study of a seated woman, with head and shoulders repeated. 'Aux trois
crayons'. $9\frac{1}{8} \times 10\frac{3}{8}$ in. ($23 \times 26 \cdot 2$ cm.). Rijksprentenkabinet, Rijksmuseum,
Amsterdam.
This young, rather plump model was used in *L'Assemblée galante*, engraved by
Le Bas (D. V. 139), and the same figure was engraved by Boucher among the
Figures de différents Caractères (51) and the head by L. Cars (*Figures de
différents Caractères* 231). With slight changes she also appears as the mother
in the painting of *The Family* (Adhémar 170). A document of 1777 identified
the family as that of Leboucq-Santussan, whose son Jean later married the
daughter of Gersaint. The person here represented may, therefore, be Mme
Leboucq-Santussan. Parker and Mathey have suggested that she is also the
model for some of Watteau's nude studies, which seems unlikely.
Notwithstanding the doubt about her identity, there is no doubt about
Watteau's masterful use of white heightening to suggest the shimmer of fabric
and flesh.

Plate 69 Seated woman. Black chalk, with a touch of sanguine. $8\frac{5}{8} \times 7\frac{5}{8}$ in. ($22 \times 19 \cdot 5$
cm.). Musée Condé, Chantilly.
This sketch could be taken as the embodiment of the de Goncourt's
'fascination of women in repose . . . the indiscretion of high heels peeping
below the skirt . . .' with the head idealised to that oval which Watteau
admired, and the drapery folds, drawn with fullness and certainty.

Plate 70 Seated woman. 'Aux trois crayons'. $9\frac{7}{8} \times 7\frac{1}{4}$ in. ($24 \cdot 9 \times 18 \cdot 4$ mm.). Cabinet des
Dessins, Musée du Louvre, Paris.
The drawing was enlarged at a later date at the left and top with additions to
the hair. Watteau seems often to have favoured a plump model and relished
the appearance of her double chin from beneath, though his success at
rendering the foreshortening and sway of the pose can be seen. The figure was
engraved by B. Audran in the *Figures de différent Caractères* (70).

Plate 71 A seated woman with book of music on her lap, and study of a hand. Sanguine
and black chalk. $5\frac{1}{4} \times 3\frac{3}{4}$ in. ($13 \cdot 4 \times 9 \cdot 5$ cm.). British Museum, London.
This rapid yet sure pose of a woman leaning back with a book of music on her
lap was used in *La Leçon de Chant* (The Singing Lesson), otherwise known as
La Trouvère (The Troubadour) in Madrid (Adhémar Plate 102). Watteau
has studied again her left hand to get the hanging pose right. The figure was
also engraved by L. Cars (*Figures de différents Caractères* 185).

Plate 72 A reclining woman in a striped dress, seen from behind. Sanguine and black
chalk with some pencil. $5\frac{3}{4} \times 7\frac{1}{8}$ in. ($14 \cdot 6 \times 18 \cdot 1$ cm.). British Museum, London.
Watteau's delight in such a reclining pose can be seen in the opportunity it
gave him to exploit the fall of the dress and its texture. The figure was used in
Plaisirs d'Amour (Dresden; Adhémar Plate 124) but with a broader, more
painterly stripe to the dress, and was also etched by Boucher in reverse for the
Figures de différents Caractères (161).

Plate 73 Two seated women, one with a fan. Sanguine and plumbago.
$6\frac{3}{8} \times 9\frac{7}{8}$ in. (16×25 cm.). Musée Condé, Chantilly.
A similar sprawling pose as the preceding drawing enables Watteau again to
exploit the fullness of the dress, perhaps at the expense of anatomical accuracy,
in the arms particularly.

Plate 74 Head and shoulders of a woman holding a mantilla. Sanguine and black chalk. $7\frac{1}{8} \times 4\frac{5}{8}$ in. (18×12 cm.). Rijksprentenkabinet, Rijksmuseum, Amsterdam. The fascinating complications of the mantilla led Watteau to make a number of drawings from one of his favourite models. The example in the Fodor Museum, Amsterdam, is closer to the woman with a mantilla, who is at the right of *Les Plaisirs du Bal*, Dulwich College, London (Brookner Plate 20). This drawing was engraved by Boucher (*Figures de différents Caractères* 286).

Plate 75 Seated woman, seen from behind. Counter-proof in sepia. $4\frac{9}{16} \times 5\frac{1}{4}$ in. ($11 \cdot 5 \times 13 \cdot 3$ cm.). Fitzwilliam Museum, Cambridge.
An example of a counter-proof has been included here to show Watteau's varying techniques. Sometimes he took a pressing from another chalk drawing, sometimes from an oil painting, in order to reverse the pose. The present example was taken from a figure in *L'Amour paisible*, Potsdam (D.V.74), which in turn derives from a drawing in trois crayons in the Groult Collection (P. & M. 824). This was larger and in the reverse direction. The rubbing for the offset has caused a tear, but even with this almost mechanical technique and the unusual use of brush Watteau's feeling for the grace of the pose and the texture of the dress is apparent.

Plate 76 Studies of two seated women. Sanguine. $8 \times 13\frac{3}{8}$ in. ($20 \cdot 2 \times 34$ cm.). Rijksprentenkabinet, Rijksmuseum, Amsterdam.
Both figures were etched by Dupuis in *Figures de différents Caractères* (120 and 206). The figure at the left was also used in *La Gamme d'Amour*. A counter-proof of the figure at the right is in the Musée Bonnat, Bayonne.

Plate 77 Sheet with two studies of a seated woman playing a guitar and another with a book. Black chalk with touches of sanguine and white chalk. $8\frac{7}{8} \times 11\frac{1}{2}$ in. ($22 \cdot 5 \times 29 \cdot 2$ cm.). Cabinet des Dessins, Musée du Louvre, Paris.
With rapid touches of sanguine and white chalk on the black he has here explored two different aspects of the same pose, altering the tilt of the head and the fall of the drapery, so that the figures create a harmony of their own on the page. He was obviously pleased with the result and a similar guitar player appears in more than one of his paintings: in *Les Charmes de la Vie* (The Music Party) Wallace Collection, London (Brookner Plate 31); *Harlequin, Pierrot and Scapin*, in the collection of the Earl Spencer, Althorp (Adhémar Plate 94). All three figures were engraved by B. Audran (*Figures de différents Caractères* 117 and 284).

Plate 78 Five studies of children by Sebastiano Ricci (1659–1734) after Watteau. Red and some black chalk. $7\frac{3}{4} \times 11\frac{5}{8}$ in. ($19 \cdot 6 \times 29 \cdot 5$ cm.). Royal Library, Windsor.
Watteau's studies of children, of which about thirty are known, are some of his most charming drawings. His great Venetian contemporary Sebastiano Ricci, was taken by Crozat to see Watteau in 1716 when he was passing through Paris. Ricci was so impressed that he made a number of copies, all of which are in an album once belonging to Consul Smith (1675-1770) and now at Windsor. The present example approaches very closely to Watteau's manner, so unlike Ricci's own. The individual heads are copied faithfully from the original, formerly in the Groult Collection (P. & M. 691), but the arrangement on the sheet has been changed. Early in his career, Watteau had drawn groups of putti, following sixteenth and seventeenth-century examples, but these are seen as rather unsympathetic mannequins. In studying Rubens he had noticed the children who act as a foil to the adults and certainly in some of Watteau's own works they have the same role. The central figure in this group is part of an attractive trio of children in *Les Champs Elysées*, Wallace Collection, London (Brookner Plate 39). Probably on the various occasions when he lived with the Sirois family (he was there for the last time in 1718), he came into close contact with the children who appear in the following drawings. Some, like the present example, are observed directly and sympathetically at play. In others we see the child growing up, aware coquettishly of the spectator.

Plate 79 Seated child. 'Aux trois crayons'. $7 \times 4\frac{7}{8}$ in. ($17\cdot8 \times 12\cdot2$ cm.).
Rijksprentenkabinet, Rijksmuseum, Amsterdam.
In this delightful study, the little girl, probably from the Sirois household, has
been posed by Watteau and returns his frank stare. In the presumably short
time at his disposal he has penetrated the seriousness of her world.

Plate 80 Child turned towards right, with left arm raised. Sanguine, plumbago and
black chalk. $6\frac{7}{8} \times 7\frac{7}{8}$ in. ($17\cdot4 \times 19\cdot8$ cm.). Formerly Museum Boymans-van
Beuningen, Rotterdam.
This rapid sketch brilliantly captures the movement of the child, in the act of
lifting the pencil.

Plate 81 Three studies of a girl. Counter-proof in sanguine. $13 \times 8\frac{1}{2}$ in. ($33 \times 21\cdot5$ cm.).
Pierpont Morgan Library, New York.
This revealing study of a child in repose in the centre of the sheet was used in
his portrait group of the Sirois family, *Sous un Habit mezzetin*, Wallace
Collection, London (Brookner Plate 15) and is confirmed as one of the
family. She wears a fancy hat which does not appear in the painting. The same
head with alteration also appears in *Pour nous prouver que cette belle* . . . or
The Music Lesson, Wallace Collection, London (Adhémar Plate 92).

Plate 82 Studies of a girl. 'Aux trois crayons.' $7\frac{3}{8} \times 9\frac{5}{8}$ in. ($18\cdot7 \times 24\cdot5$ cm.). Pierpont
Morgan Library, New York.
In these beautiful studies a slightly older girl shows herself to be more aware
of the spectator; the head at the right might have been described by Horace
Walpole as 'slightly arch'. The clothes, the line of the nose and the hair style
already prefigure Watteau's ideal feminine type. The same girl appears in
another study at Orléans and was also used in his composition *Pour nous
prouver que cette belle* . . . or *The Music Lesson*, Wallace Collection, London
(Adhémar Plate 92).

Plate 83 Boy with a large hat. Sanguine and black chalk. $7\frac{1}{2} \times 5\frac{1}{2}$ in. (19×14 cm.).
Musée Cognacq-Jay, Paris.
This study of a little boy with chubby cheeks, his floppy hat and frilly collar is
close to the type of child found in Rubens and was used by Watteau as a small
flautist in *Iris, c'est de bonne heure* or *The Dance* at Potsdam (D. V. 76).

Plate 84 Studies of two comedians. Sanguine. $6\frac{1}{4} \times 4\frac{5}{8}$ in. ($15\cdot9 \times 10\cdot9$ cm.). Count
Antoine Seilern Collection, London.
Like Gainsborough, Watteau was happy in the company of actors and
musicians, mostly from the Italian Comedy. They provided from an early
period in his career the source of so many of his pictures. He observed them in
action and at rest with a sense of reality which he then transformed in his
paintings. Occasionally, definite figures or known occasions can be recognised
and these have been included in a group of portrait drawings. The actors, of
course, inhabited a special world slightly removed from reality. Their clothes
and gestures were extravagant and suited Watteau's ideal world — Caylus,
with some surprise, noted that he was 'an acute, even a fastidious, judge of
music and the arts', and his studies of musicians and the power of music were
part of his allegories. They furnished that interplay of figures and hands for
which Watteau's eye was so sure. The present taut and elongated drawing is
an early study of two comedians. They probably represent *Crispins*, who
appeared in French comic theatre, wore a distinctive costume and acted a
stock supporting role. The two figures were used in the background of his
painting *La Perspective*, Museum of Fine Arts, Boston (Brookner Plate 10),
more visible in the engraving by Créquy than in the painting itself, which
probably dates from about 1714–15.

Plate 85 Two actors. Sanguine. $6\frac{1}{4} \times 4\frac{1}{4}$ in. ($17 \cdot 3 \times 10 \cdot 6$ cm.). Fitzwilliam Museum, Cambridge.
The youthful actor with his hand on his sword handle was transformed by the substitution of the actor Poisson's head and appears at the right of *L'Amour au Théâtre français*, at Berlin-Dahlem, Staatliche Museen (Brookner Plate 22). The picture may well have been inspired by the return of the Italian players to Paris in 1716. The other figure in the drawing seen from the back was also used as the figure in the foreground of the painting.

Plate 86 Seated Mezzetin. 'Aux trois crayons', on light brown paper. $9\frac{5}{8} \times 6\frac{1}{4}$ in. ($24 \cdot 2 \times 15 \cdot 9$ cm.). Teylers Museum, Haarlem.
Watteau was attracted by the Mezzetin's elaborate costume in this single study but the figure was not used in a painting, though it was engraved by Boucher in *Figures de différents Caractères* (119).

Plate 87 Standing Pierrot. 'Aux trois crayons', on brownish paper. $9\frac{5}{8} \times 6\frac{1}{4}$ in. ($24 \cdot 3 \times 15 \cdot 8$ cm.). Teylers Museum, Haarlem (M. 16).
This amusing figure bowing towards the spectator and drawn mainly with a few rapid touches of black chalk, was engraved by Boucher in *Figures de différents Caractères* (17) and appears in two paintings by Watteau *Le Bal champêtre* (Adhémar 131) and *Les Habits sont italiens* (Adhémar 155).

Plate 88 L'Indifférent. 'Aux trois crayons'. $10\frac{3}{4} \times 7\frac{1}{2}$ in. ($27 \cdot 1 \times 18 \cdot 9$ cm.). Museum Boymans-van Beuningen, Rotterdam.
Though the drawing is known by the title of the painting in the Louvre, (Brookner Plate 17) of about 1716–17, which it resembles, but in reverse, other drawings show a similar figure in the same masquerade costume and with variants of possibly a dance pose. Such a figure stands at the heart of Watteau's world: poised as if in an other-worldly minuet and strangely vulnerable.

Plate 89 Studies of the heads of two actors, two hands holding a flute and a kneeling child. 'Aux trois crayons'. $7\frac{3}{4} \times 10$ in. ($19 \cdot 6 \times 25 \cdot 4$ cm.). Rijksprentenkabinet, Rijksmuseum, Amsterdam.
Heads of actors, hands holding musical instruments, children in a natural pose — these essentials of Watteau's ideal world were extracted from the melange on this sheet for more than one painting. The child occurs in a large composition, *La Recréation musicale*, in the Louvre (listed under Adhémar 171). The two heads are similar to the principal figures in a smaller version of this painting, engraved by Scotin as *Le Lorgneur* (The Quizzical Glance; Adhémar Plate 98) in which the child does not appear. A pendant to *Le Lorgneur*, called *La Lorgneuse*, utilises the hands holding the flageolet.

Plate 90 Study of a violinist. Sanguine, heightened with white. $7\frac{1}{2} \times 6\frac{1}{4}$ in. ($19 \times 15 \cdot 8$ cm.). British Museum, London.
This incisive study was used for the *Marriage Contract* (Prado, Madrid; Adhémar 134) and without the cape on which he has lavished so much attention, in *Les Plaisirs du Bal*, Dulwich College (Brookner Plate 20).

Plate 91 Two studies of a bagpipe player. Sanguine, black chalk with touches of white on grey-brown paper. $10\frac{5}{8} \times 8\frac{3}{4}$ in. ($27 \cdot 1 \times 22 \cdot 2$ cm.). Cabinet des Dessins, Musée du Louvre, Paris. (33.382)
The figure with the flaxen locks occurs in early drawings by Watteau (see Plate 3) and the paintings with which it can be connected are also apparently from his early maturity, for example, *Les Bergers*, Berlin-Dahlem (Plate 115) and in *L'Accordée de village* (The Village Bride), Sir John Soane's Museum, London (Brookner Plate 8). The drawing, however, is confident and mature and must surely date from after 1712. Watteau also used the pose, but substituted his own head, in *Fêtes Vénétiennes* in the National Gallery of Scotland (Brookner Plate 35) of about 1718. The figure possibly represents the actor La Thorillière, cast as a rustic musician.

Plate 92 Two studies of a man playing a guitar and a study of an arm. 'Aux trois crayons', on light brown paper. $9\frac{5}{8} \times 15$ in. (24.4×37.9 cm.). British Museum, London.

This superb sheet with the study of the guitarist at the left is one of Watteau's happiest drawings of a musician and he used it in a number of compositions: including *La Recréation Galante* at Berlin, and *La Gamme d'Amour*, National Gallery, London (Brookner Plate 19). The articulation of the wrists and fingers playing the guitar is particularly notable. The figure at the right appears in *La Perspective* (Brookner Plate 10). The outstretched arm is similar to the group of studies connected with *L'Indifférent* (reproduced here, Plate 88) and may have been used for the Mezzetin in *Les Comédiens Italiens* (Brookner Plate 46). A further related drawing is also reproduced here (Plate 97).

Plate 93 A man playing a flute. 'Aux trois crayons', on buff paper. $6\frac{3}{4} \times 6\frac{7}{8}$ in. (16.9×17.3 cm.). Fitzwilliam Museum, Cambridge.

The musician is leaning on a balustrade; at the left is part of a study of a hand holding a staff. The figure was used with the addition of a hat in the *Concert champêtre* in the Musée d'Angers (Plate 118) and again in another *Concert champêtre* known from the etching by B. Audran (D. V. 72) but bareheaded. The following drawing does not have the same directness and concentration on the act of playing but continues the same figure to full length.

Plate 94 Full-length figure of a man playing a flute, with two seated women. 'Aux trois crayons.' $10 \times 14\frac{7}{8}$ in. (25.3×37.5 cm.). British Museum, London.

See the preceding drawing. The two studies of a woman are seen from different angles with the pose slightly altered to exploit the differences of the drapery folds.

Plate 95 Study of a man playing a viola da gamba. Black and red chalk. $9\frac{3}{4} \times 6\frac{1}{8}$ in. (24.8×6 cm.). Kupferstichikabinett, Berlin.

In this ethereal study, Watteau has hardly drawn in the musician but concentrated instead on the expressive hands of the performer who grips the bow like a double bass player. It is an interesting example of Watteau's beginning a sketch of one of his beloved musicians and, in the most economical way, rapidly securing the essentials.

Plate 96 Two violinists and a slight study of a man. Sanguine. $10\frac{1}{4} \times 14\frac{3}{8}$ in. (26.1×36.5 cm.). Ashmolean Museum, Oxford.

This rapid and flowing sketch, seemingly from an actual performance, was used in *La Contredanse* in the collection of Sterling Post, New York (Adhémar Plate 86). The chalk lines seem to create an independent harmony of their own. The slight sketch at the right, with the hands more highly finished, seems to be an idea for a man embracing a woman, rather than holding a musical instrument.

Plate 97 Group of three comedians. Counter-proof in black chalk, sanguine and wash. $15\frac{3}{8} \times 11\frac{1}{2}$ in. (38.8×29.2 cm.). Private Collection, London.

This bold and dramatic study fully exploits the atmospheric quality of the counter-proof. The figures in reverse appear in *Les Comédiens Italiens* (Brookner Plate 46) in the National Gallery of Art, Washington, one of two large compositions he painted for Dr Mead in London in 1720. The figure of the actress who appears in the painting is barely indicated at the right of the drawing.

Plate 98 Antoine de la Roque. Sanguine. $8\frac{3}{8} \times 6\frac{3}{8}$ in. (21 × 16 cm.). Fitzwilliam Museum, Cambridge.

Watteau constantly used the faces and figures of those around him as studies for his paintings, yet it is tantalising that relatively few are identifiable and that his well-known acquaintances such as Caylus, Gersaint and Crozat cannot be recognised. Some appear, however, in drawings whose realism puts them more into the category of serious portrait studies rather than mere sketches from the life for later use in his paintings. Antoine de la Roque (1672–1744), who is shown here with crutches, had been wounded at the battle of Malplaquet. He was later to be famous as a writer and as director of the *Mercure de France* from 1721 to 1744, and it was for this paper that he wrote the first obituary of Watteau whose close friend he had become. He had probably met Watteau in the entourage of Crozat, some time between 1712 and 1716. This drawing probably dates from this period and Watteau was to paint his portrait seated in a landscape, now lost, but engraved by B. Lépicié and known from a replica (Adhémar Plate 79), which permits the identification.

Plate 99 Philippe Poisson the actor as Blaise. Sanguine and black chalk. $13\frac{1}{4} \times 7\frac{3}{8}$ in. (33·8 × 18·7 cm.). British Museum, London.

This rather supercilious figure occurs frequently in Watteau's work. After the title of an engraving made after a similar drawing it was proposed that the figure represented Philippe Poisson, the actor, in the role of Blaise in Dancourt's comedy *Les Trois Cousines*. The print was one of the *Figures françaises et comiques* (D. V. 55) but they were not always accurate. The person may accordingly be the actor Touvenelle or even M. Leboucq-Santussan, owing to the likeness between this drawing and the principal figure of *The Family* (D. V. 56) which was documented as representing the family of Leboucq-Santussan. Nevertheless, Poisson remains a strong candidate.

Plate 100 Portrait of Vleughels. Sanguine and plumbago. $11\frac{1}{2} \times 7\frac{1}{8}$ in. (29·1 × 18 cm.). Staedelsches Kunstinstitut, Frankfurt.

Nicholas Vleughels, the artist (1668–1737), appears in a number of drawings and paintings by Watteau, notably *Les Charmes de la Vie* in the Wallace Collection, London, (Brookner Plate 31) and in a different pose in *Les Fêtes Vénétiennes*, National Gallery of Scotland, Edinburgh, (Brookner Plate 35). Vleughels had been in Italy in 1712 and 1713 but had returned to Paris where he was made an academician in 1716, inhabiting a house with Jeaurat. Watteau moved in with them after leaving Sirois in 1718, the probable date of this drawing.

Plate 101 Pierre Sirois. Sanguine. $6\frac{3}{8} \times 4\frac{1}{4}$ in. (16 × 10·7 cm.). P. Bordeaux-Groult, Paris.

Used as a study for the central figure of *Sous un Habit de Mezzetin*, Wallace Collection, London; Brookner Plate 15. A manuscript note by Mariette is quite precise that this painting represents 'Sirois, friend of Watteau, shown in the middle of his family, as the figure of Mezzetin playing the guitar.' Pierre Sirois (1665–1726), dealer and frame-maker, was one of Watteau's closest friends. He brought his first pictures and published the first engravings after his works. Between 1710 and 1718, Watteau lived with him intermittently until he moved in with Vleughels.

Plate 102 Studies of two heads. Sanguine and black chalk. $7\frac{1}{2} \times 4\frac{7}{8}$ in. (18·9 × 12·3 cm.). British Museum, London.

The two heads were also used for the portrait of Sirois and his family in the Wallace Collection (see preceding drawing) and may therefore be identified as two of his daughters, or a daughter and his wife. As they were used in a painting with an ideal subject, it is surprising that Watteau has not adjusted the facts of their faces to a more ideal type but allowed his realism to shine through.

Plate 103 An engraver at his work table. Sanguine. $9\frac{1}{4} \times 12$ in. ($23\cdot5 \times 30\cdot4$ cm.). British Museum, London.

An old inscription, no longer on the back of the drawing, noted that the engraver was Bernard Baron, who had worked in England and knew Dr Mead. The drawing may, therefore, have been executed during Watteau's stay in London, during 1720. Whether or not this identification is certain, the drawing gives a fascinating glimpse into the world of printmaking, with the burins, ink and acid baths, so important for the popular success of Watteau and his contemporaries.

Plate 104 Three portraits of musicians. Sanguine black chalk with white heightening. $9\frac{1}{2} \times 10\frac{3}{4}$ in. ($24 \times 27\cdot4$ cm.). Cabinet des Dessins, Musée du Louvre, Paris.

We have, in this atmospheric and luminous study, a precious souvenir of Watteau's world. According to a note on the mount by Mariette, who owned the drawing, the singer at the right is Mlle d'Argenon, niece of the painter Charles de la Fosse, who stayed on in the Crozat town house after her uncle had died, to achieve fame as a singer. The musician in the centre is Antonio Paccini who was in the French royal household from 1707 until his death at Versailles in 1745. The third at the left is the violinist Giovanni-Antonio Guido, known as Antonio, who was patronised by the Duke of Orleans, the Regent. The event is almost certainly a society concert at the Hôtel Crozat on 30th September 1720, mentioned in the Diary of Rosalba Carriera, who may be represented in the two slight sketches at the bottom of the sheet. The style of the drawing accords well with this date and a resemblance has been noted between Antonio and the man leaning on his elbow in *L'Enseigne de Gersaint* (Plate 120) of about the same date. The drawing is more than just an interesting record, for Watteau, so keen a lover of music, has captured the spirit of the scene and the concentration of the musicians, united by a masterful control of light and shade.

Plate 105 A priest. Sanguine and black chalk. $5\frac{3}{8} \times 3\frac{7}{8}$ in. ($13\cdot8 \times 9\cdot8$ cm.). British Museum, London.

The priest who appears in this slight sketch also appears on another drawing in the British Museum, and in the following example. One wonders whether it might be the Abbé Harenger, one of Watteau's five legatees. At all events it is a sad reminder of the closing year of Watteau's life, underlined by the inscription on the back which is the pathetic remains of a prescription for his last illness.

Plate 106 Rosalba Carriera at the dressing table. Sanguine. $9\frac{1}{2} \times 12\frac{5}{8}$ in. (24×32 cm.). Rijksprentenkabinet, Rijksmuseum, Amsterdam.

Rosalba Carriera (1675–1757), Watteau's Venetian contemporary whose work he admired so much and who, in turn, made one of her celebrated pastel portraits of him which has recently been rediscovered, visited Paris in 1720 and 1721 on the invitation of Crozat and was present at the concert, recorded in Plate 104. She also, incidentally, had some talent as a violinist. This intimate scene establishes Watteau's familiarity and it was engraved in the *Figures de différents Caractères*. There is some doubt, however, owing to certain weaknesses in the treatment of the Abbé (see preceding drawing) and the dressing table whether the drawing is actually from Watteau's hand or a copy after his original.

Plate 107 The quack. Sanguine. $6\frac{7}{8} \times 9$ in. ($17\cdot6 \times 22\cdot8$ cm.). Ashmolean Museum, Oxford.

Designs for definite compositions in Watteau's art are rare. A number of independent designs exist from the beginning of his career, perhaps before he had found his true way. The present example emphasises his interest in genre scenes and is reminiscent of a similar scene by Rembrandt. The satirical comment which Gersaint noted in such studies by Watteau is subtly made explicit by the figure of the charlatan.

Plate 108 The finding of Moses. Sanguine. $8\frac{3}{8} \times 11\frac{7}{8}$ in. ($21\cdot4 \times 30\cdot3$ cm.). Ecole des Beaux-Arts, Paris.
It is not true to say that preliminary designs for the compositions of Watteau's maturity were not made. This beautiful design was probably an idea for his reception piece for the Academy which he later abandoned with such revolutionary results. The story of Moses and its treatment is much more conventional with overtones of Veronese and the Venetians whom he admired.

Plate 109 Diana at the bath. Sanguine. $6\frac{3}{4} \times 6\frac{3}{8}$ in. ($17\cdot2 \times 16\cdot3$ cm.). Graphische Sammlung, Albertina, Vienna.
A careful study for his painting *Diana at the Bath* in the Groult collection (Adhémar Plate 69) which is, in fact, a recreation of a design by Louis de Boulogne, executed as a painting in 1709. This rare excursion into the world of classical mythology shows what Watteau might have become and it was left to his followers such as Boucher to develop the poetry of this drawing with its Venetian landscape background. Gainsborough was influenced probably by Aveline's print after Watteau's painting, in his Romantic painting *Musidora* (Tate Gallery, London).

Plate 110 A group of figures near a fountain. Sanguine. $6\frac{7}{8} \times 7\frac{7}{8}$ in. ($17\cdot5 \times 19\cdot8$ cm.). Cabinet des Dessins, Musée du Louvre, Paris (773).
This rapid sketch has certain analogies with the *Plaisirs d'amour* at Dresden (Adhémar Plate 124) and emphasises that Watteau, brilliant designer though he was, could not compose his large-scale figure works entirely in his head. Such a quick sketch could be augmented by the drawings in his albums of studies but Watteau never seems to have produced highly finished, squared-up, preliminary designs. He seems to have preferred to invent a new pose where required as he went along, as in the following drawing.

Plate 111 A man helping up a seated woman. Sanguine, black and white chalks on light brownish paper. $13\frac{1}{4} \times 8\frac{7}{8}$ in. ($33\cdot6 \times 22\cdot6$ cm.). British Mueseum, London.
The careful harmonies of the *Embarkation from the Isle of Cythère* (Plate 119) seem inimitable and effortless but the present drawing reveals that he would, on occasions, while he was engaged on the picture, have recourse to nature to establish a certain relationship or pose; in this case, that of the pilgrim helping the woman to her feet at the right of the composition. It is noticeable that he did not need to finish the drawing in any great detail, unlike his everyday studies from the life, and the general outlines were sufficient to establish the ' swing of the pose.

Plate 112 Figures from *L'Embarquement à l'Isle de Cythère*. Counter-proof. $14\frac{3}{8} \times 10\frac{1}{2}$ in. ($35\cdot7 \times 26\cdot7$ cm.). National Gallery of Scotland, Edinburgh.
Watteau seems to have taken counter-proofs from his painted sketches, which were then altered, as he proceeded and which could also be used for other compositions. This seems to have been one in an early stage of *The Embarkation* (Plate 119).

Plate 113 Le Naufrage: an allegory. Sanguine. $8\frac{7}{8} \times 13\frac{3}{8}$ in. ($23\cdot3 \times 34$ cm.). Ashmolean Museum, Oxford.
The probable subject of this rare allegorical work is a comment on Watteau's return from England in 1720. Watteau's friend Jean de Jullienne is shown welcoming the artist after the crash of John Law's bank in Paris in which many people had lost their money. Jullienne, however, is said to have saved on Watteau's behalf about 6000 *livres*, for which the artist doubtless expressed his gratitude by this drawing.

Plate 114 Le Remède. 'Aux trois crayons', on grey paper. $9\frac{1}{4} \times 15\frac{5}{8}$ in. ($23\cdot4 \times 37$ cm.). P. Bordeaux-Groult, Paris.

This frank drawing could be compared with the more intimate of his nude studies (see Plate 45). The nude figure of the woman is carefully observed but the servant is less so. The composition may have been started as a study from the life and became, on the way, an idea for one of his late intimate nudes, such as *La Toilette* (Wallace Collection; Brookner Plate 42). We know that Watteau could occasionally be pungent; presumably over medical matters about which he had so much experience at the end of his life, he could be even more so.

PAINTINGS BY WATTEAU

Plate 115 The Diversions of War. Engraving. $8\frac{5}{8} \times 12\frac{3}{4}$ in. ($21\cdot7 \times 32\cdot8$ cm.). Fitzwilliam Museum, Cambridge.

Engraving by L. Crépy after Watteau's painting in the Hermitage, Leningrad. The print was part of the *Recueil Jullienne* (D. V. 216) and gives an idea of the loving care with which knowledge of Watteau's art was spread by his friends. A pendant to the *Hardships of War* (Adhémar Plate 45), also in the Hermitage, Leningrad, both of which belonged to his friend Antoine de la Roque. (See Plates 10, 98.) They were probably executed after his return from Valenciennes and mark the success of his new genre with the dealers of Paris. Roque, recently invalided out of the army, doubtless appreciated the subjects.

Plate 116 Zephyr and Flora (Spring). Oil on canvas. $46\frac{3}{4} \times 38\frac{1}{2}$ in. (119×98 cm.). Previously in a private collection, England (destroyed).

One of four oval paintings, representing *The Seasons*, for the dining room of Crozat's town house, c. 1712–15, (see Plate 39). 'Its tender gallant mythologising leads directly on to Boucher' (Levey).

Plate 117 Les Bergers. Oil on canvas. 56×81 in. (56×81 cm.). Gemäldegalerie, Berlin-Dahlem.

The present picture reveals a more bucolic aspect of Watteau's *fêtes galantes*, with the actor La Thorillière (see Plate 91) occupying a prominent position, playing the bagpipes. Nevertheless, the essential elements of Watteau's art are present, music, dance, courtship, love, a pretty girl on a swing, dalliance, all set in a harmonious landscape.

Plate 118 Le Concert champêtre. Oil on canvas in feigned oval. $26\frac{3}{4} \times 19\frac{7}{8}$ in. ($67 \times 51\cdot2$ cm.). Musée des Beaux-Arts, Angers.

A number of drawings reproduced here were used in this little-known charming picture by Watteau, for example the flute player (Plate 93) and the gardener (Plate 20). It has been dated by Adhémar to the end of 1716.

Plate 119 L'Embarquement pour l'Isle de Cythère. Oil on canvas. $50 \times 75\frac{1}{2}$ in. (127×192 cm.). Musée du Louvre, Paris.

Watteau's celebrated picture painted for the Academy in 1717, of which another version was painted for Jullienne and is now at Berlin. (See Brookner Plates 26, 27, and 29.) It has now been established that the pilgrims are returning *from* the Isle of Love. (See page .) For a drawing connected with the composition, see Plate 111.

Plate 120 L'Enseigne de Gersaint. Oil on canvas. $71\frac{3}{4} \times 121\frac{1}{4}$ in. (182×307 cm.). Germäldegalerie, Berlin-Dahlem.

Watteau's famous painting for his friend Gersaint's gallery. (See Brookner Plate 44 and Plate 22 of this volume.

Plate 121 **François Boucher** (1703–70), attributed to. Portrait of Watteau. 'Aus trois crayons'. $8\frac{1}{2} \times 10$ in. (21.5×25.3 cm.). Musée Condé, Chantilly.
A copy by Boucher of a lost self-portrait drawing by Watteau, which Boucher had himself engraved for the *Figures de différents Caractères*. Boucher's admiration for the world of Watteau can be seen in the careful sensitivity of his copy.

Plate 122 **Nicolas Henri Tardieu** (1674–1749), after Watteau. Self-Portrait with Jullienne. Engraving. $15 \times 11\frac{1}{2}$ in. (38×29.2 cm.). Size of image, without inscription. Fitzwilliam Museum, Cambridge.
It has been established that this engraving was after a lost painting by Watteau, showing him out of doors with his friend Jean de Jullienne. It had lines addressed to the artist beginning: *Assis, aupres de toy.* . . . A perceptive critic has recently remarked that 'combined here are those elements which contributed to Watteau's art: the refinements of Parisian society, the harmony of music, and above all, the inspiration of nature. Jullienne . . . selected this image to appear at the head of his corpus of engravings after the master's paintings.'

Plate 123 **Bernard Lépicié** (1698–1755), after Watteau. Self-Portrait. Engraving. $5\frac{1}{4} \times 4\frac{3}{16}$ in. (13.3×10.6 cm.). Fitzwilliam Museum, Cambridge.
This engraving also reproduces a lost self-portrait painting also belonging to Jullienne, which shows, more realistically, Watteau at work indoors. The pose is similar to the Tardieu engraving (see Plate 122) and is also very similar to the copy by Boucher of a lost Watteau drawing (Plate 121).

Plate 124 **Claude Gillot** (1673–1722). Scene from the Italian Comedy: The False Coquette. Pen and black ink, sanguine wash. $6\frac{1}{4} \times 8\frac{1}{2}$ in. (16.1×21.7 cm.). Cabinet des Dessins, Musée du Louvre, Paris.
This drawing illustrated a scene from Act II of the *False Coquette*, a comedy first staged by the Italian Comedy in 1694, at their headquarters, the Hôtel de Bourgogne. Harlequin is shown with three hats on his head in the company of Mezzetin and Pasquarelle, with Marinette and Colombine arriving in the background. Watteau's debt in his early drawings to such a source, both of subject and style, is obvious but although Watteau soon surpassed his master in subtlety of expression and suppleness of pose, Gillot's pioneering role must not be overlooked.

Plate 125 **Jacques Callot** (1594–1635). Standing Figure. Sanguine. $9\frac{3}{8} \times 6\frac{1}{8}$ in. (23.8×15.6 cm.). Galleria degli Uffizi, Florence.
This elegant study comes very close in manner of execution and style to Watteau's practice. It may be connected with Callot's Florentine period and his designs for the important print of *The Fair at Impruneta*, dated 1620.

Plate 126 **Gilles-Marie Oppenort,** attributed to (1672–1742). Design for a fountain, with a dragon and triton. Sanguine. $9\frac{3}{4} \times 8$ in. (24.8×20.3 cm.). Fitzwilliam Museum, Cambridge.
The present drawing is one of the problematical fountain designs which have been attributed to both Watteau and Oppenort (see pages 9–10). Another slightly inferior version of this drawing is at Stockholm (P. & M. 228).

Plate 127 **Sir Peter Paul Rubens** (1577–1640). Isabella Brant. Oil on canvas. $33\frac{1}{2} \times 24\frac{3}{8}$ in. (85×62 cm.). Galleria degli Uffizi, Florence.
The original painting which inspired Watteau's copy (see Plate 26) was once in the collection of the Archduke Leopold Wilhelm of Brussels.

Plate 128 **Sir Anthony Van Dyck** (1599–1641). Adam de Coster. Black
chalk. $9\frac{5}{8} \times 7\frac{1}{8}$ in. (24·3 × 18 cm.). Staedelsches Kunstinstitut, Frankfurt.
One of Van Dyck's drawings for his series of portraits of famous
contemporaries, which were then engraved and known as his *Iconographie*.
Watteau probably knew this drawing when it was in the Crozat collection,
though he may also have used Pieter de Jode's engraving, if the more detailed
treatment of cuff and doublet are taken into account (see Plate 27).
Watteau has, if anything, made the figure of the artist de Coster even more
elegant than Van Dyck's original, notably in his personal treatment of the head.

Plate 129 **Titian** (Tiziano Vecellio) (1477[?]–1576). Two figures in a landscape.
Pen, brown ink. $9\frac{3}{8} \times 8\frac{3}{8}$ in. (23·6 × 21·3 cm.). Graphische Sammlung,
Albertina, Vienna.
One of Titian's rare drawings which is convincingly attributed to him and
assigned to his early period, *c.* 1511. The combination of landscape and figure
style is similar to his frescoes at Padua and the mood is still very close to
Giorgione. The drawing belonged to Mariette and may therefore have come
from the Crozat collection where Watteau may have seen it. He was
undoubtedly impressed by the force and power of its pen work which he has
suavely translated into sanguine, tidying Titian's more forceful strokes of the
pen and eliminating Titian's changes of mind. The poetic landscape with its
tall buildings is reminiscent of other Venetian landscapes which he copied
(see Plate 31), by artists such as Campagnola, for use in his own ideal
landscapes.

Plate 130 **Charles de la Fosse** (1636–1716). Flora and Zephyr. Sanguine and black
chalk. $10\frac{1}{4} \times 8\frac{1}{2}$ in. (26 × 21·4 cm.). Cabinet des Dessins, Musée du Louvre, Paris.
It has been argued that this drawing and another similar design by de la Fosse,
also in the Louvre, were his preliminary ideas which he handed on to Watteau
for the dining room of Crozat's town house (see Plate 39), where de la Fosse
was also engaged on his larger scheme of the *Birth of Minerva* for the ceiling of
the Gallery. It has been suggested further that a drawing of *Bacchus* at
Alençon, with an old attribution to de la Fosse, is connected with *Autumn*
(see Plate 40). However, if we compare Watteau's marvellously supple studies
with these heavy and rather awkward figures we can recognise the advance
Watteau had made over the older artist.

Plate 131 **Nicolas Lancret** (1690–1745). Standing figure of a man with a nude torso.
'Aux trois crayons', on brown paper. $17\frac{1}{2} \times 8\frac{1}{4}$ in. (44·5 × 21 cm.). Museum
Boymans-van Beuningen, Rotterdam.
This drawing has also been attributed to Watteau and it makes use of his
technique of three chalks. Nevertheless, it is a study by Lancret for his picture
Les Lunettes, Château de Compiègne. Here Lancret follows the more normal
studio practice of posing a model for one of the principal figures in his picture,
which illustrates a story by La Fontaine. The treatment of details is sketchier,
particularly in the head and trousers, than Watteau's method and generally
Lancret's approach is more anecdotal leading on to the sentimentality of Greuze.

Plate 132 **Jean-Baptiste François Pater** (1695–1736). Two studies of women, one on
a swing. Sanguine. $7\frac{1}{8} \times 9\frac{3}{4}$ in. (18·1 × 24·8 cm.). Museum Boymans-van
Beuningen, Rotterdam.
Pater, Watteau's pupil, comes very close to Watteau's style of drawing and this
example was at one time attributed to Watteau. It has, however, been
recognised as a study sheet for two of Pater's paintings. The woman on the
swing appears in his painting, *The Swing*, in the Louvre and also in another
painting of the same title which was in the Stehli Collection in New York.
The leaning woman occurs in *Le Bain rustique*, previously in the Arenberg
Collection. As might be expected with a follower, Pater tends to imitate
Watteau's early style rather than his more mature drawings, and his hand can
be distinguished by its nervous finickyness, particularly noticeable here.

43

Bibliography

This bibliography is not intended to be exhaustive. It is a basic list with items included from recent periodical literature which are considered to be useful for further study of Watteau. For a more general bibliography up to 1940 see Thieme-Becker, *Allgemeines Lexikon der Bildenden Künstler*, XXXV, 1942, pages 190–196 and Parker and Mathey (see below).

Adhémar, H., *Watteau, sa vie, son œuvre*, Paris, 1950.

Bouchot-Saupique, J., *Les Dessins de Watteau*, Paris, 1953.

Brookner, A., *Watteau*, The Colour Library of Art, Paul Hamlyn, 1967.

Cailleux, J., 'Four studies of soldiers by Watteau', in *Burlington Magazine*, CI, nos. 678–9, Sept.–Oct. 1959, suppl. pages.

Cailleux, J., 'Newly Identified Drawings by Watteau', in *Burlington Magazine*, CIX, no. 766, Feb. 1967, pages 56–63.

Cailleux, J., and Michel, M. R., *Watteau et sa génération*, exhibition at Galerie Cailleux, Paris, 1968.

Champion, P., *Notes critiques sur les vies anciennes d'Antoine Watteau*, Paris, 192▶

Dacier, E., and Vuaflart, A., *Jean de Jullienne et les graveurs de Watteau au XVIIIe Siècle*, 4 vols., Paris, 1921–29.

Eidelberg, M.P., 'Watteau's use of landscape drawings' in *Master Drawings*, V, no. 2, 1967, pages 173–182.

Eidelberg, M.P., 'Watteau, Lancret and the Fountains of Oppenort', in *Burlington Magazine*, CX, no. 785, August 1968, pages 447–456, and further correspondence by the author, Cailleux and Parker in *Burlington Magazine*, Feb. 1969.

Eidelberg, M.P., 'Watteau's *La Boudeuse*' in *Burlington Magazine*, CXI, no. 794, May 1969, pages 275–278.

Eisler, C., 'Two Immortalised Landscapes – Watteau and the *Recueil Jullienne*', in *The Metropolitan Museum of Art Bulletin*, XXIV, 1966, pages 165–76.

Goncourt, E. and J. de, *L'Art du XVIIIe Siècle*, 3 vols., Paris, 1927–8.

Goncourt, E. de, *Catalogue raisonné de l'œuvre peint, dessiné et gravé d'Antoine Watteau*, Paris, 1875.

Hasselt, C. van, *Les Dessin français dans les Collections hollandais*, 2 vols., exhibition, Paris and Amsterdam, 1964.

Kimball, Fiske, *The Creation of the Rococo*, paperback edition, New York, 1964.

Levey, M., 'The Real Theme of Watteau's *Embarkation for Cythera*', in *Burlington Magazine*, CIII, no. 698, May 1961, pages 180–185.

Levey, M., 'A Watteau Rediscovered: Le Printemps for Crozat', in *Burlington Magazine*, CVI, no. 731, Feb. 1964, pages 53–58.

Levey, M., *Rococo to Revolution*, London, 1966.

Mathey, J., 'Remarques sur la chronologie des peintures et dessins d'Antoine Watteau', in *Bulletin de la Societé de l'Histoire de l'art Français*, 1939.

Mathey, J., 'Early Paintings of Watteau', in *Art Quarterly*, XIX, 1956.

Mathey, J., *Antoine Watteau, peintures réapparues, inconnues ou négligées*, Paris, 1959.

Mathey, J., 'Drawings by Watteau and Gillot', in *Burlington Magazine*, CII, no. 689, Aug. 1960, pages 357–361.

Parker, K.T., 'The Drawings of Antoine Watteau in the British Museum', in *Old Master Drawings*, June 1930.

Parker, K.T., *The Drawings of Antoine Watteau*, London, 1931.

Parker, K.T., and Mathey, J., *Antoine Watteau, catalogue complet de son œuvre dessiné*, 2 vols., Paris, 1957.

Watteau, A., *L'Œuvre d'Antoine Watteau, Peintre du Roy, gravé d'après ses tableaux et dessins originaux tirez du cabinet du Roy et des plus curieux de l'Europe par les soins de M. de Julliene*, Paris, c. 1730–1740. ('Recueil Jullienne'). 2 vols.

Watteau, A., *Figures de différents caractères de paysages et d'études dessinées d'après nature par Antoine Watteau*, Audran et Chereau, 2 vols., Paris, 1725–28.

Watteau, A., *Figures de modes dessinées et gravées à l'eau forte par Watteau et terminées au burin par Thomassin le fils*, Paris, n.d.

Watteau, A., *Figures françaises et comiques nouvellement inventées par M. Watteau, Peintre du Roy*, (engraved by Cochin, Desplaces and Thomassin) Paris, n.d.

Watteau, A., *Suite des figures inventées par Watteau, gravées par son ami C . . .* , (Caylus), n.d.

Zimmerman, E.H., *Watteau, Klassiker der Kunst*, XXI, Stuttgart, 1912.

Le Cabinet d'un Grand Amateur, P.-J. Mariette, exhibition, Louvre, Paris, 1967.

Dessins français du XVIIIe Siècle, Amis et Contemporains de P.-J. Mariette, XXXVIII, exhibition, Cabinet des Dessins, Louvre, Paris, 1967.

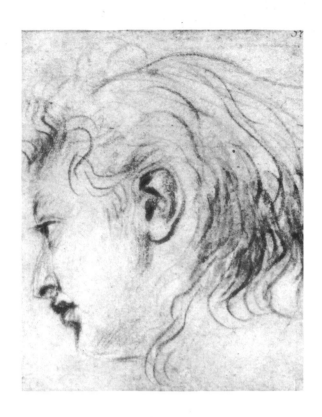

Plate 1

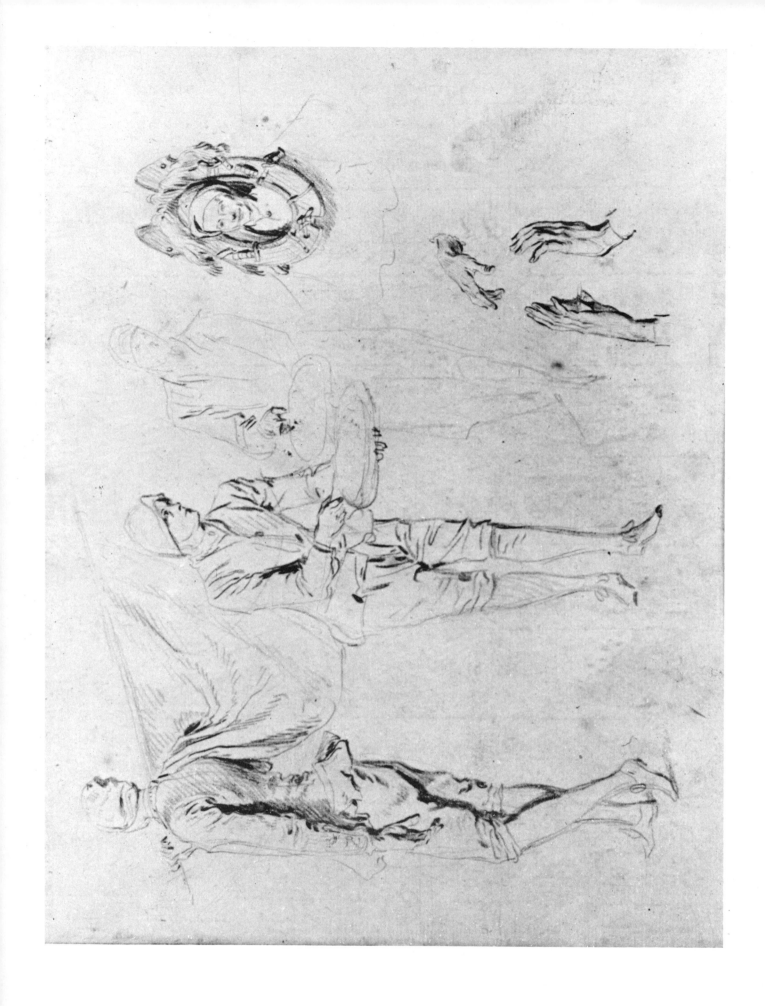

Plate 2

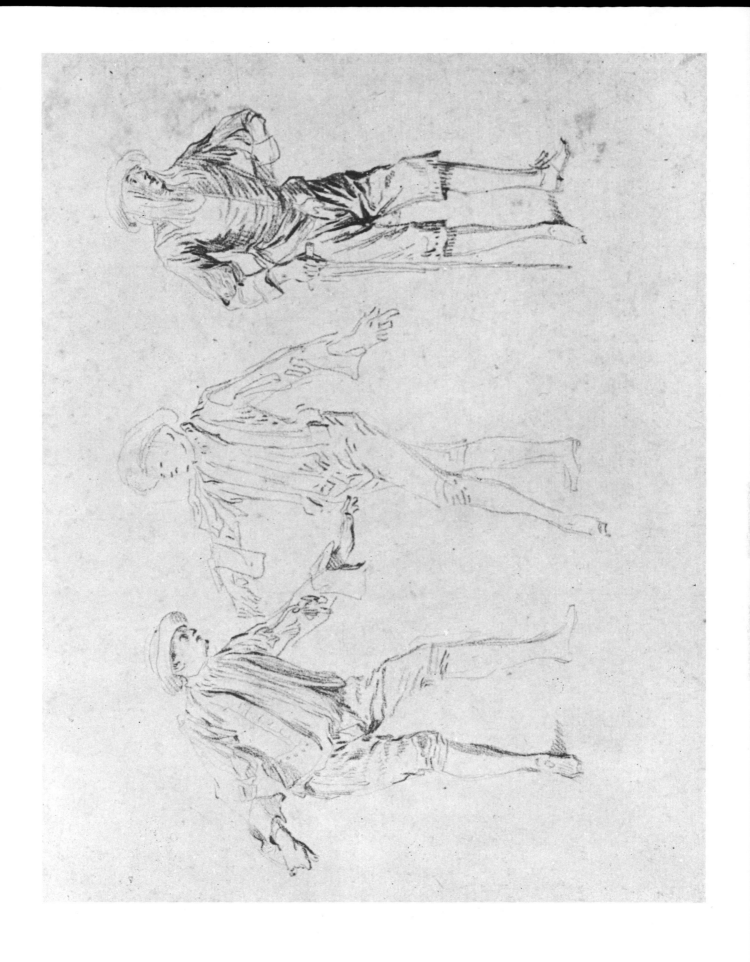

Plate 3

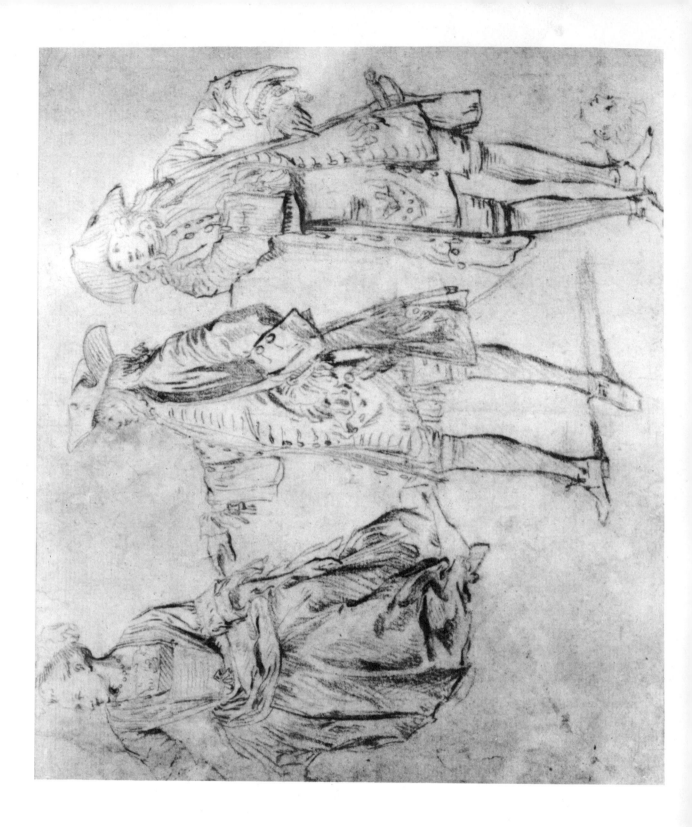

Plate 4

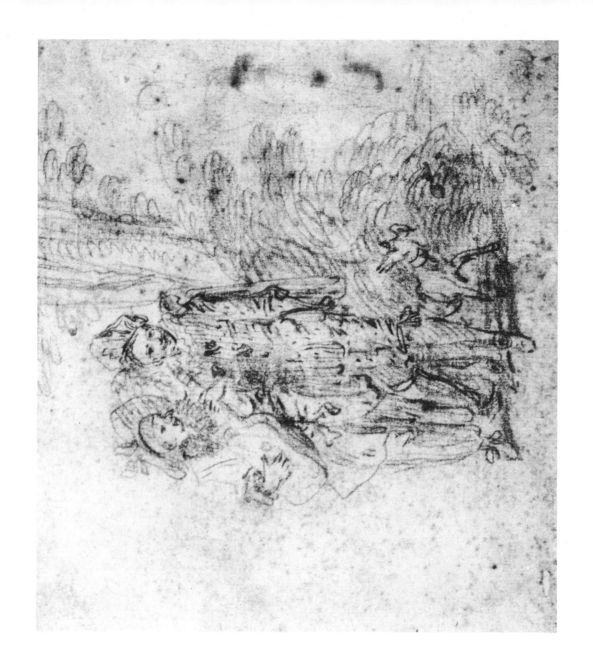

Plate 5

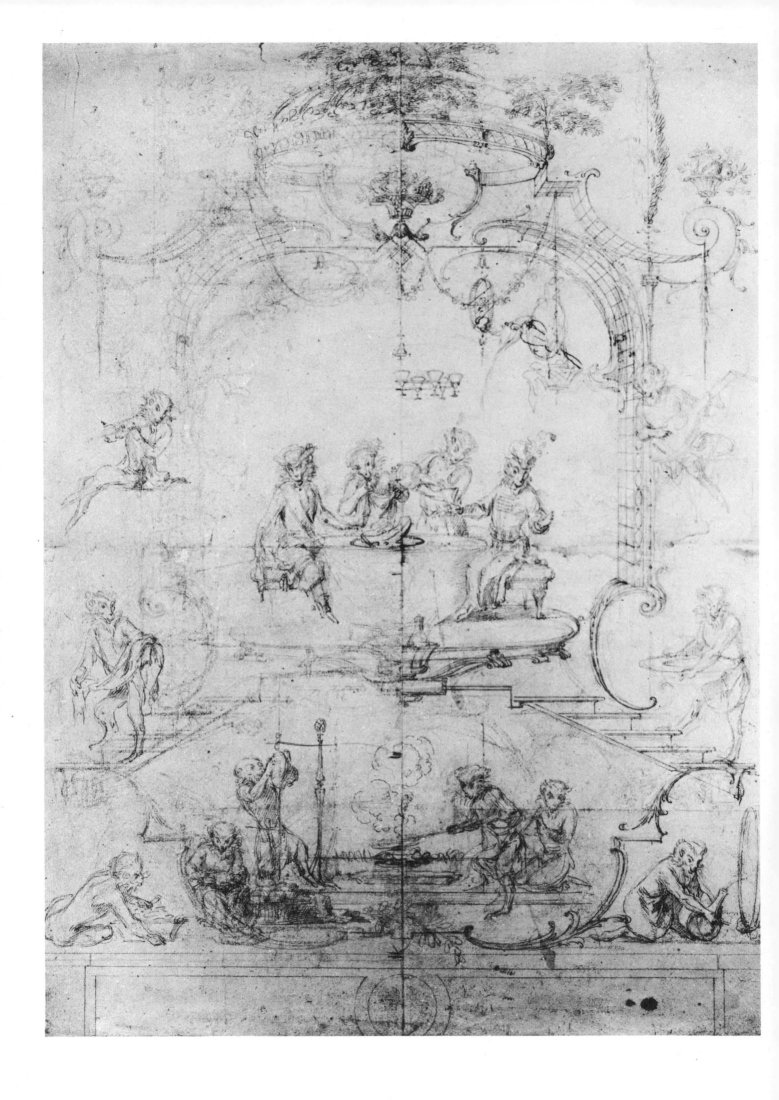

Plate 6

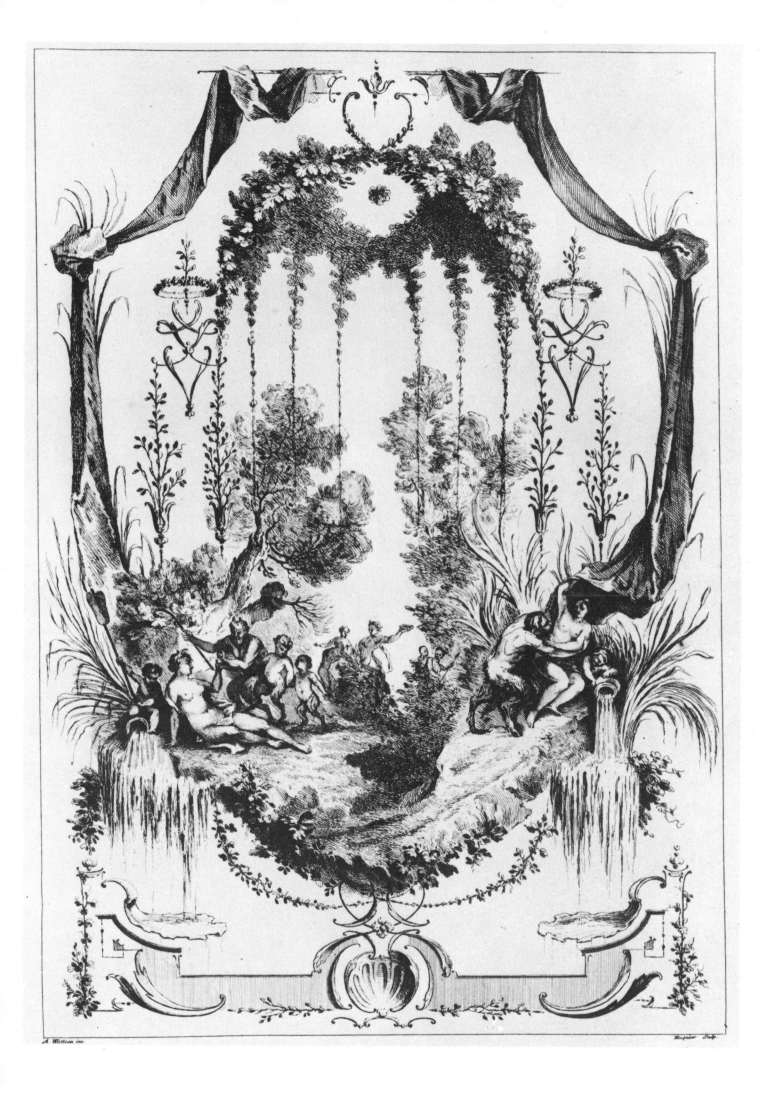

A. Watteau inv. Berquier Sculp.

Plate 7

Plate 8

Plate 9

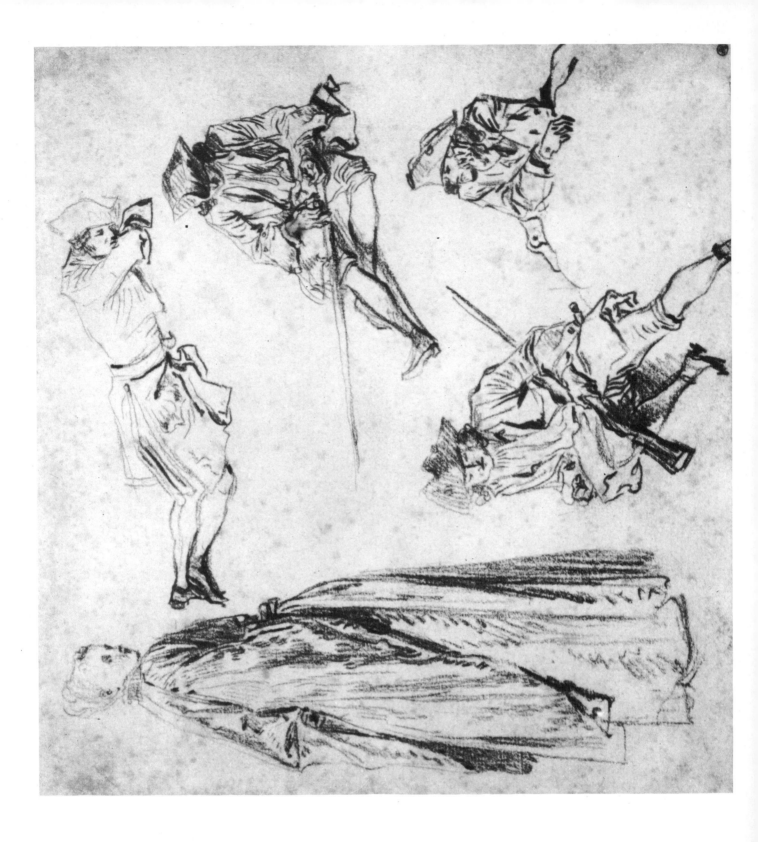

Plate 10

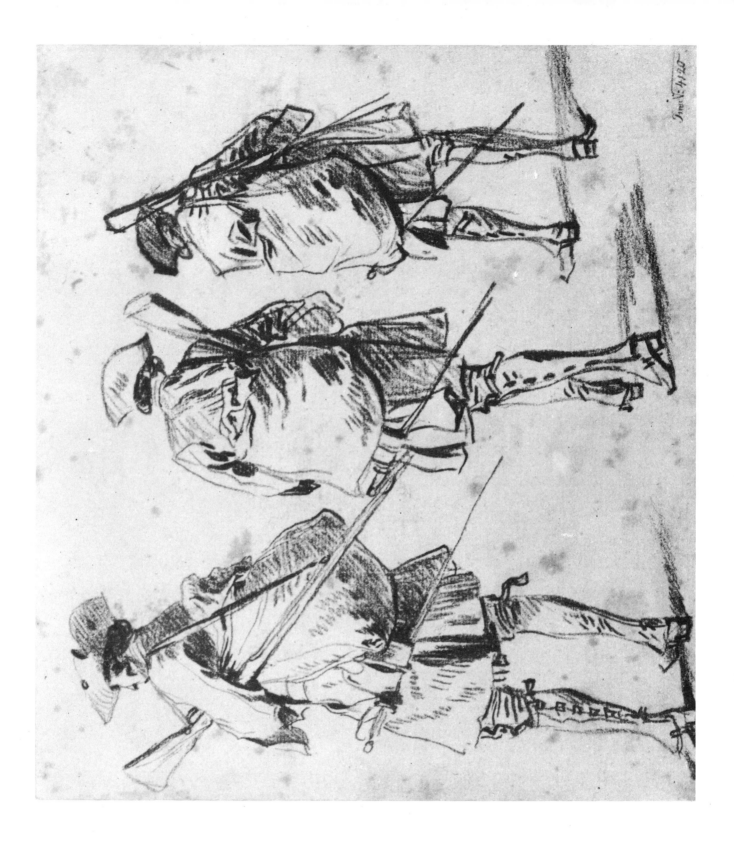

Plate 11

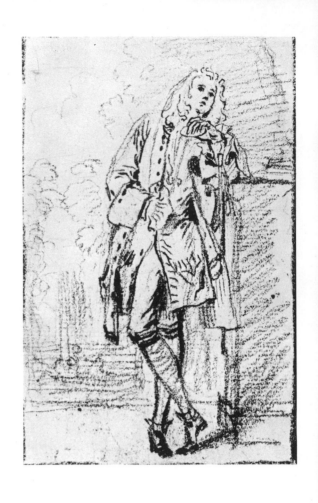

Plate 12

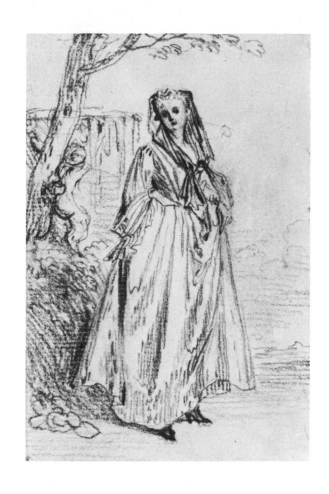

Plate 13

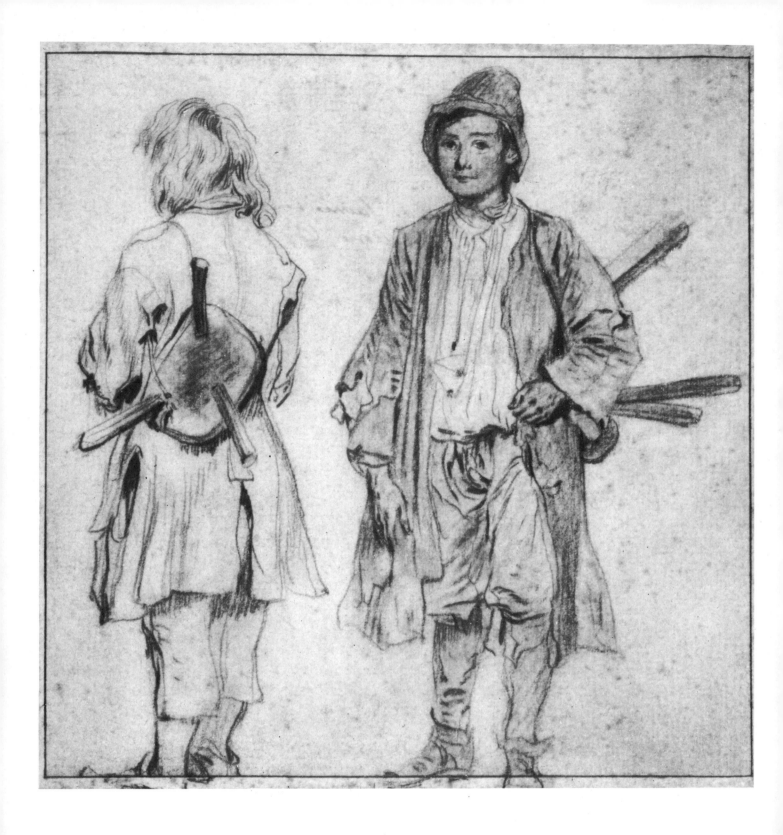

Plate 14

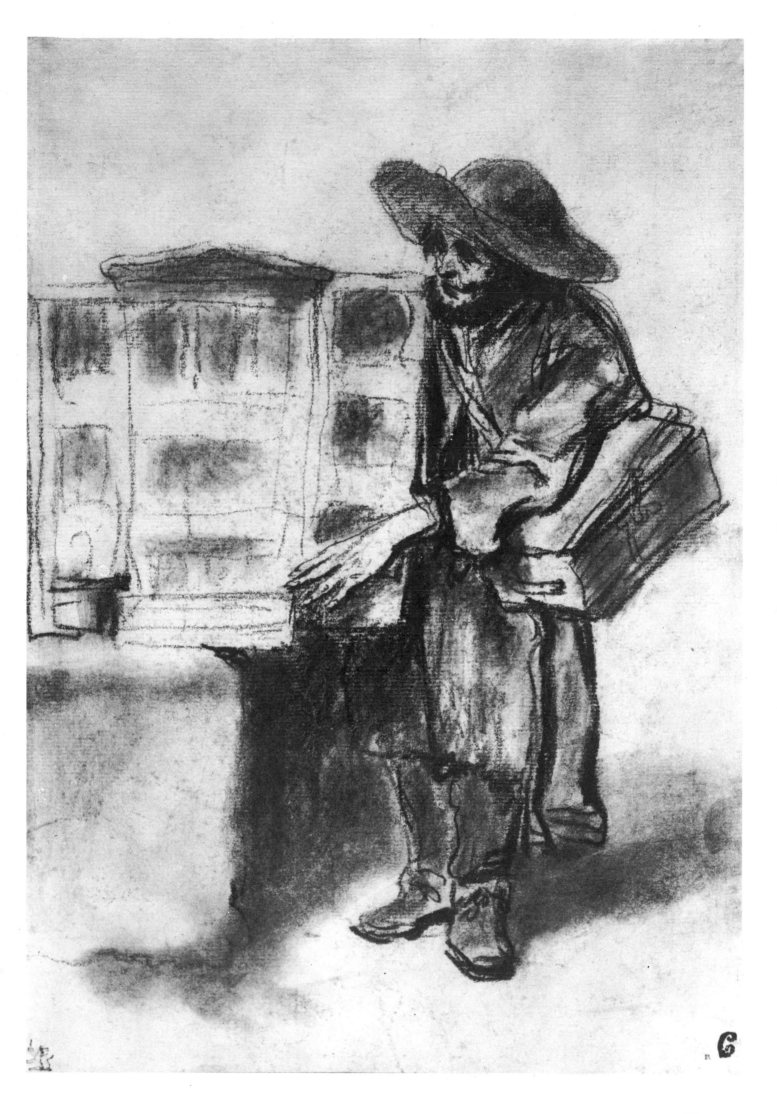

Plate 15

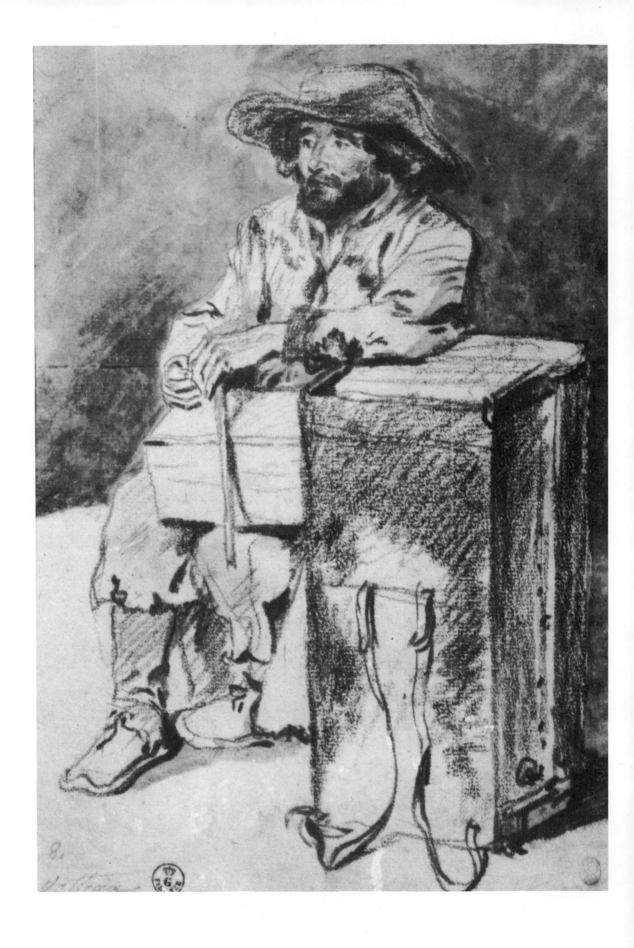

Plate 16

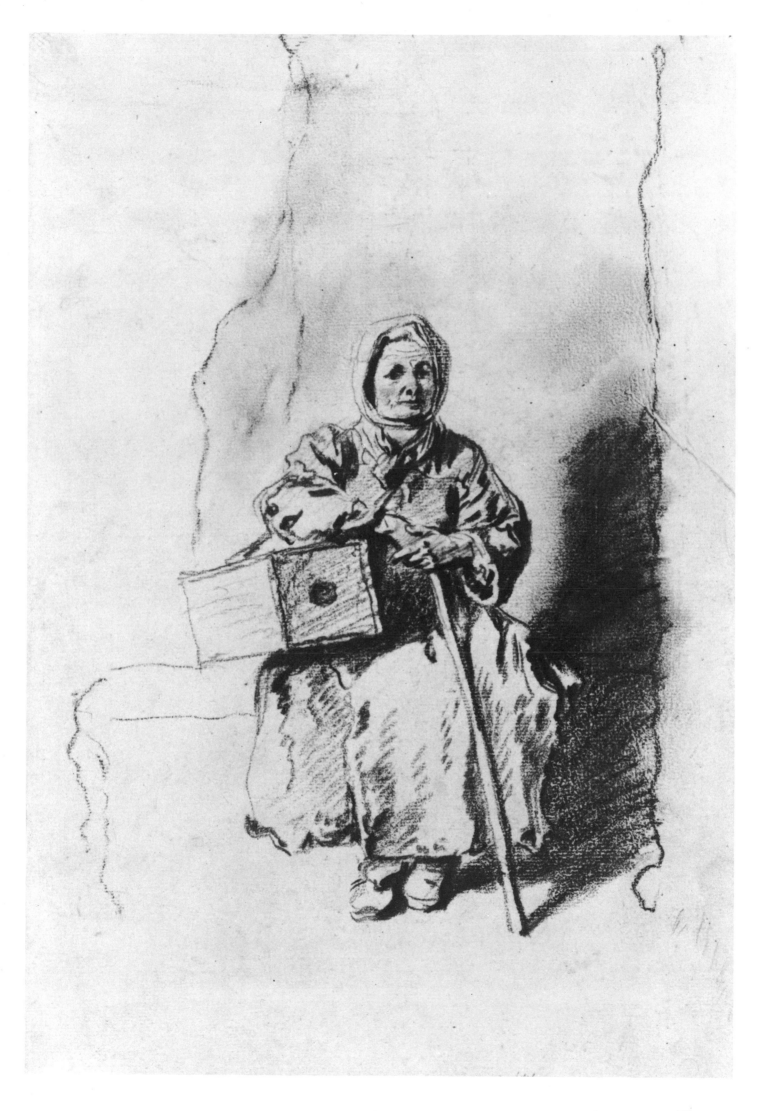

Plate 17

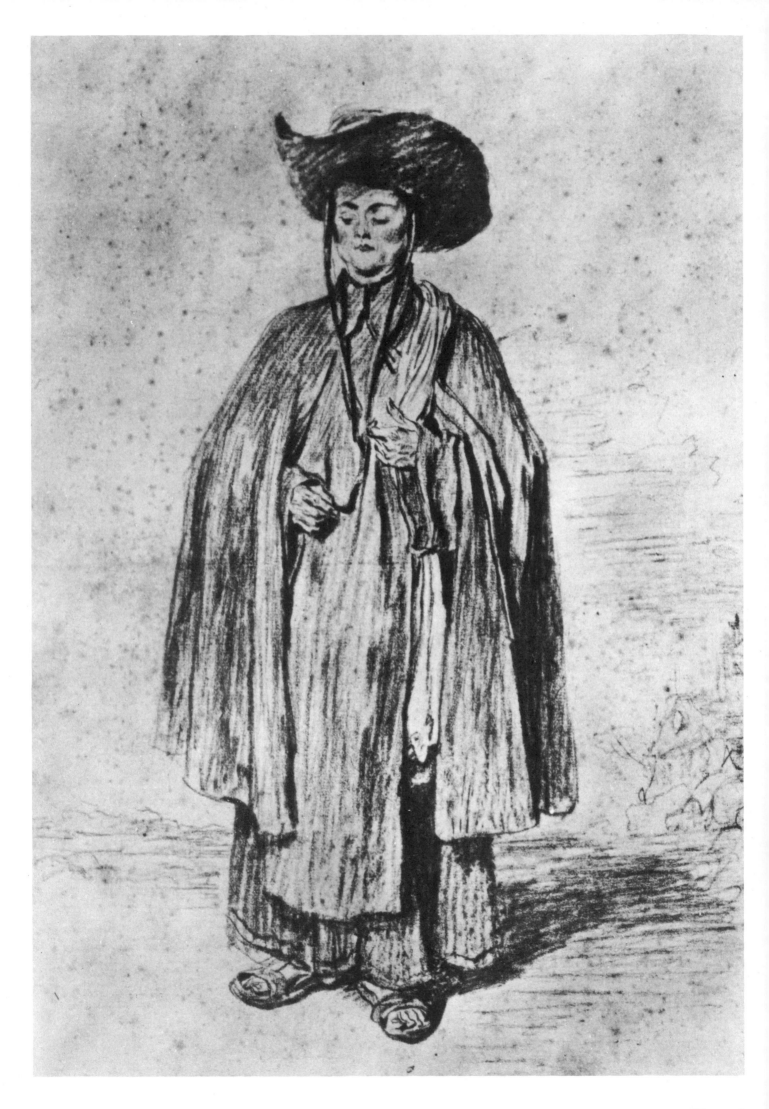

Plate 18

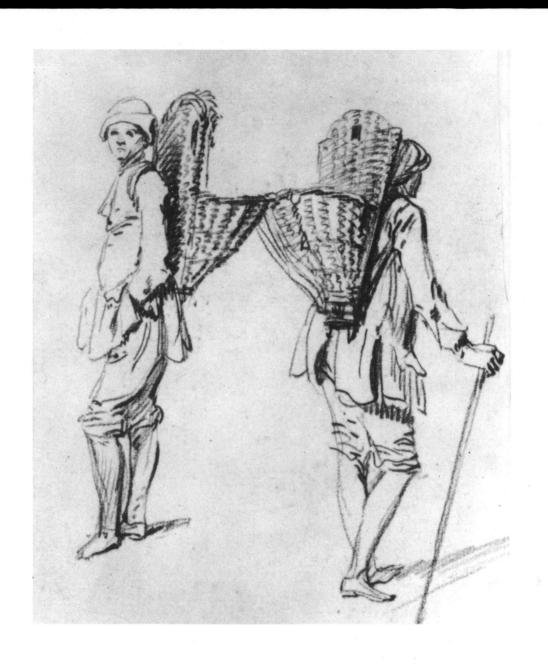

Plate 19

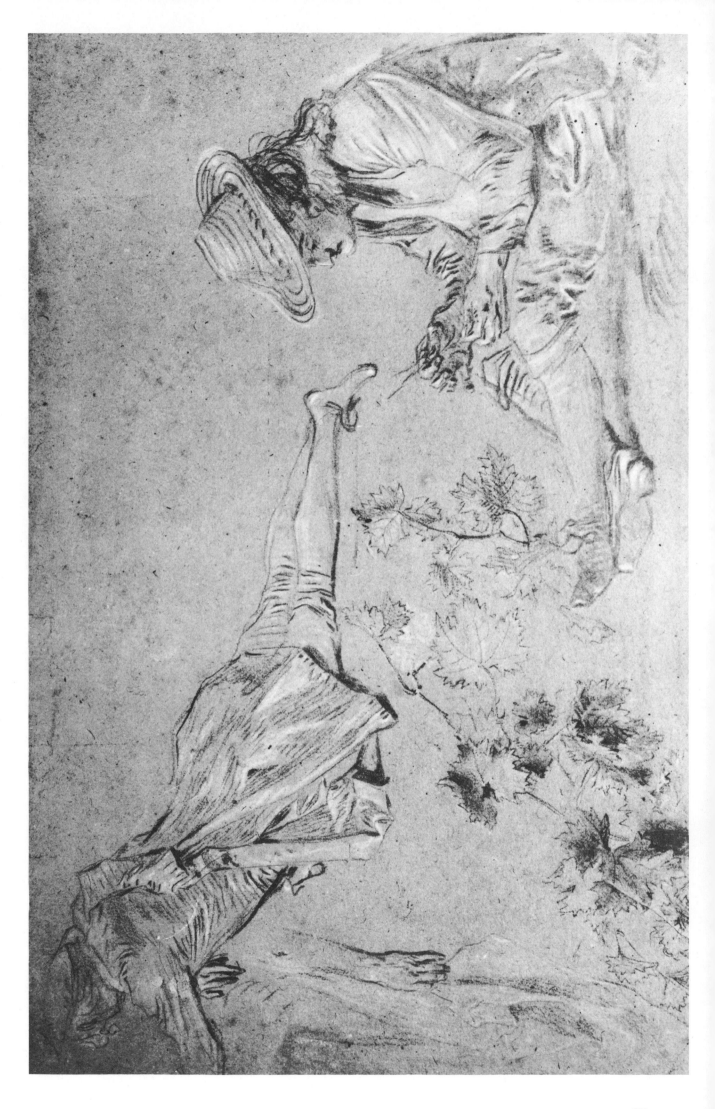

Plate 20

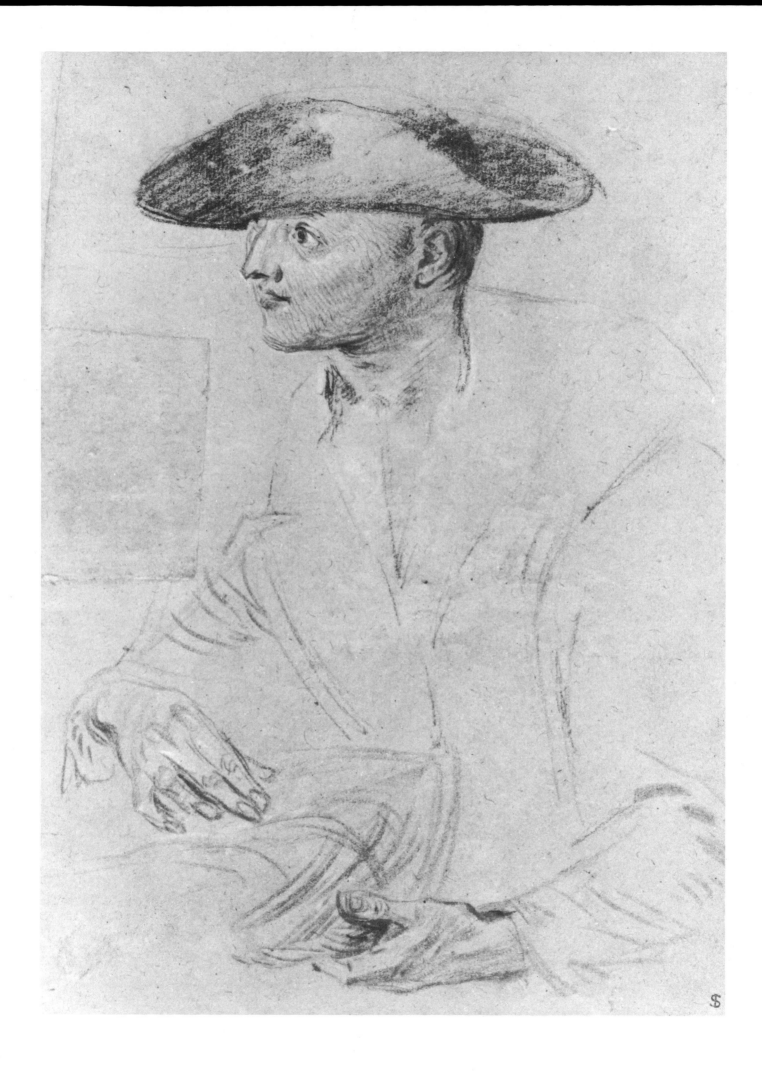

Plate 21

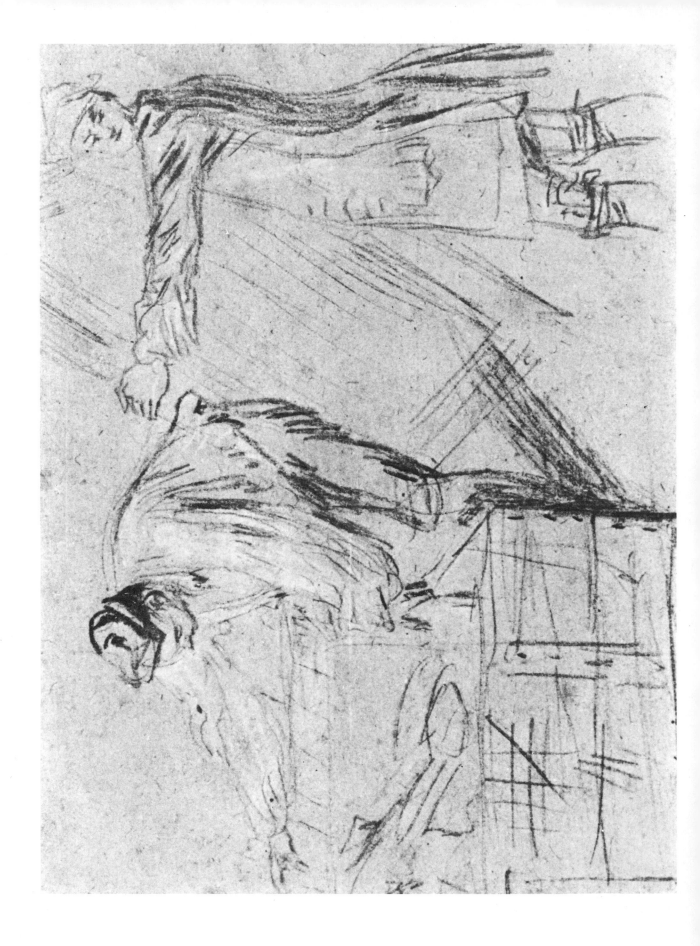

Plate 22

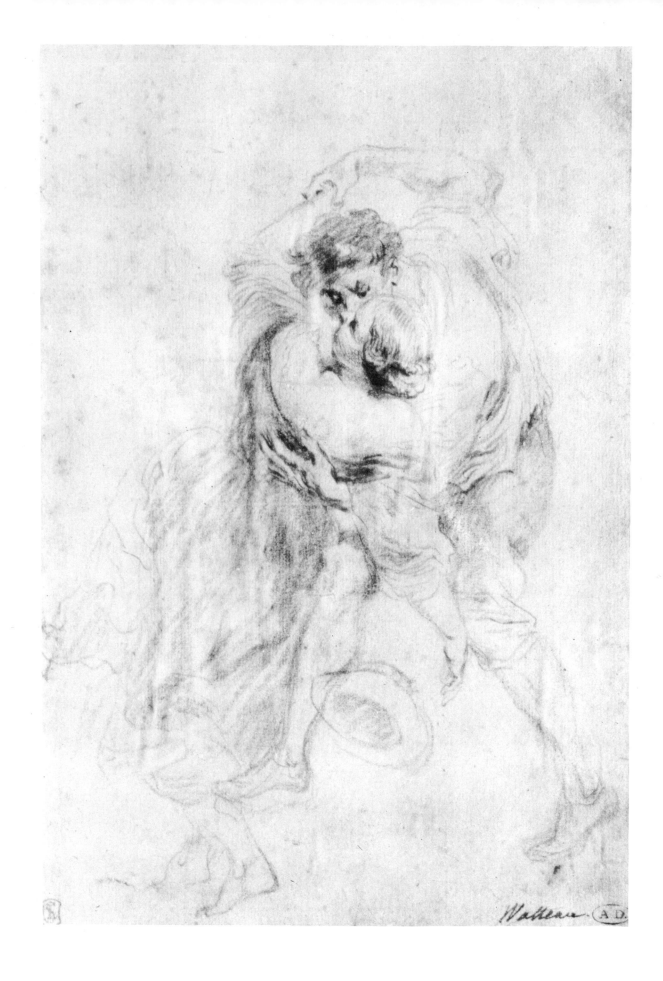

Plate 23

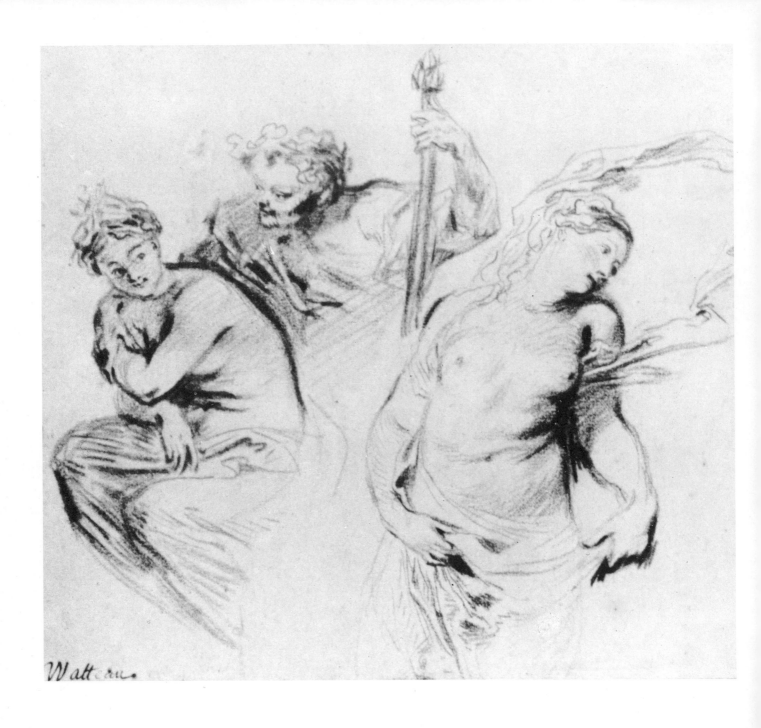

Watteau.

Plate 24

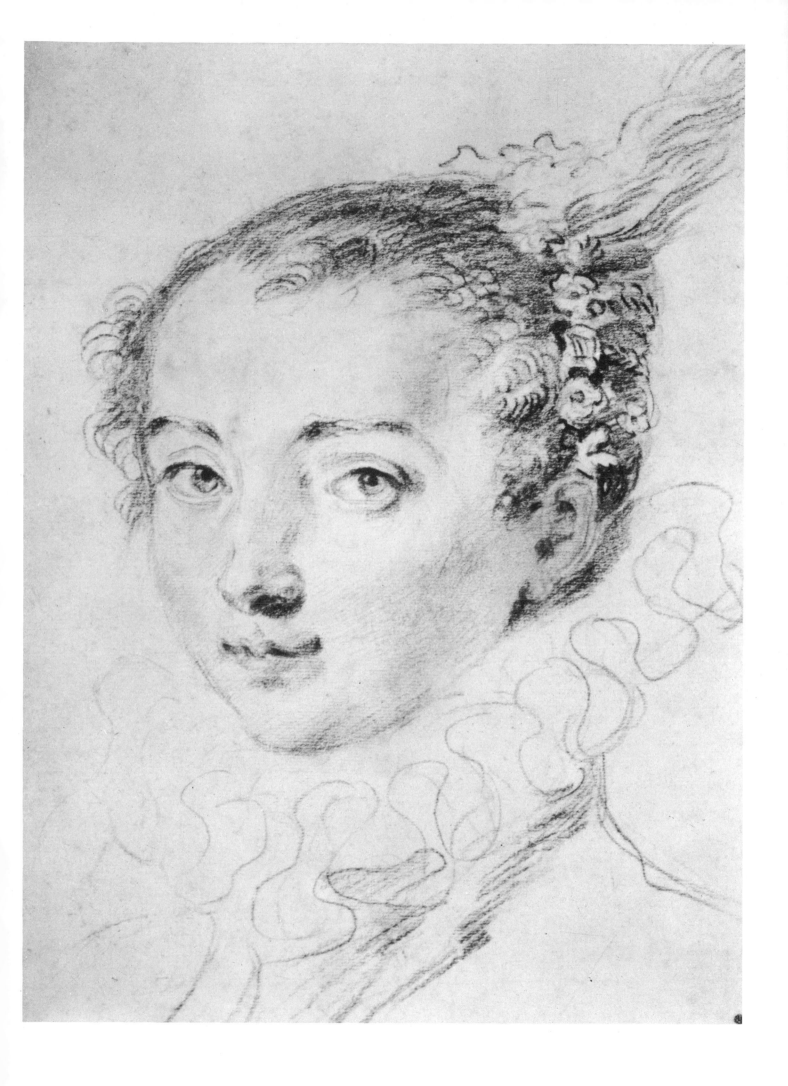

Plate 25

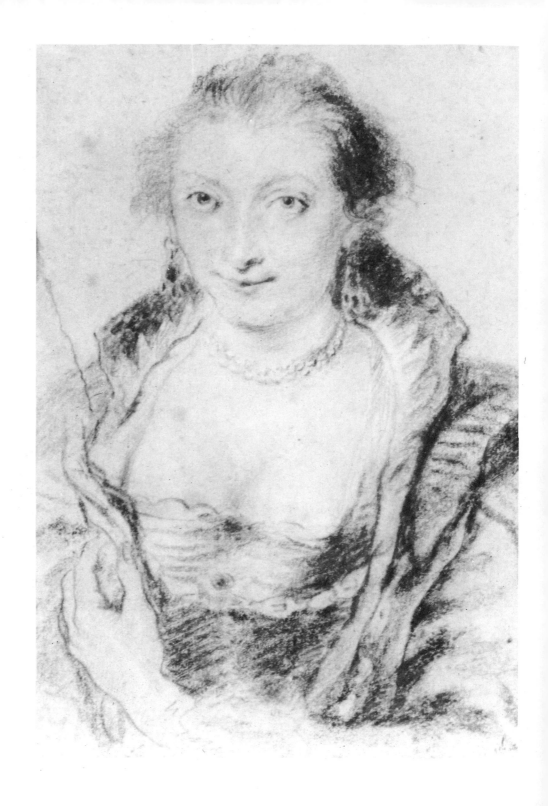

Plate 26

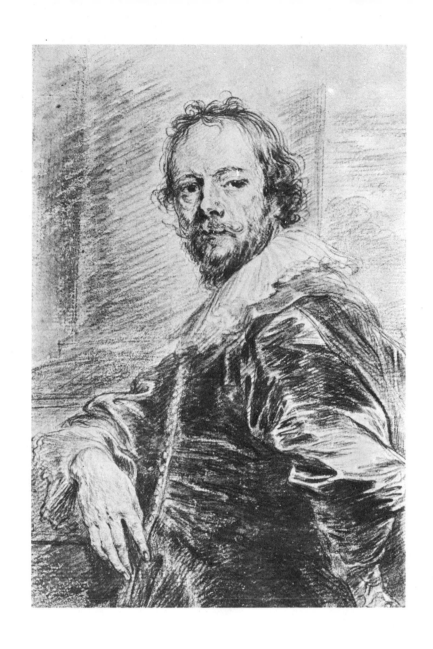

Plate 27

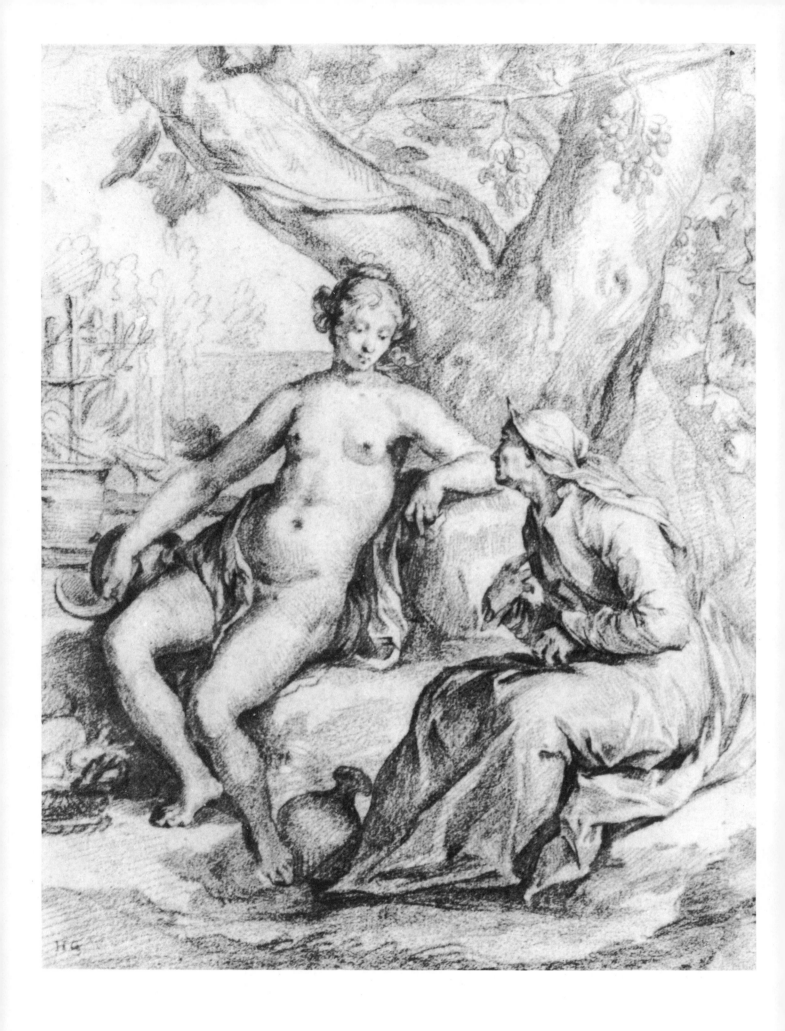

Plate 28

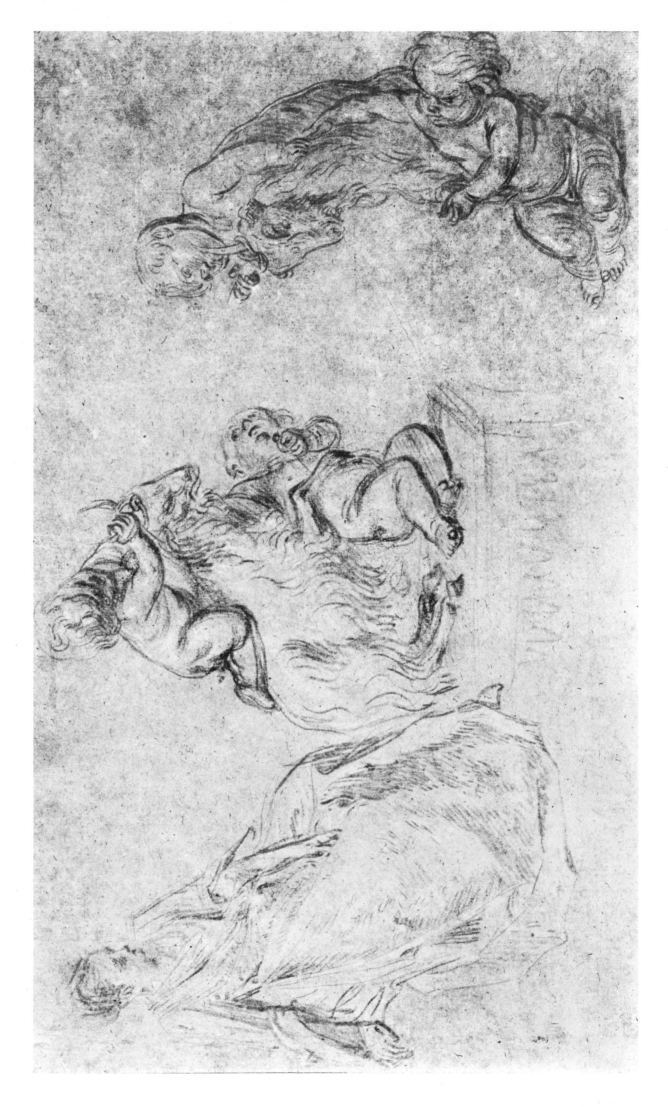

Plate 29

Plate 30

Plate 31

VATAX

Plate 32

Plate 33

Plate 34

Plate 35

Plate 36

Plate 37

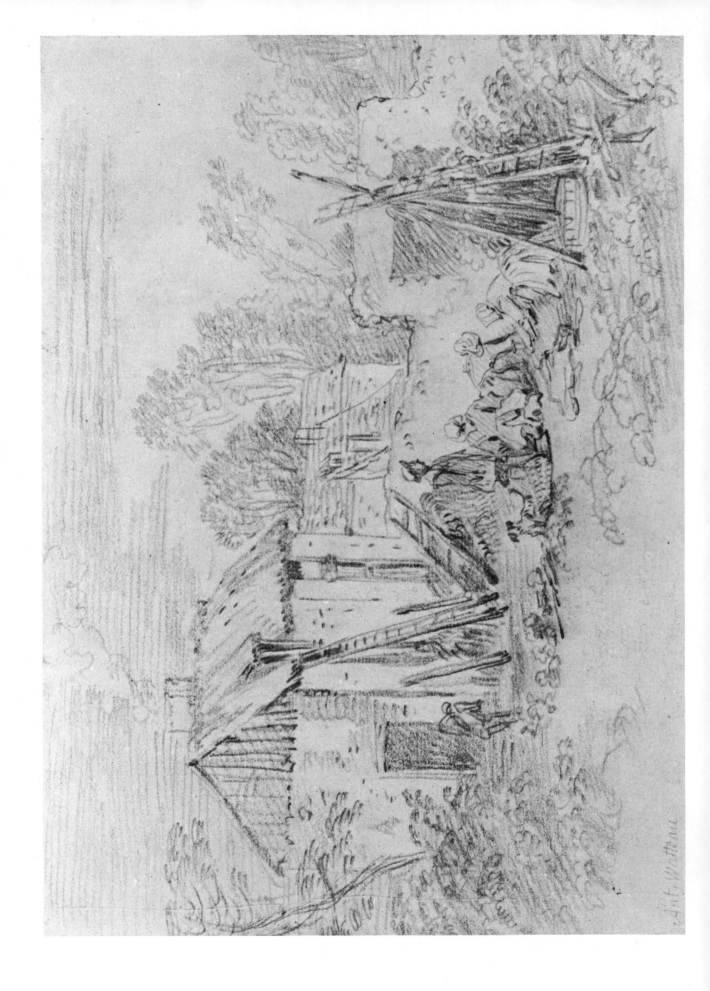

Plate 38

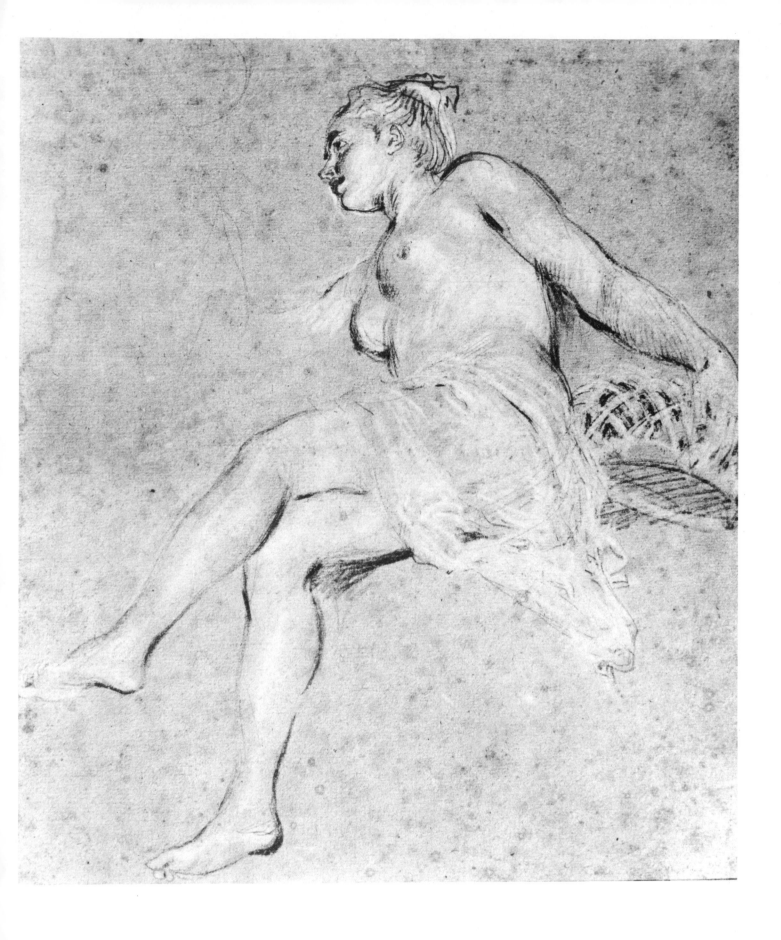

Plate 39

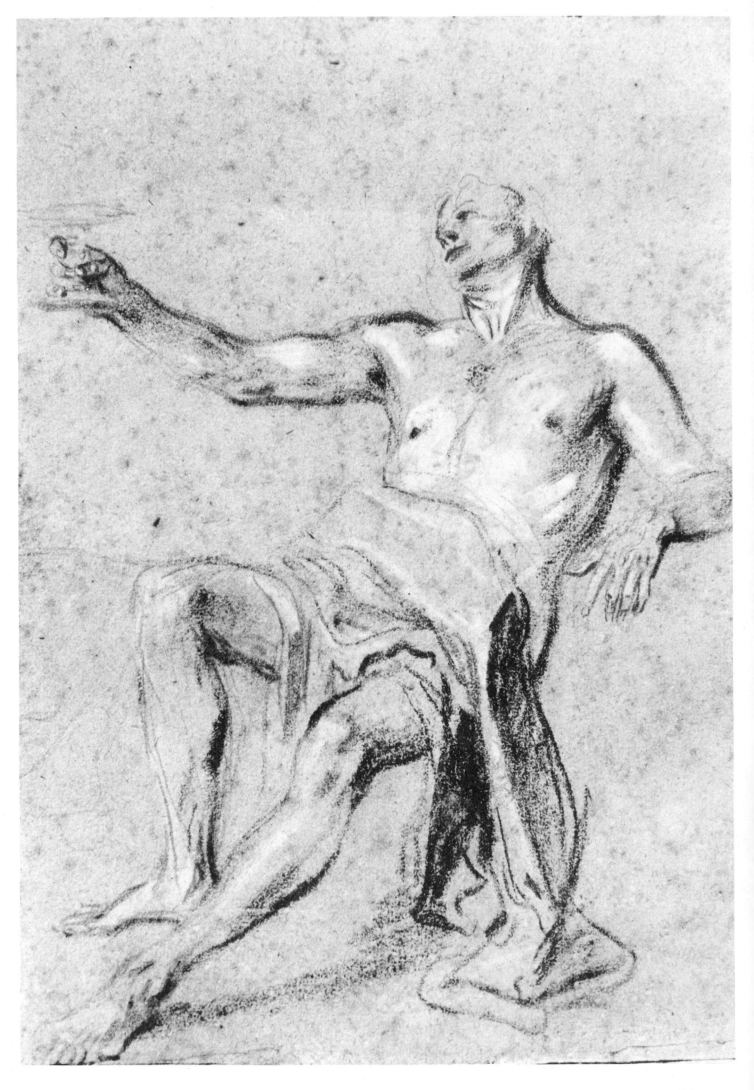

Plate 40

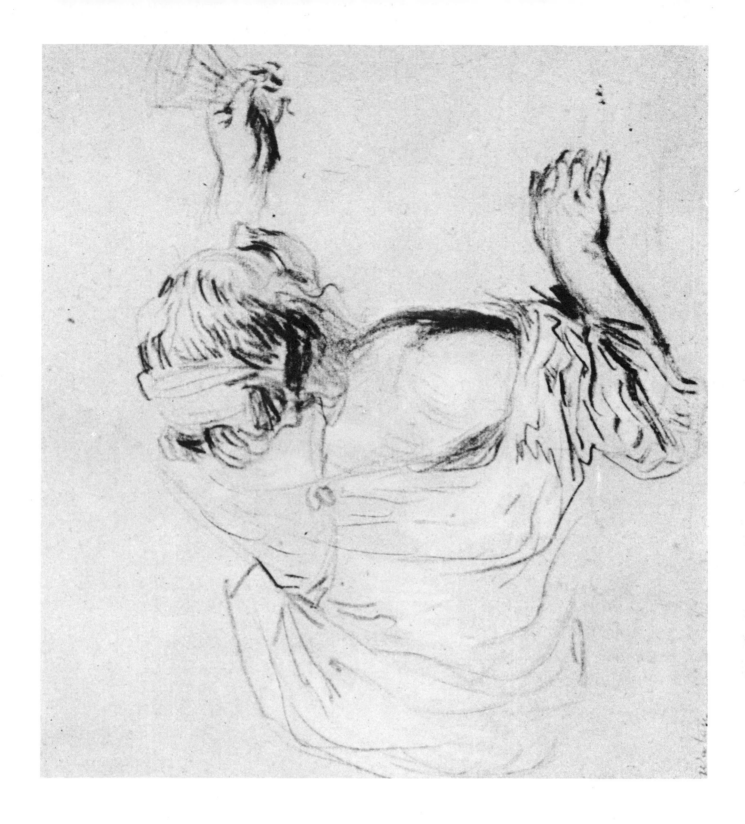

Plate 41

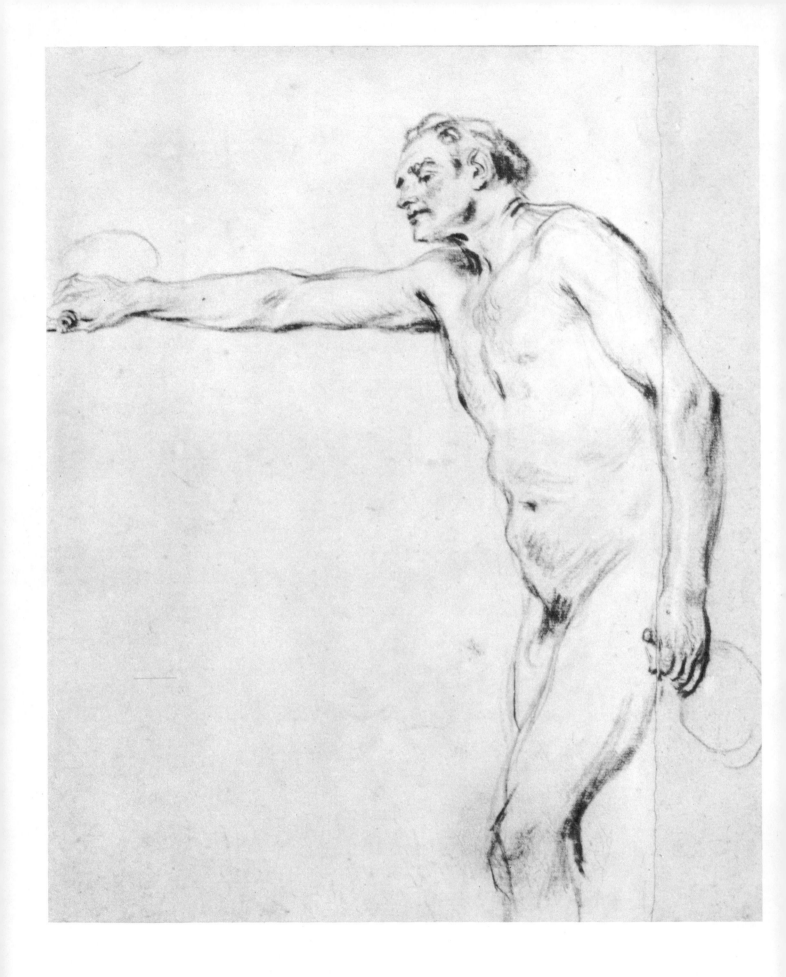

Plate 42

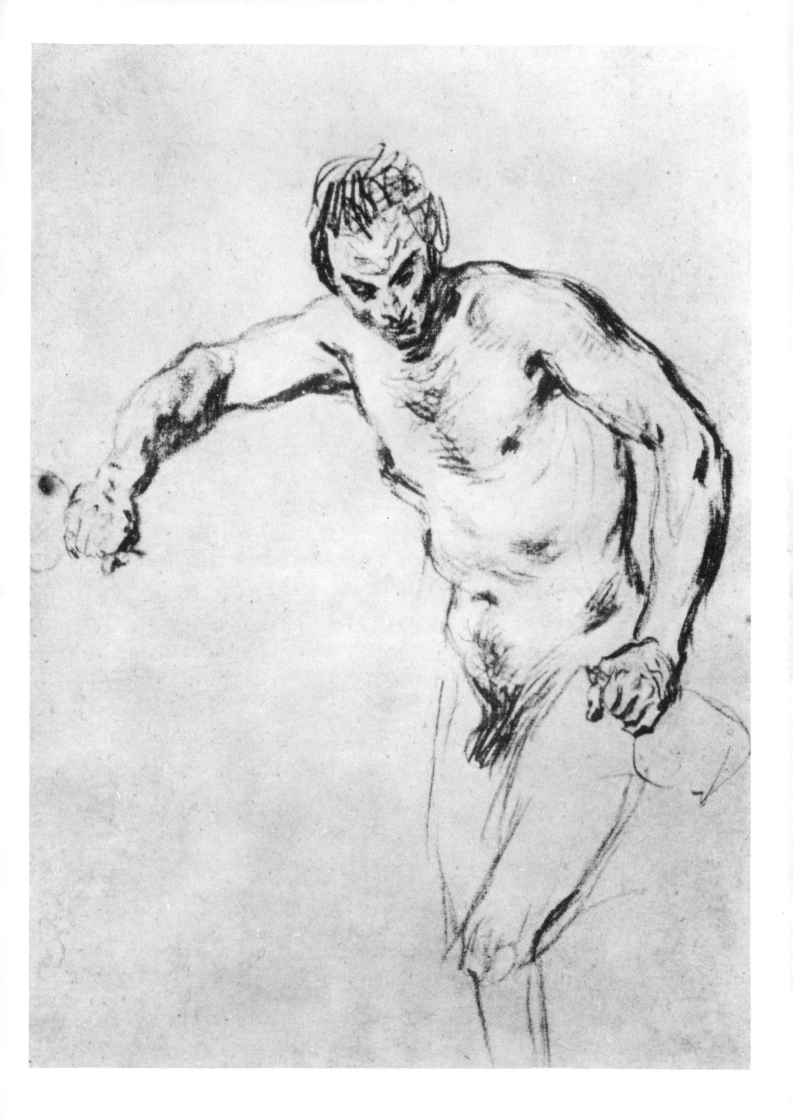

Plate 43

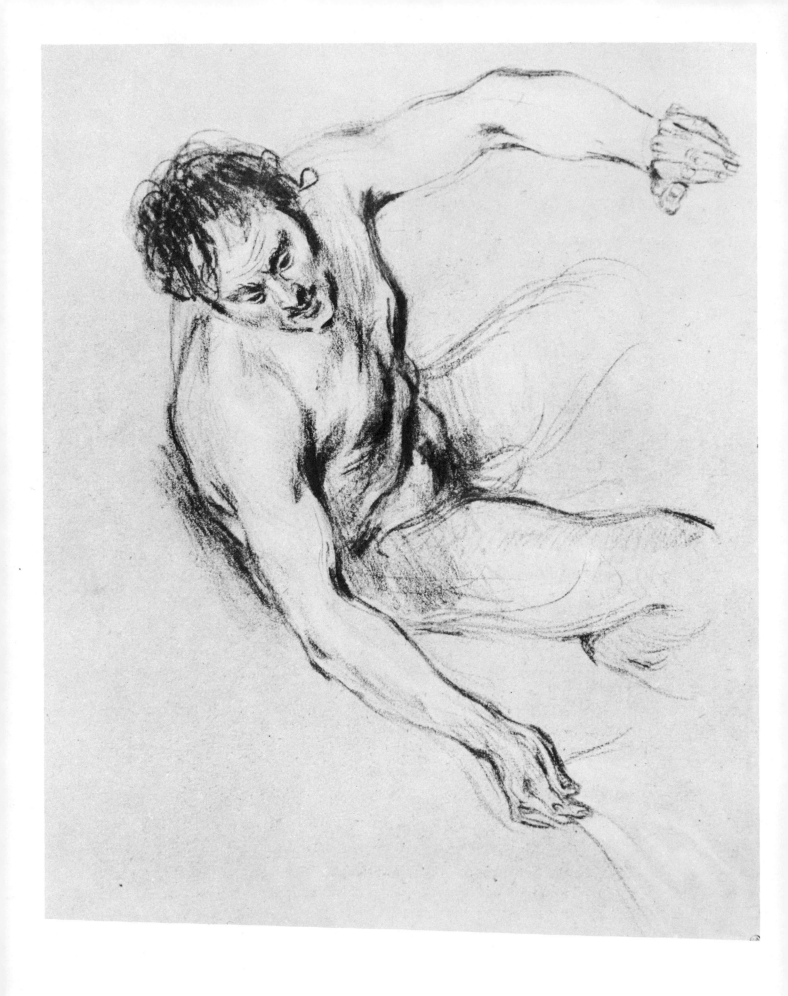

Plate 44

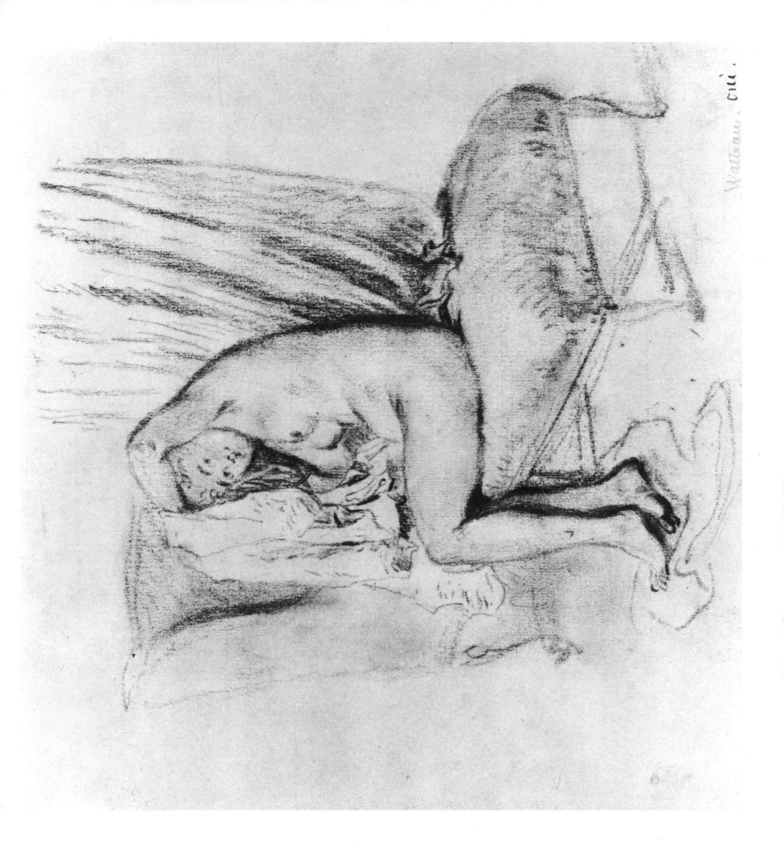

Plate 45

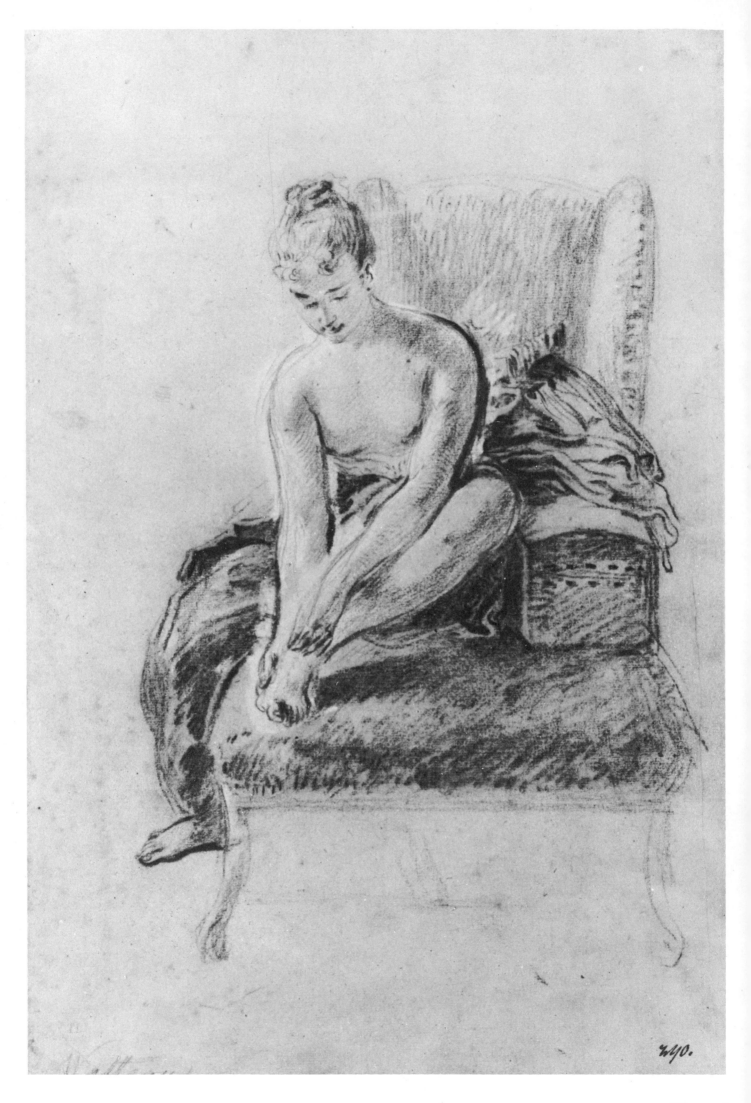

Plate 46

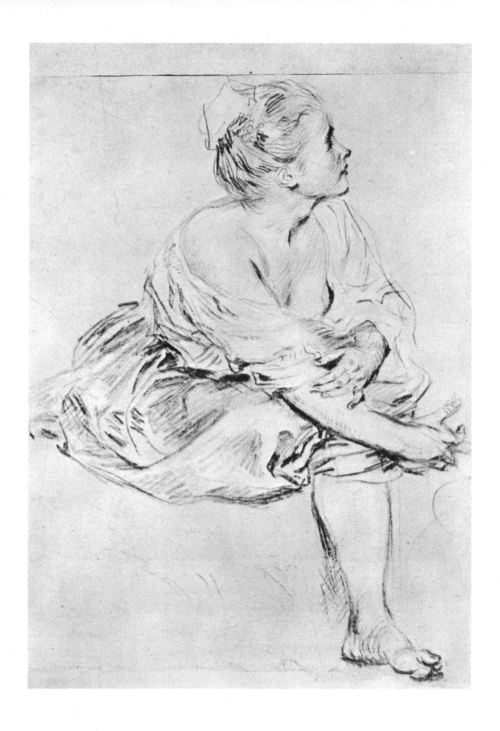

Plate 47

Plate 48

Plate 49

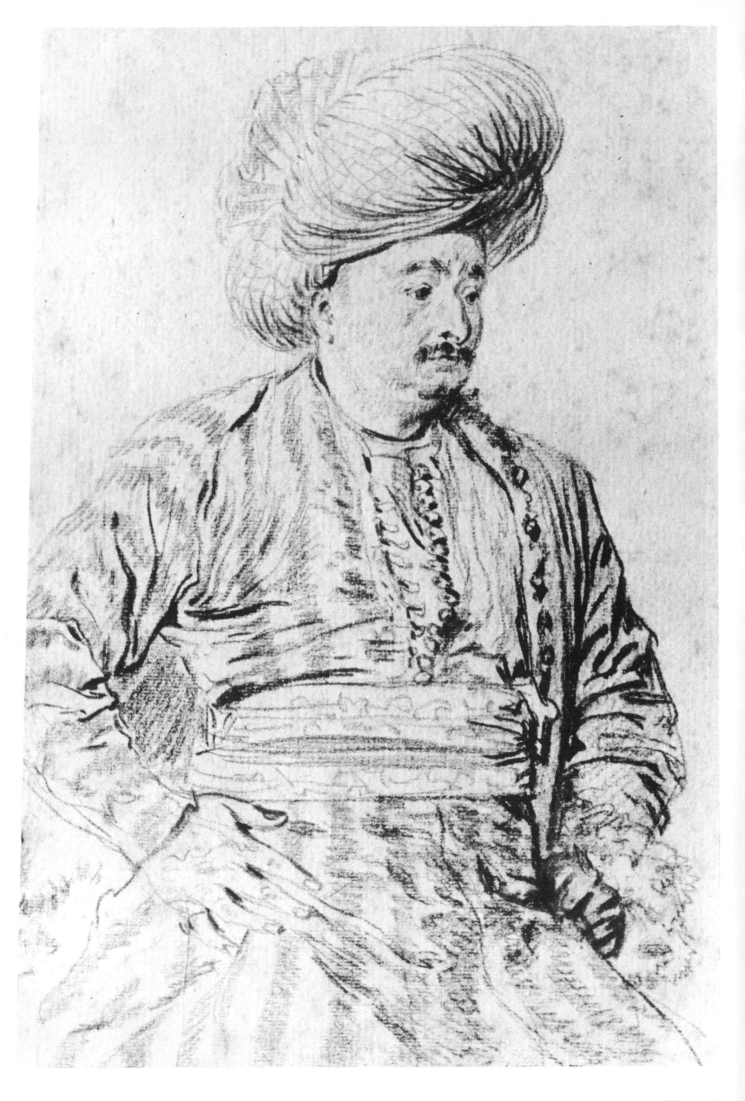

Plate 50

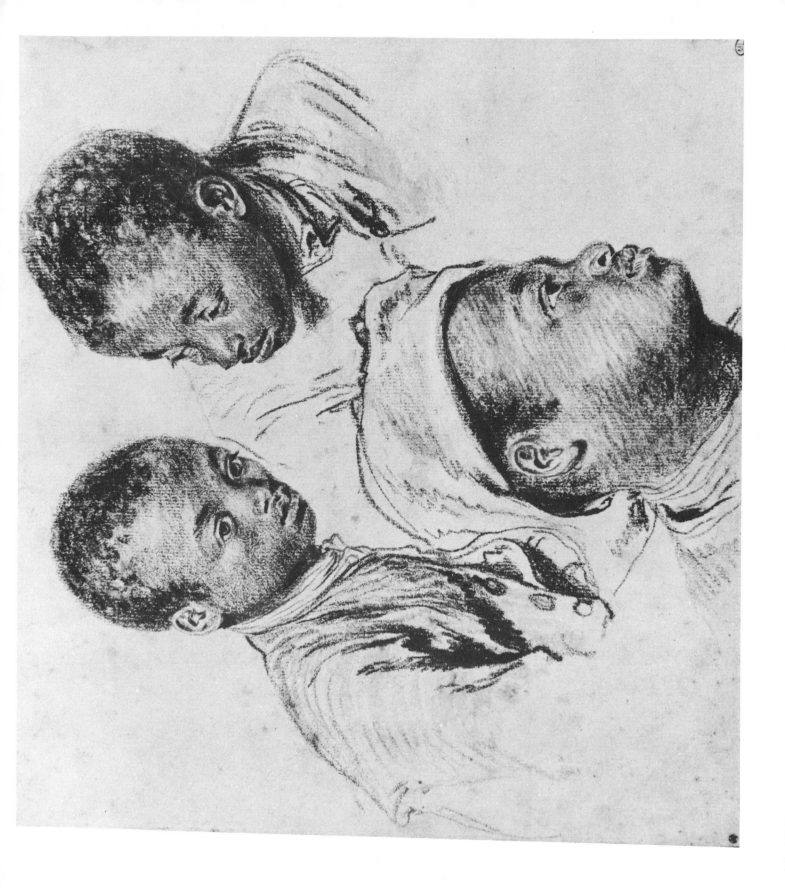

Plate 51

Plate 52

Plate 53

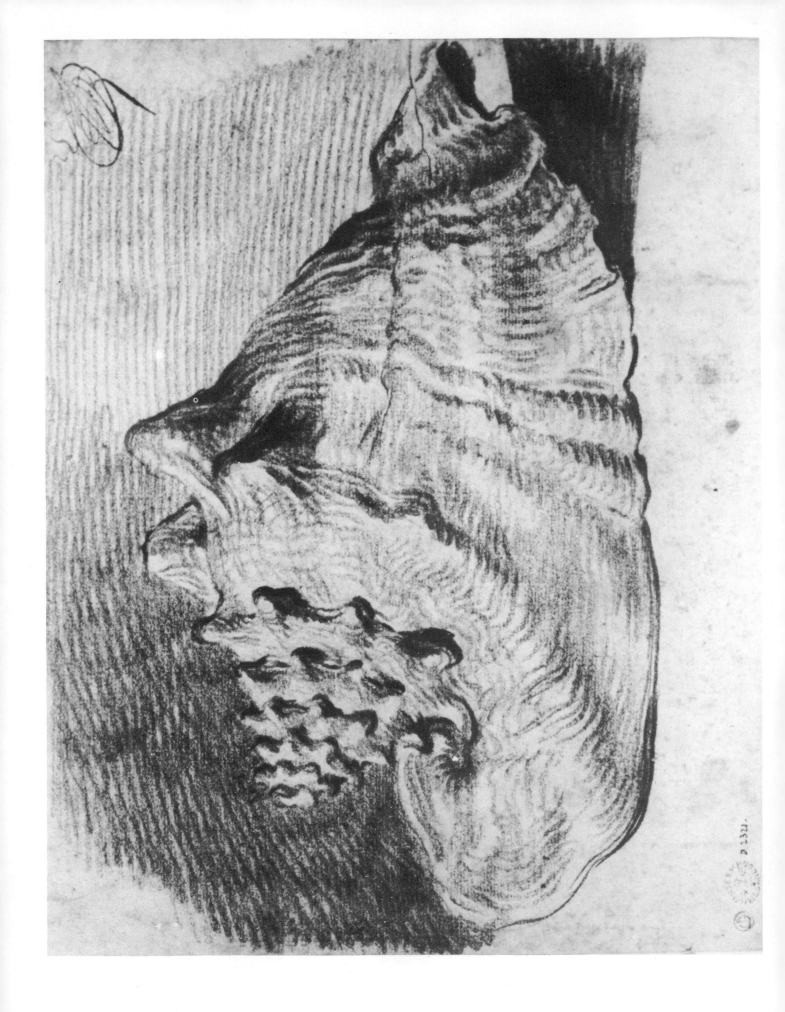

Plate 54

Plate 55

Plate 56

Plate 57

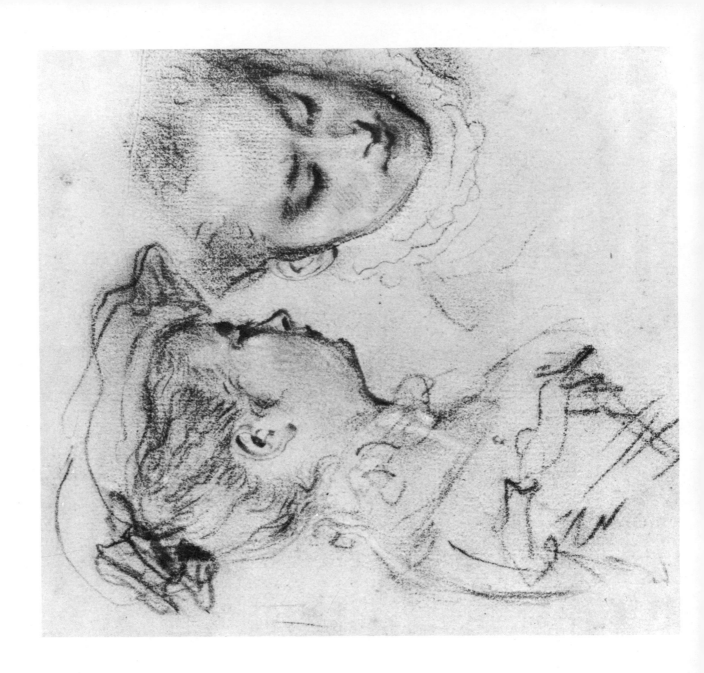

Plate 58

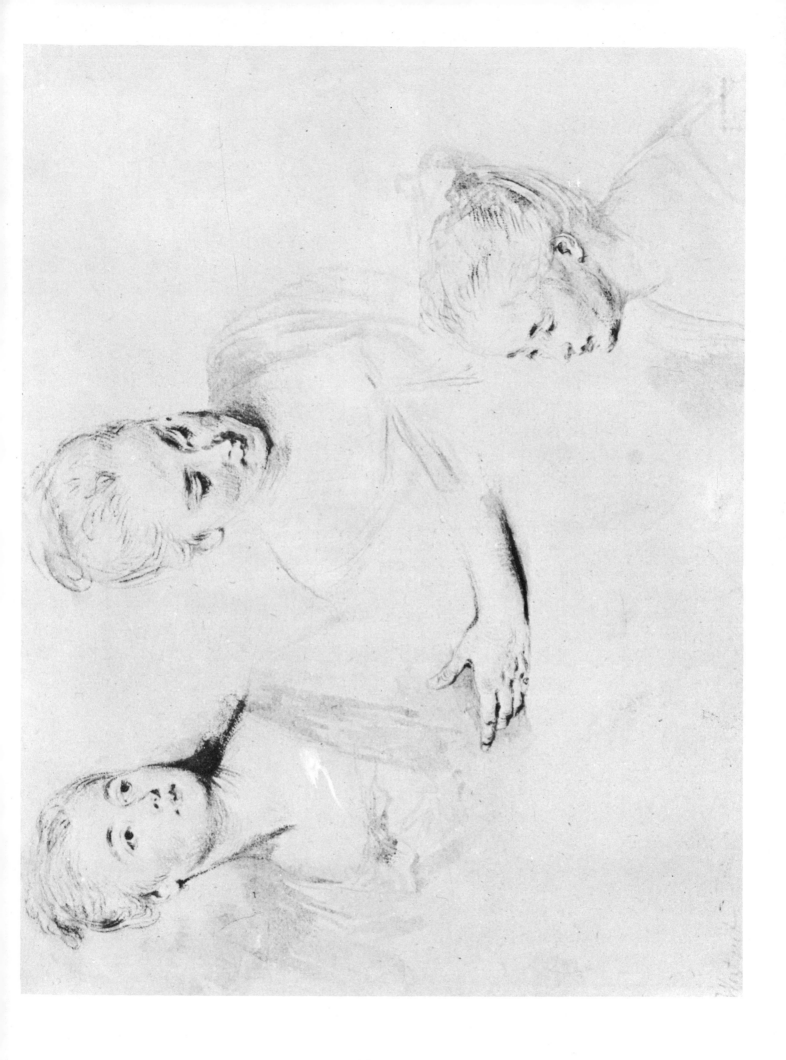

Plate 59

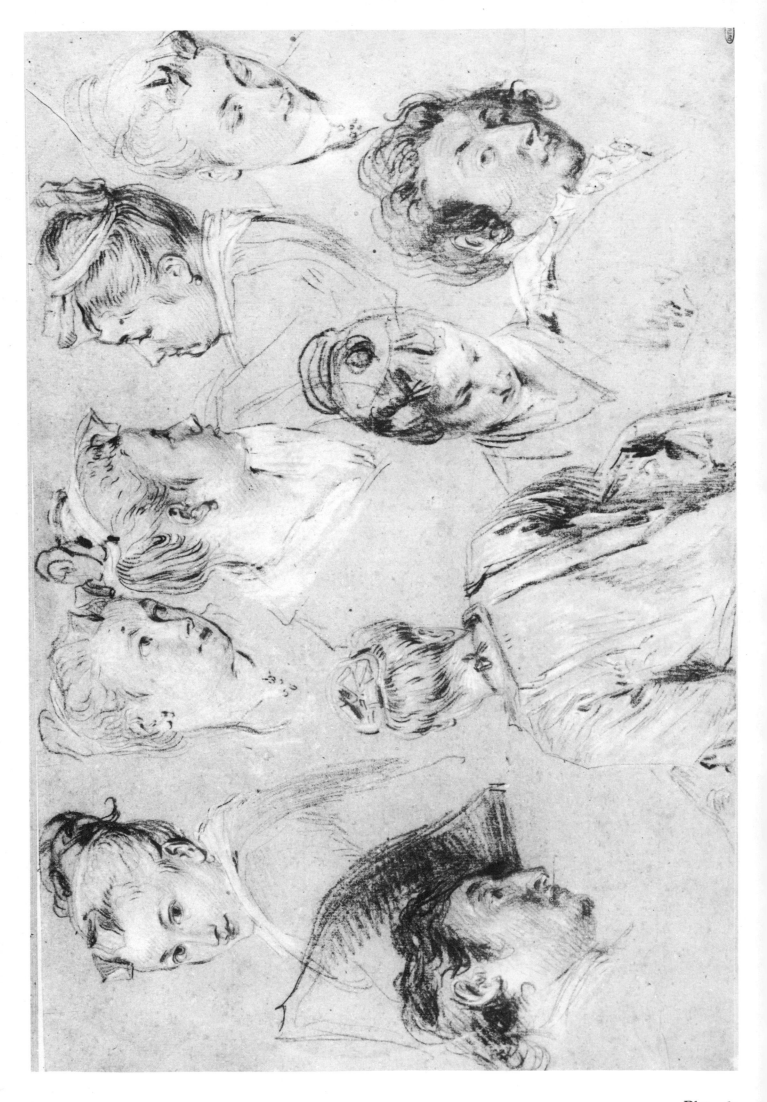

Plate 60

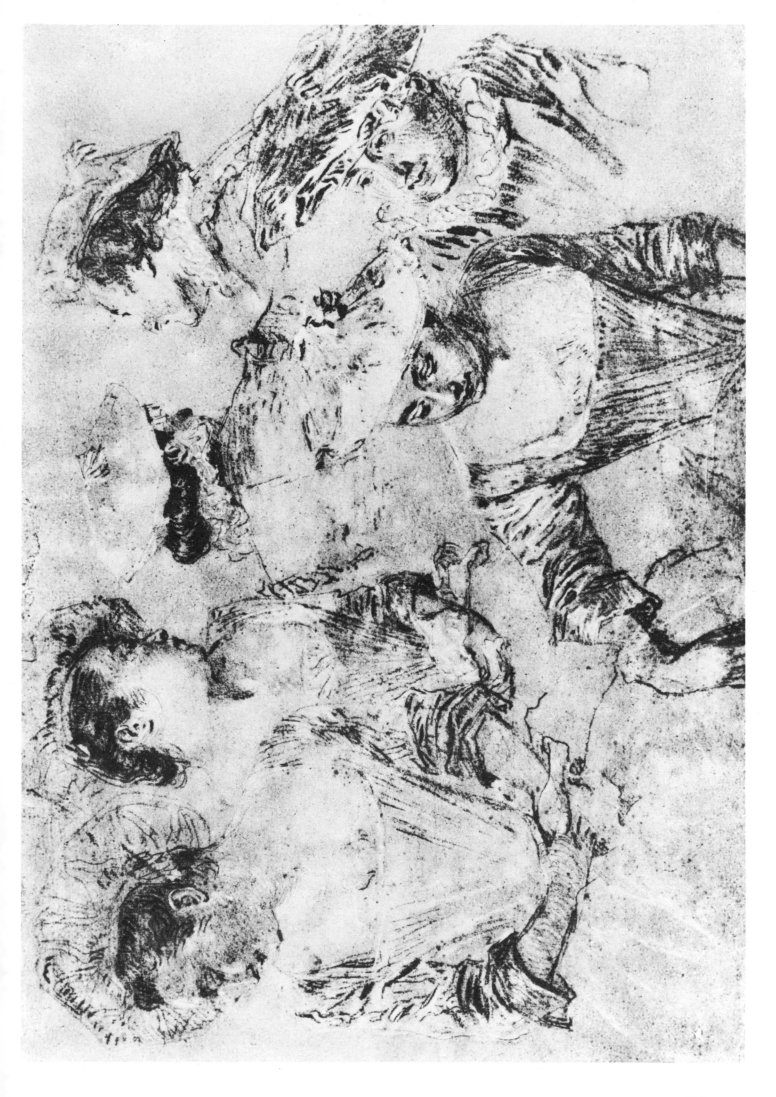

Plate 61

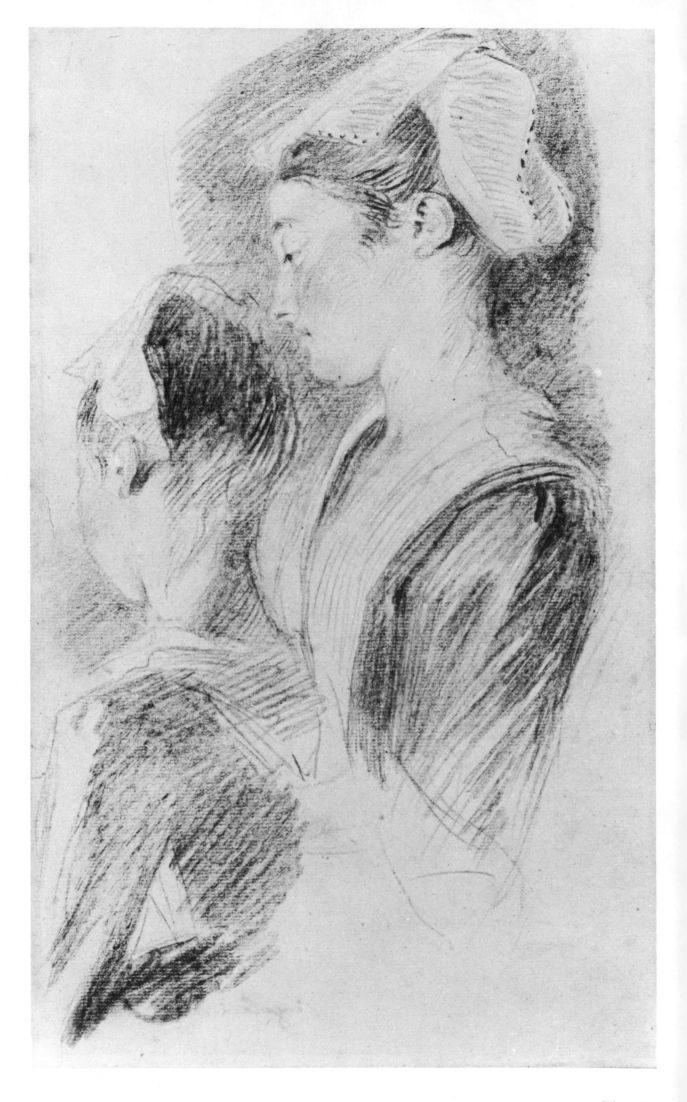

Plate 62

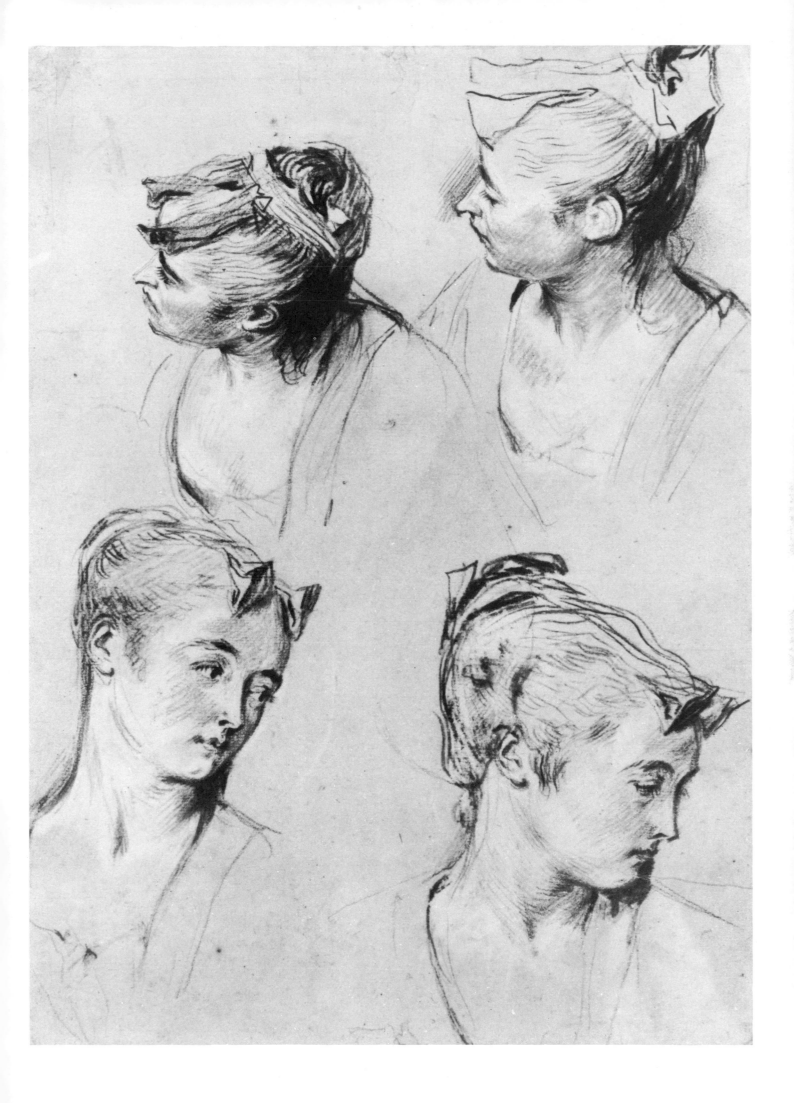

Plate 63

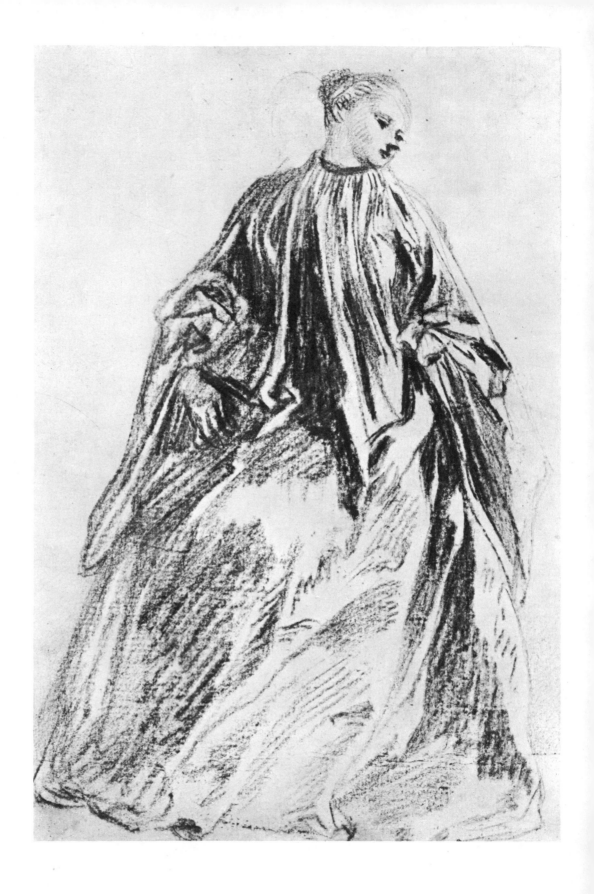

Plate 64

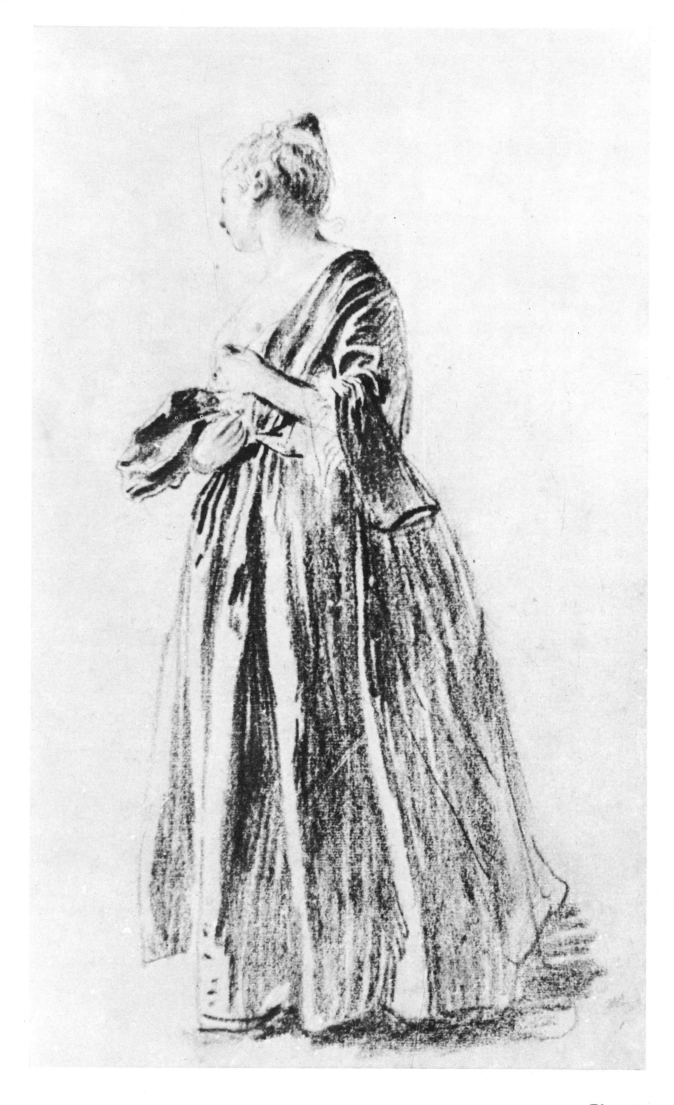

Plate 65

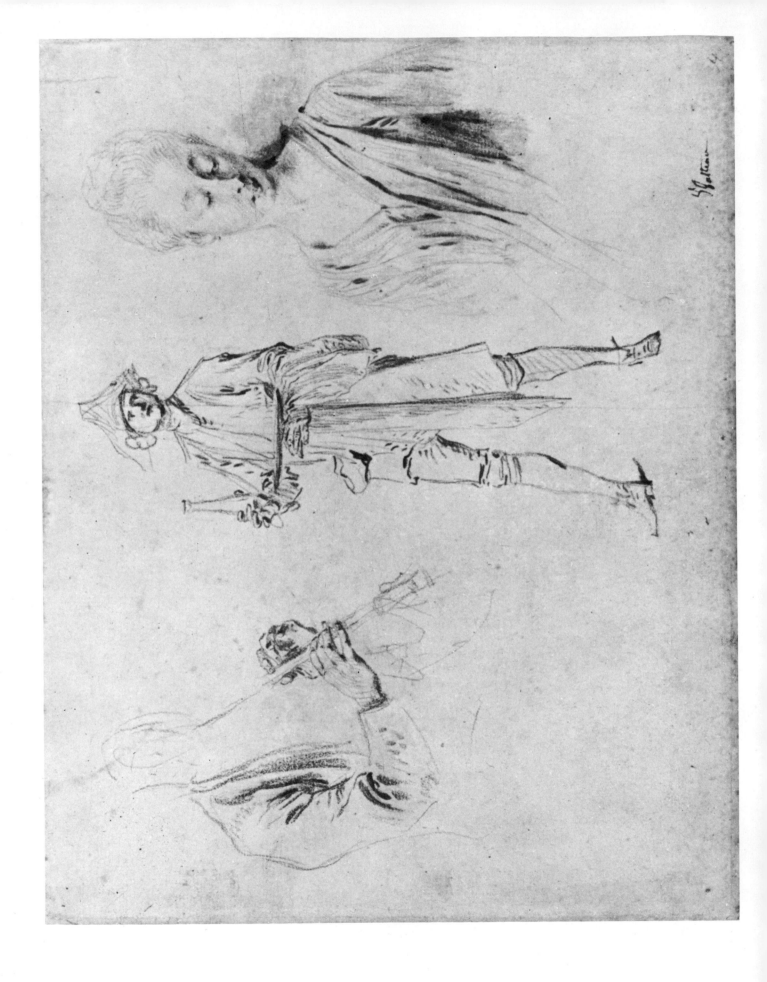

Plate 66

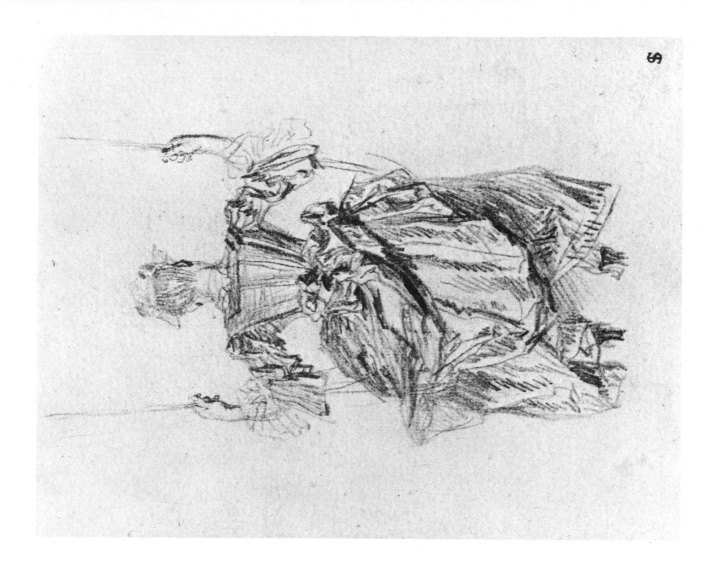

Plate 67

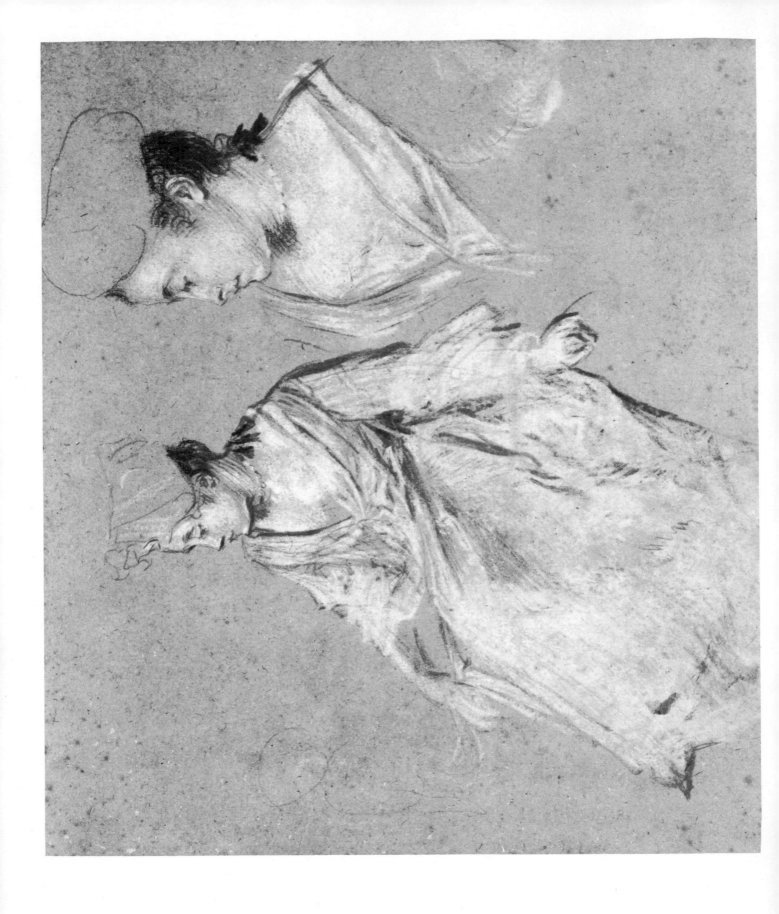

Plate 68

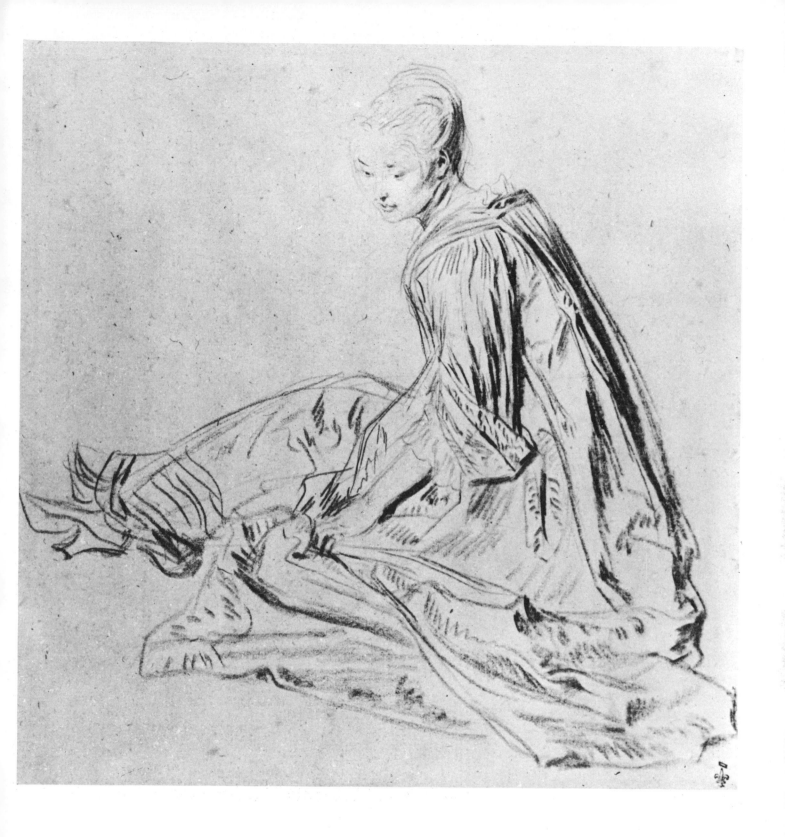

Plate 69

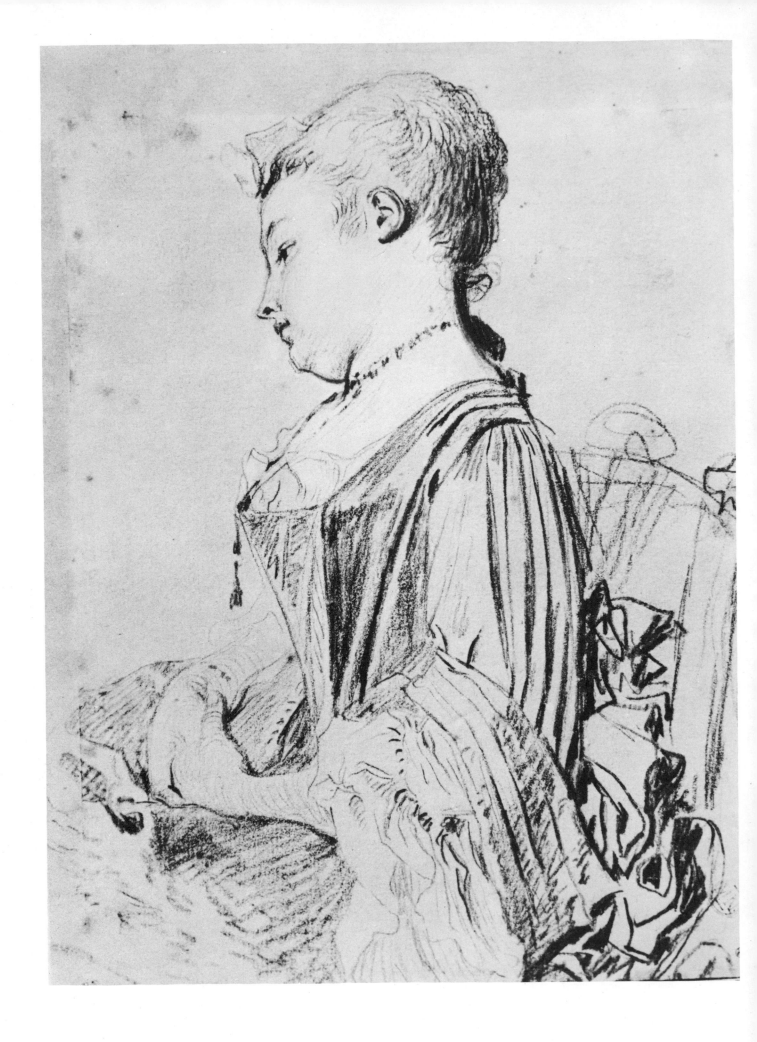

Plate 70

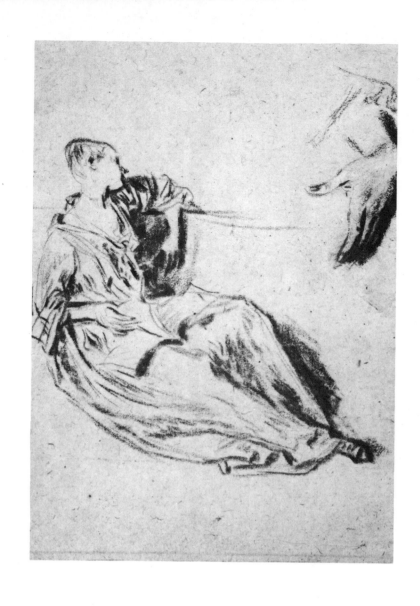

Plate 71

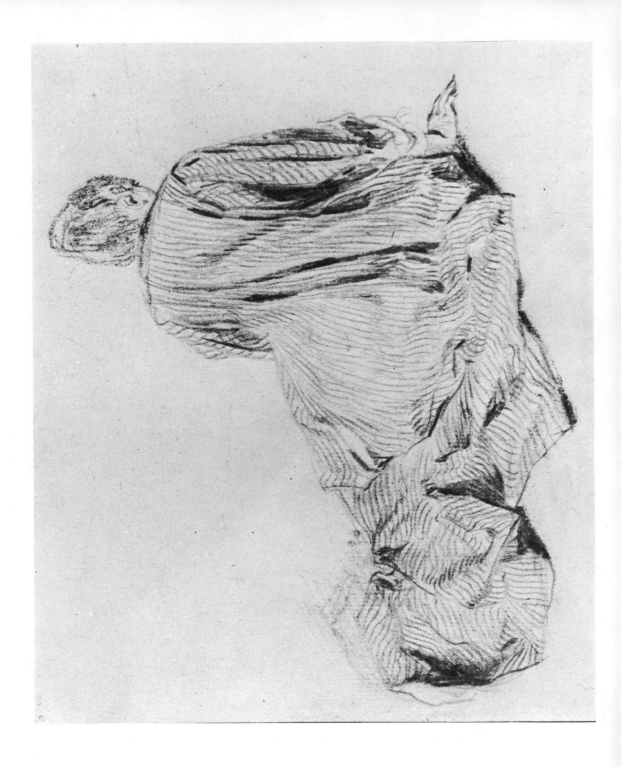

Plate 72

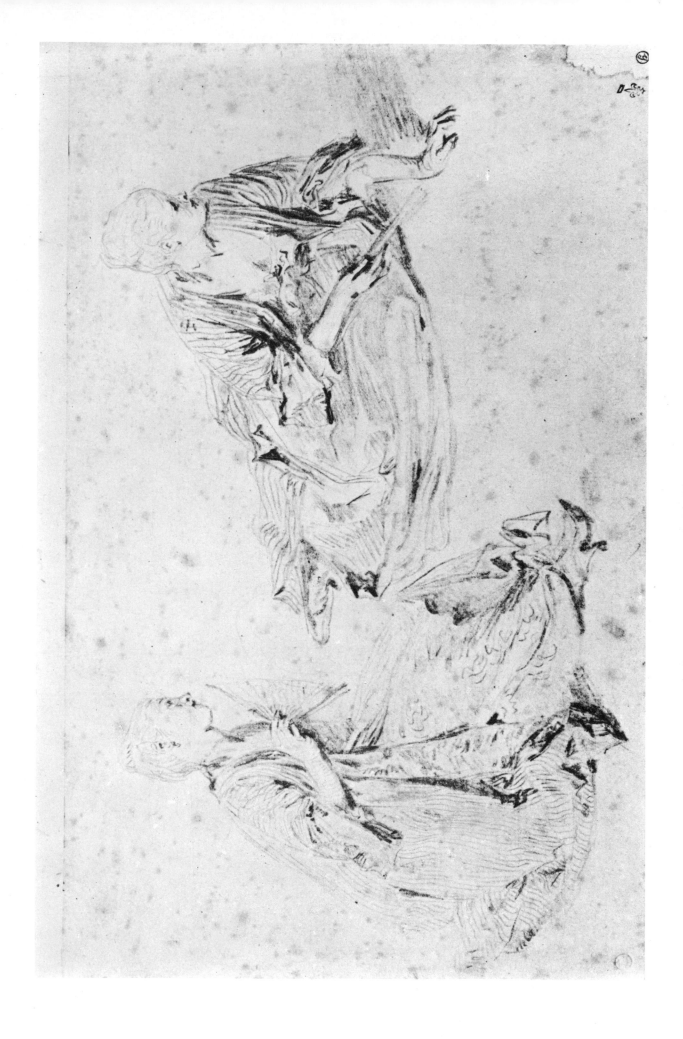

Plate 73

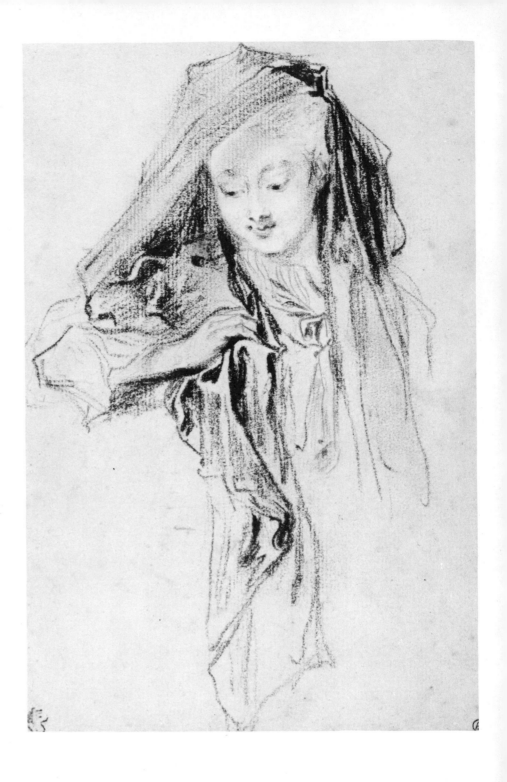

Plate 74

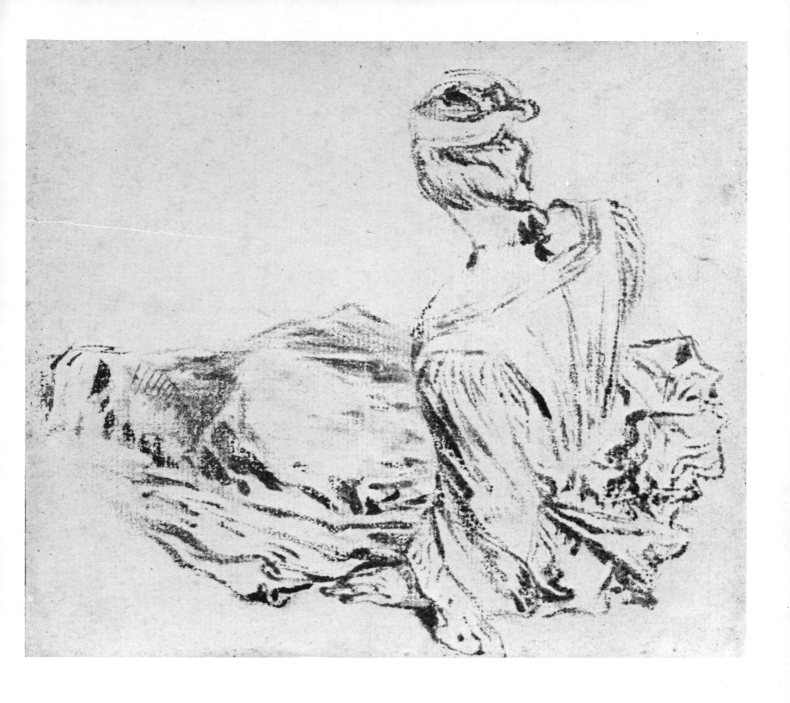

Plate 75

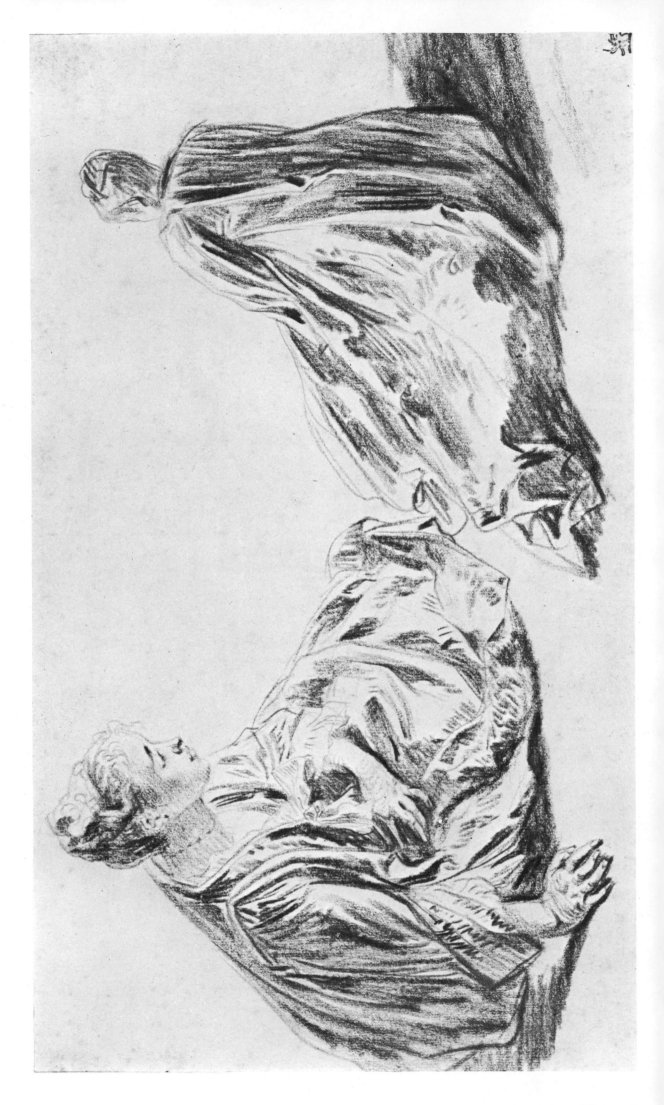

Plate 76

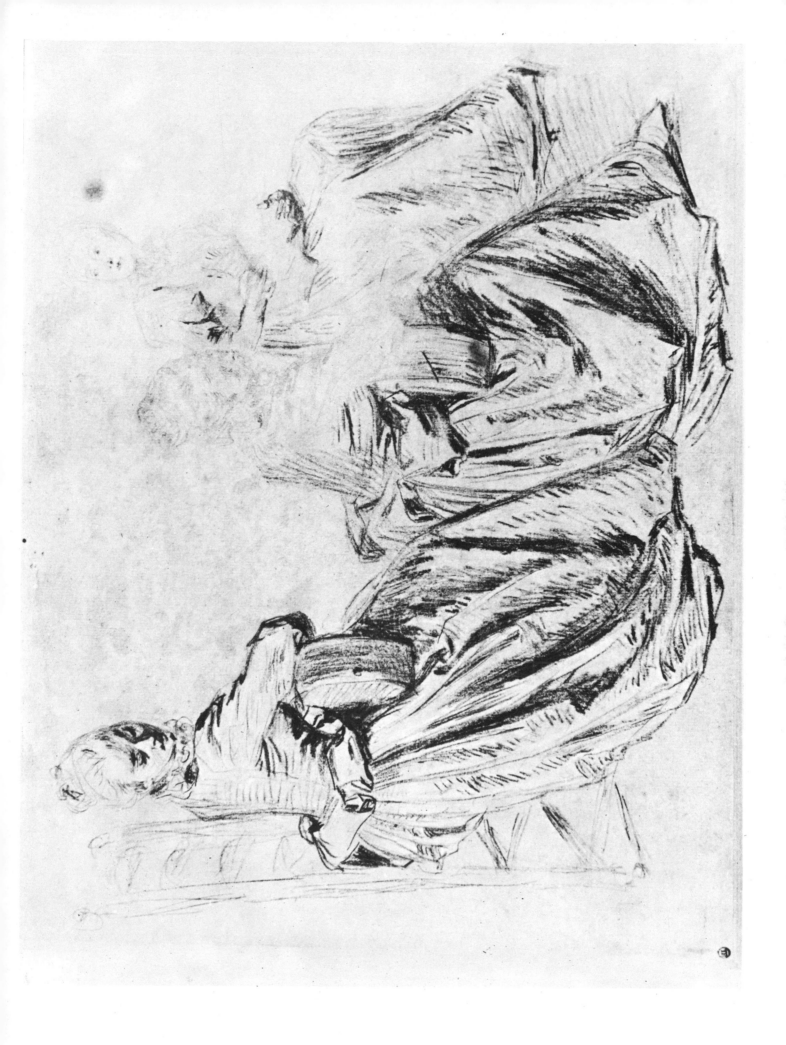

Plate 77

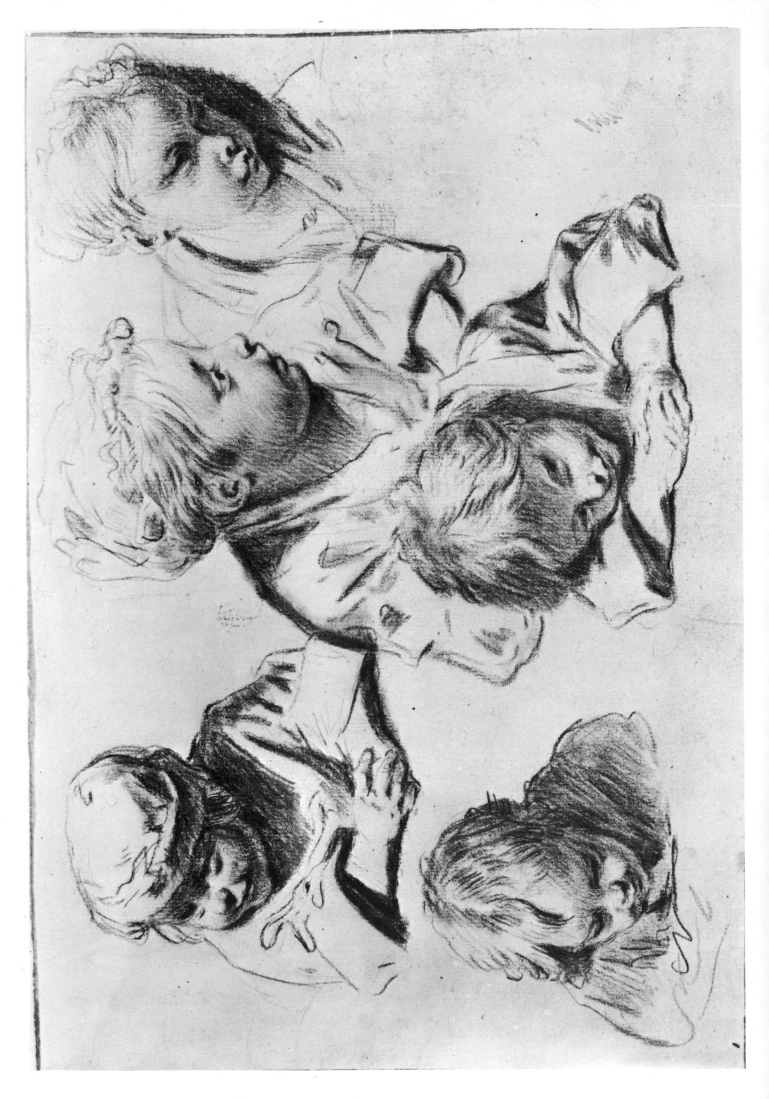

Plate 78

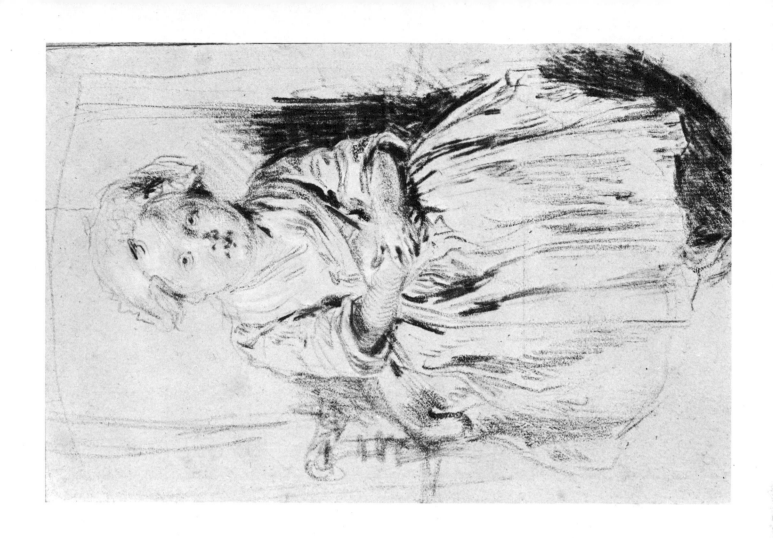

Plate 79

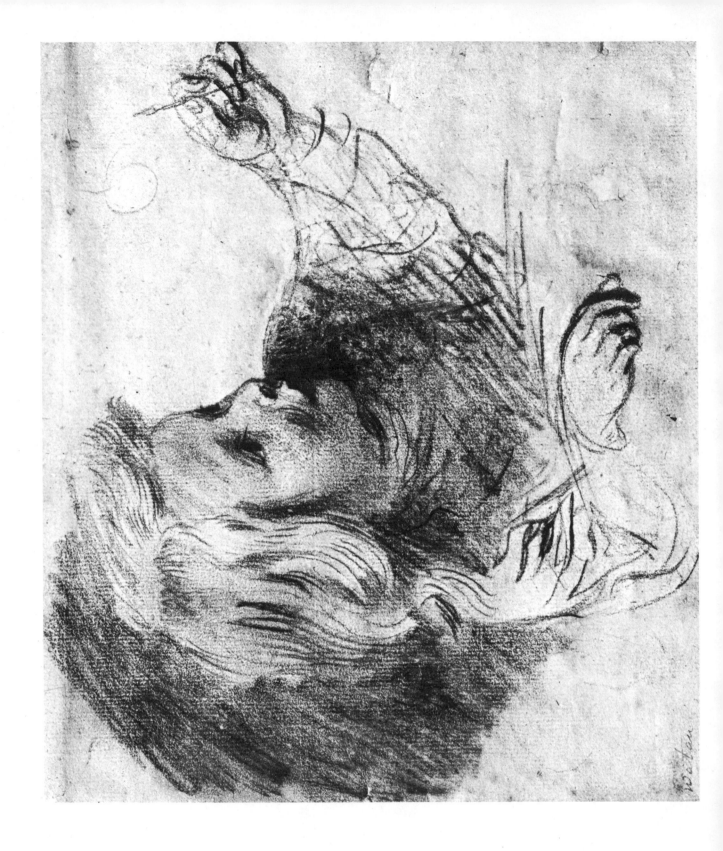

Plate 80

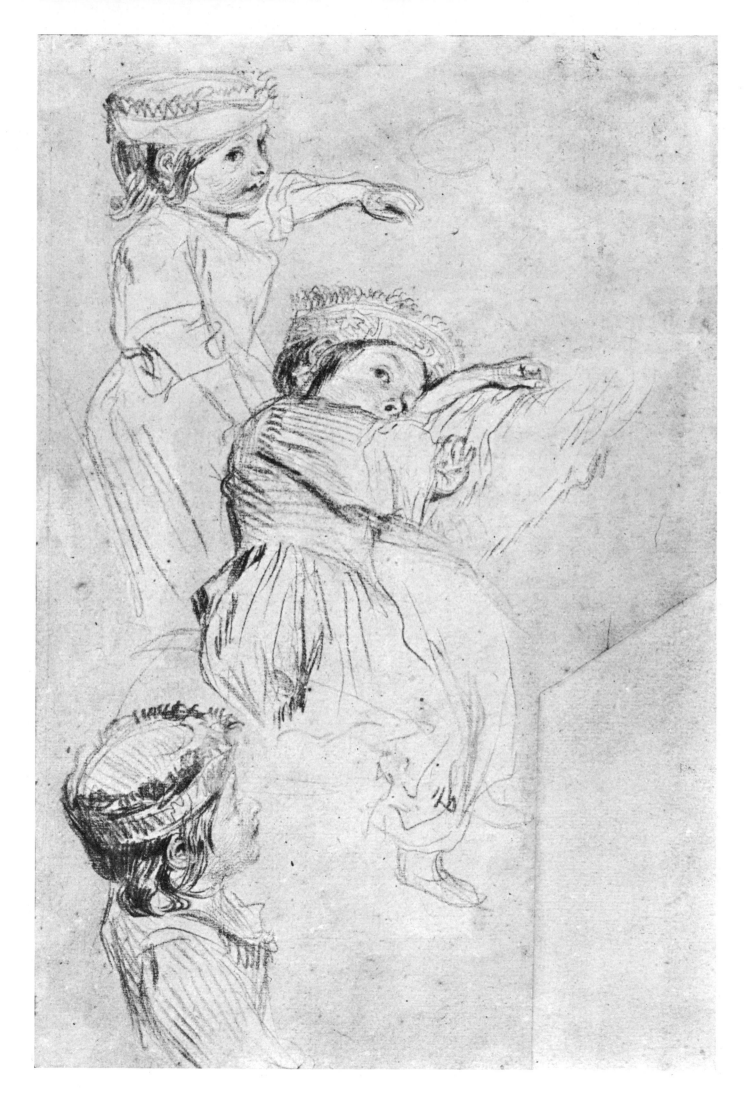

Plate 81

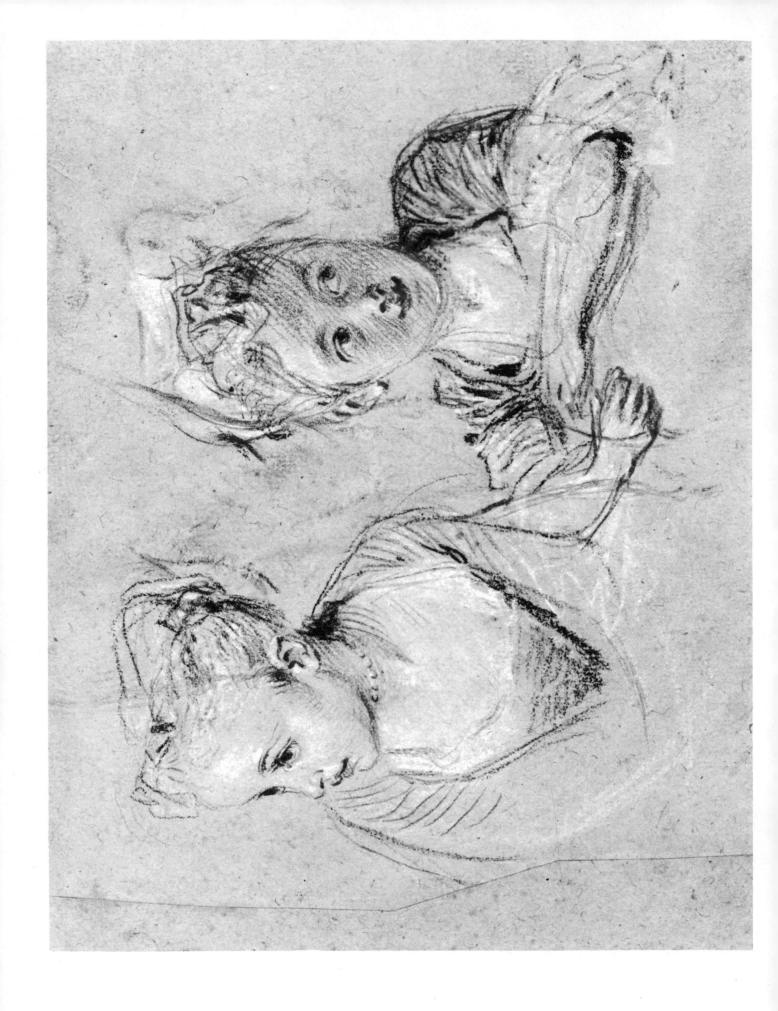

Plate 82

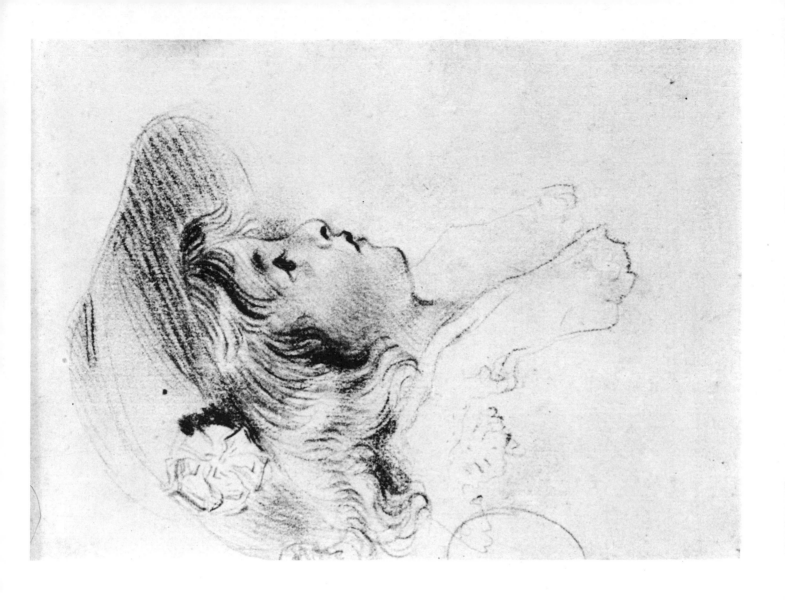

Plate 83

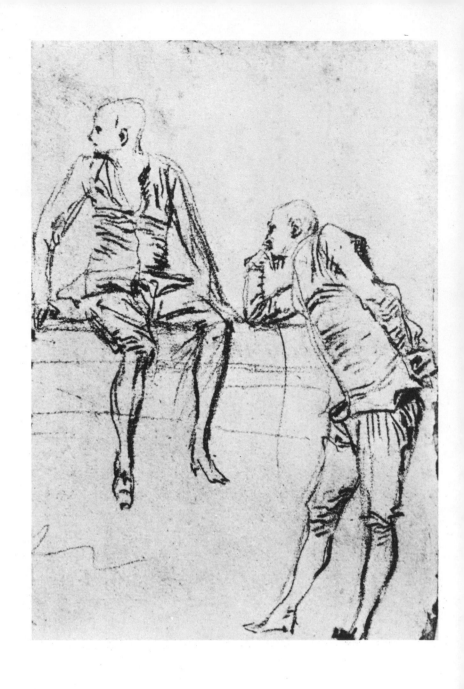

Plate 84

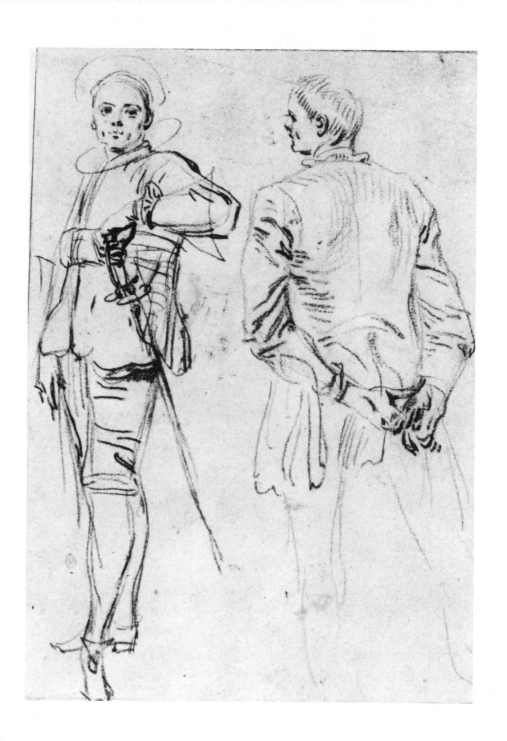

Plate 85

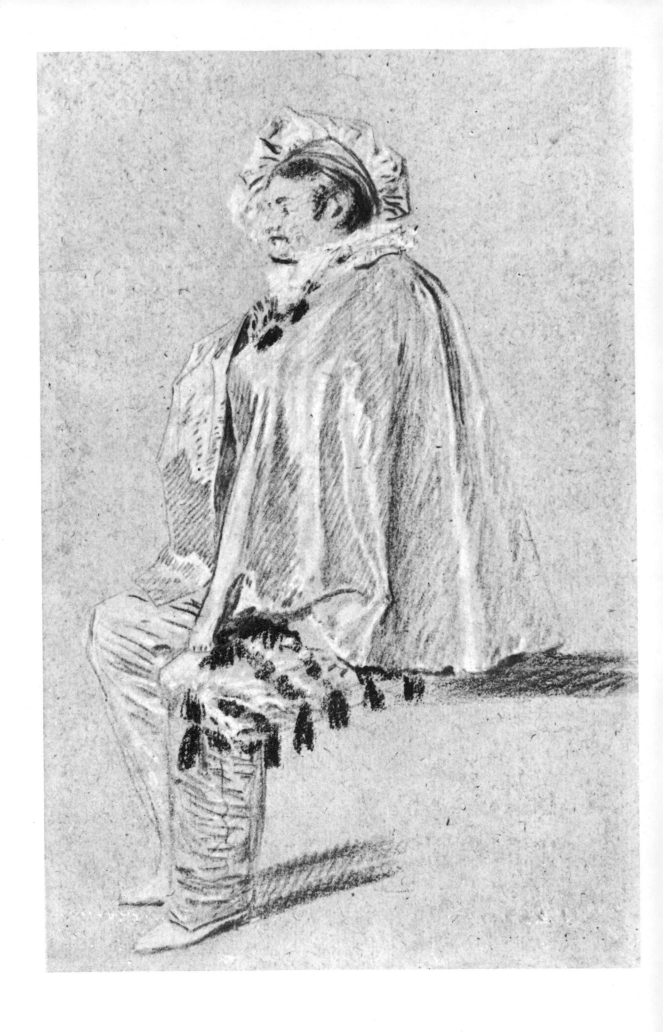

Plate 86

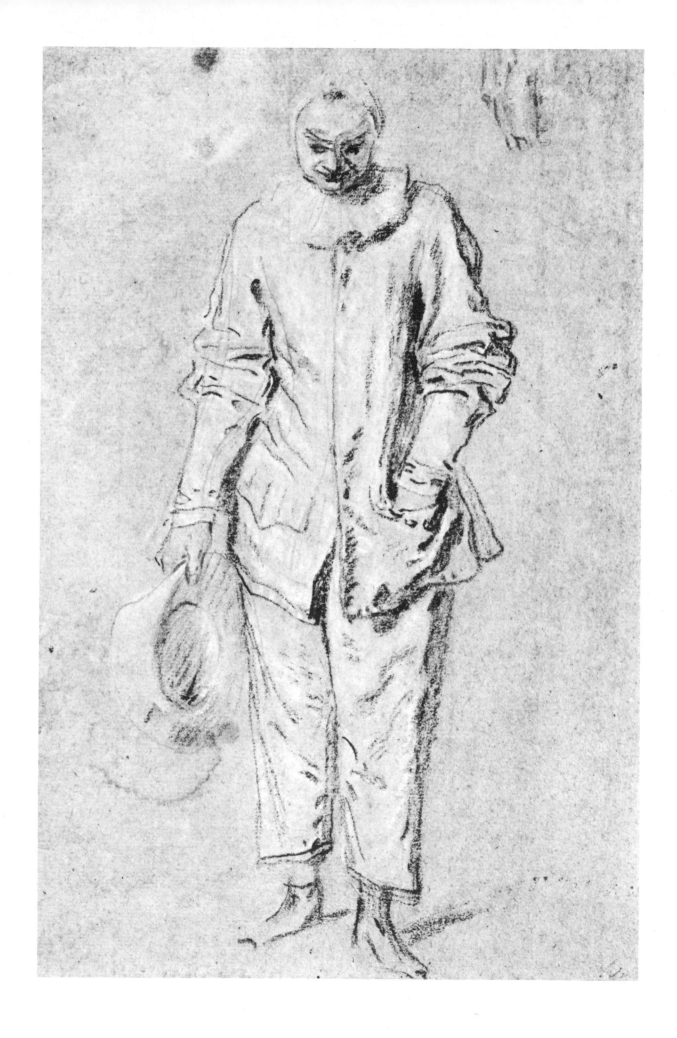

Plate 87

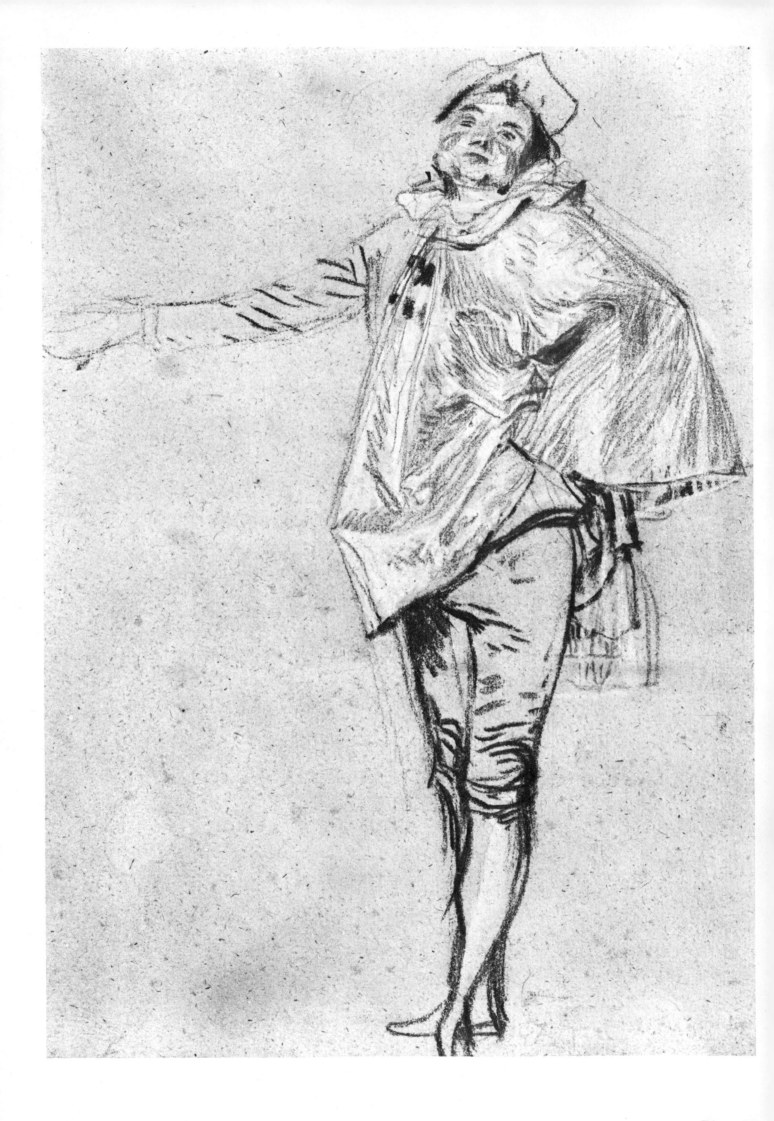

Plate 88

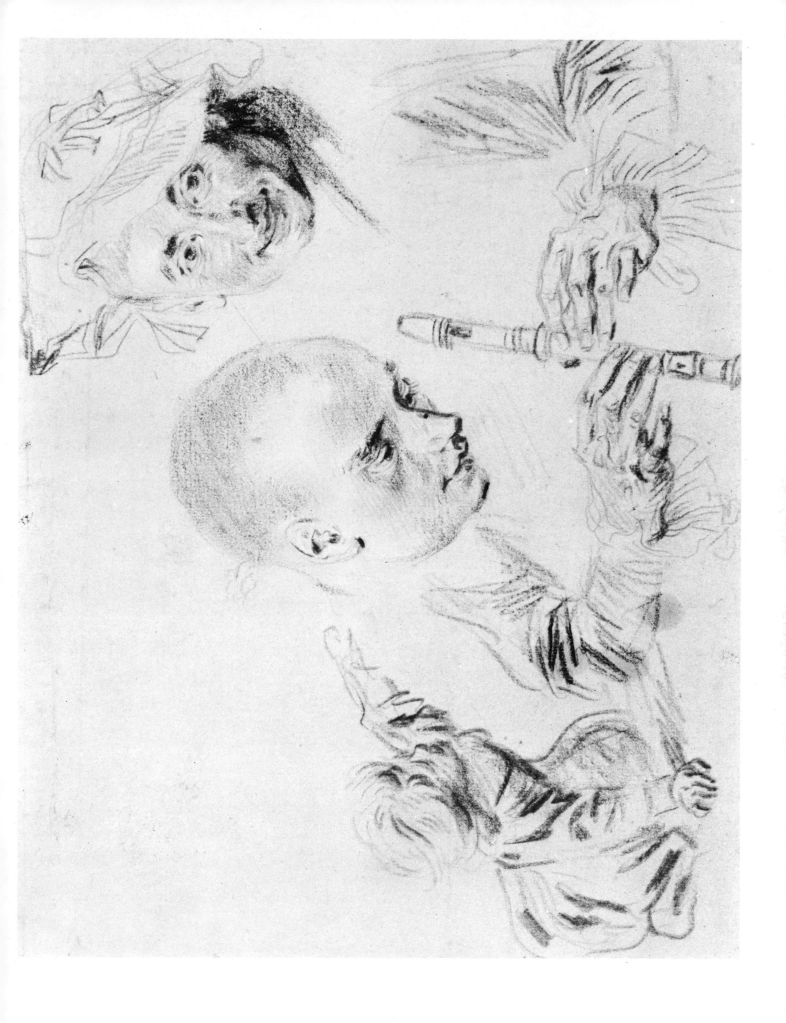

Plate 89

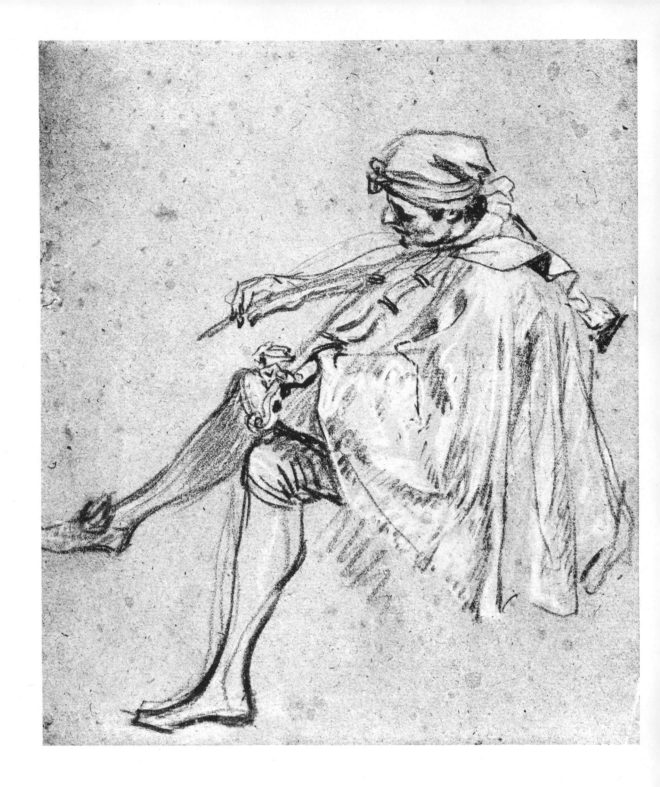

Plate 90

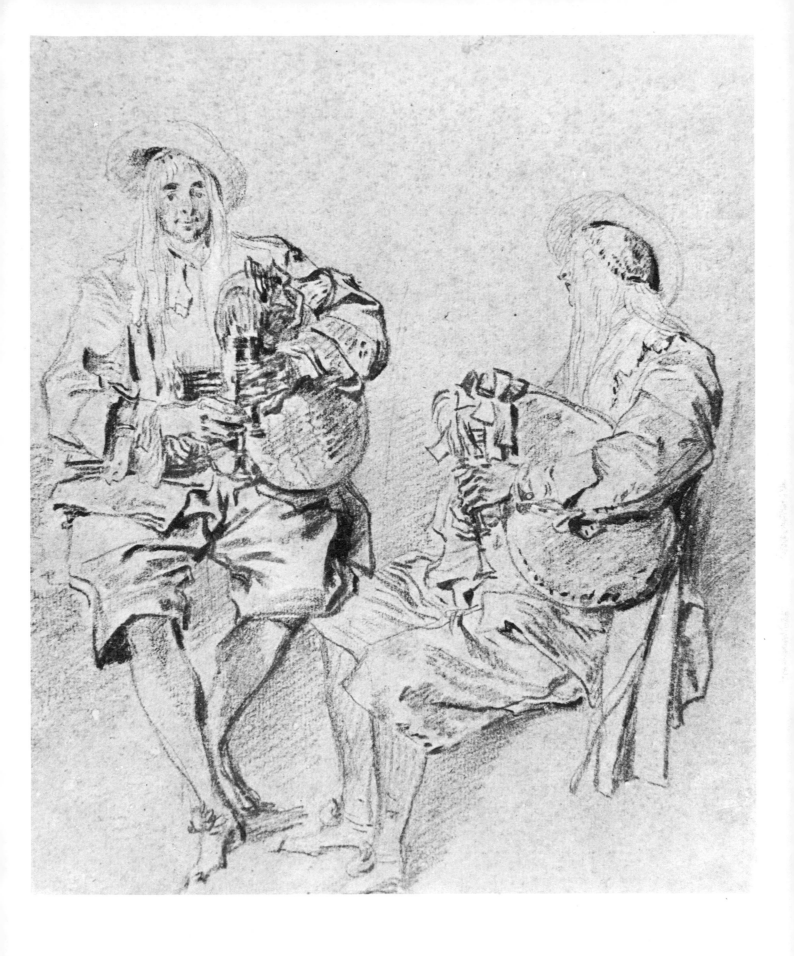

Plate 91

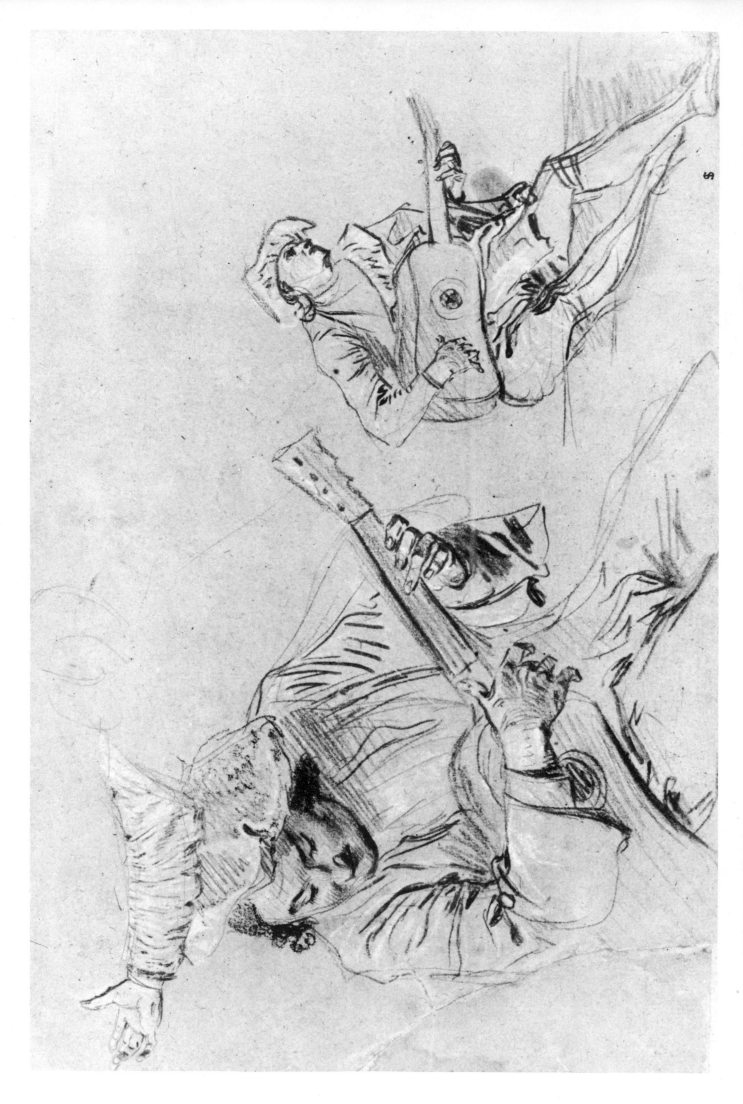

Plate 92

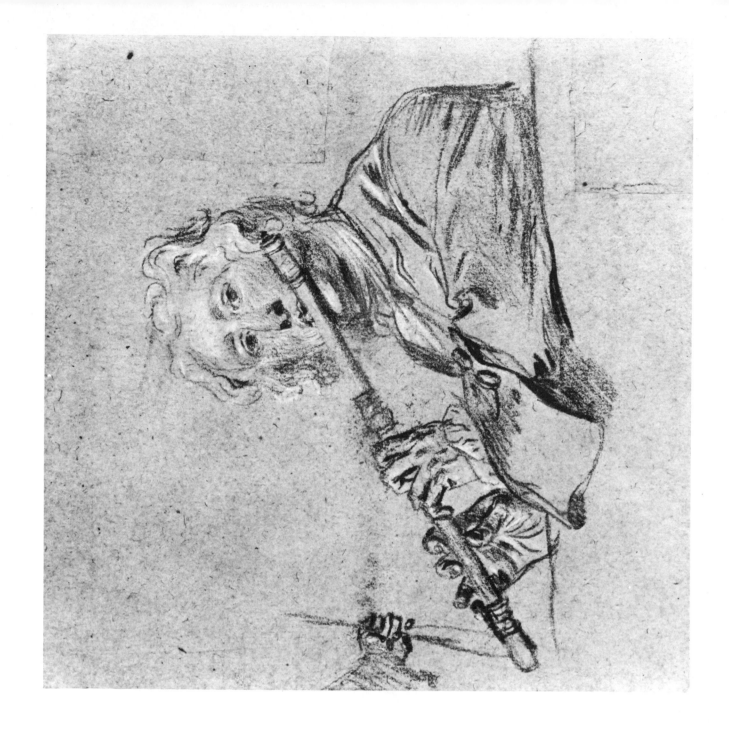

Plate 93

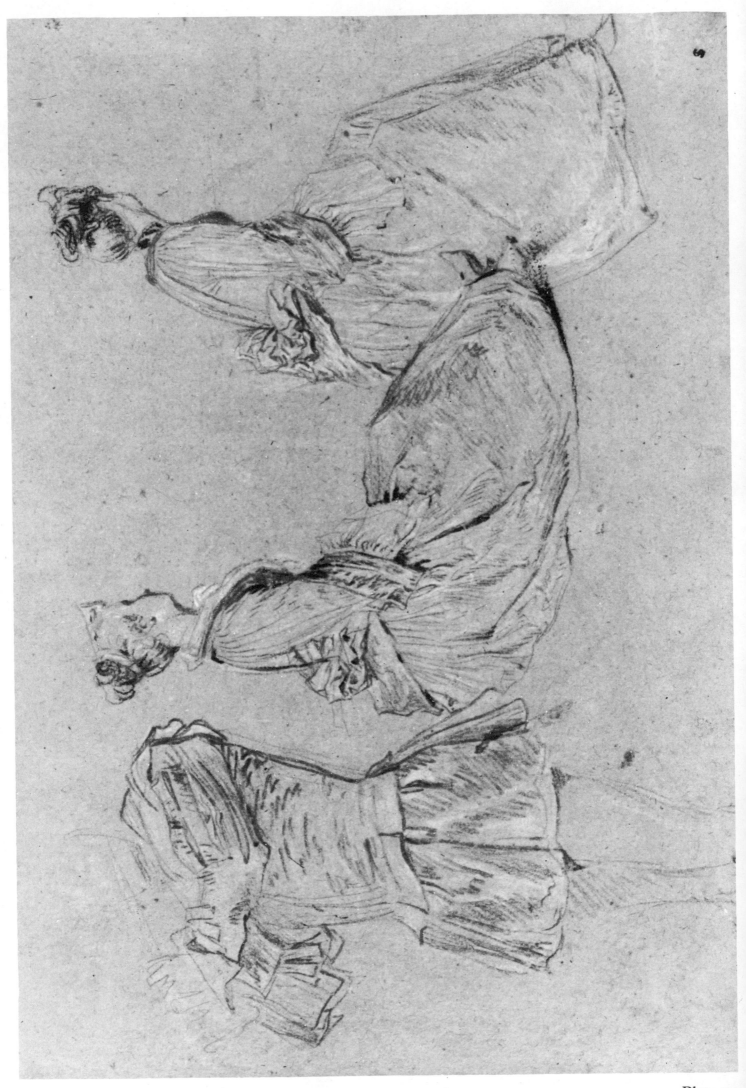

Plate 94

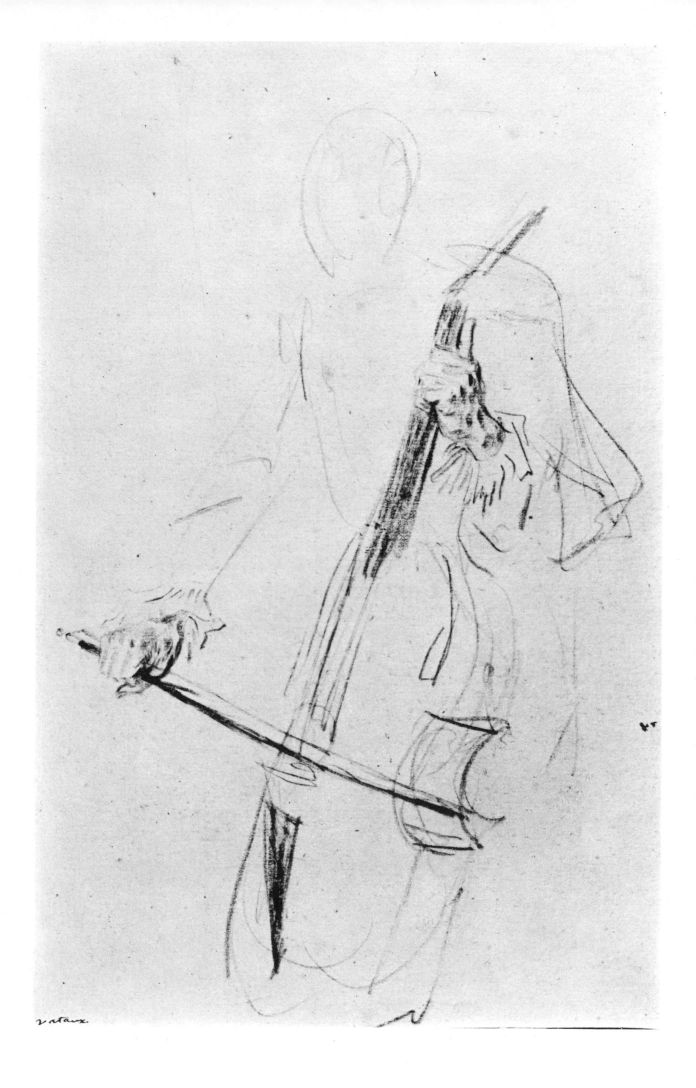

Plate 95

Plate 96

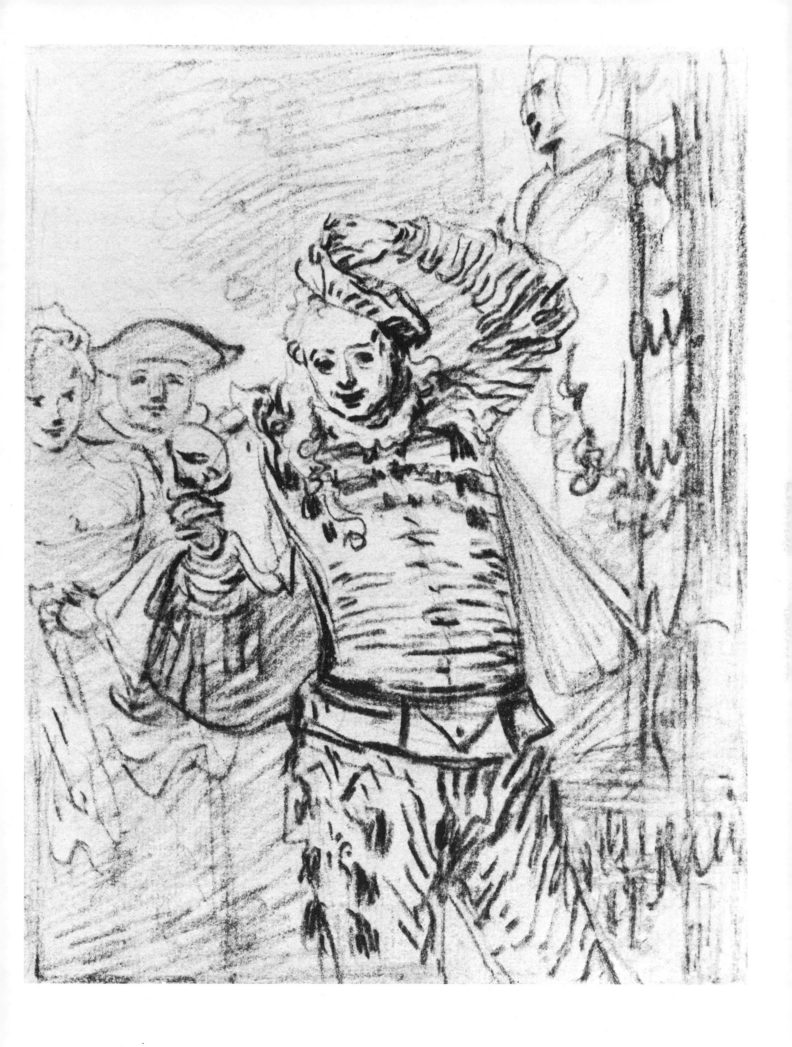

Plate 97

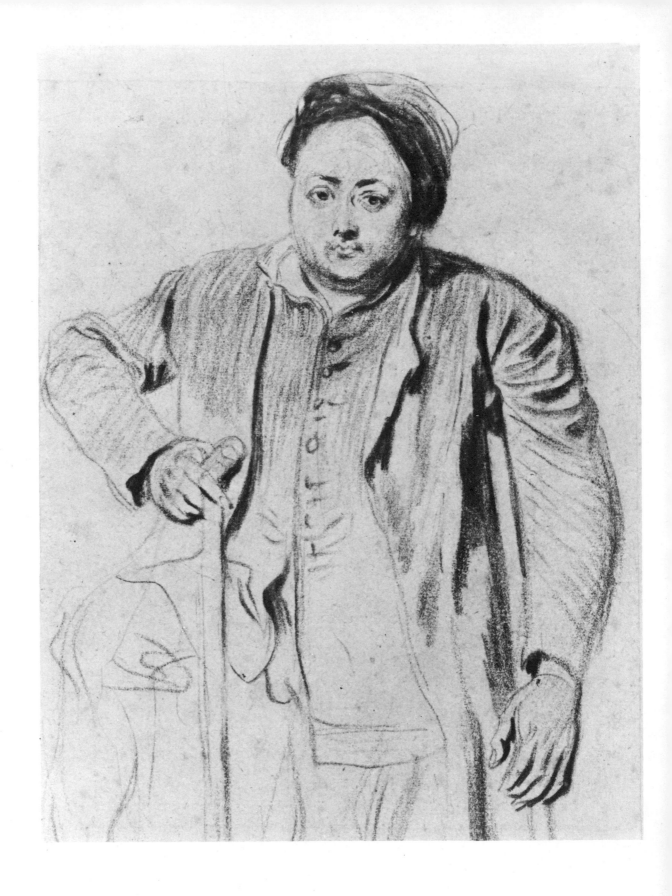

Plate 98

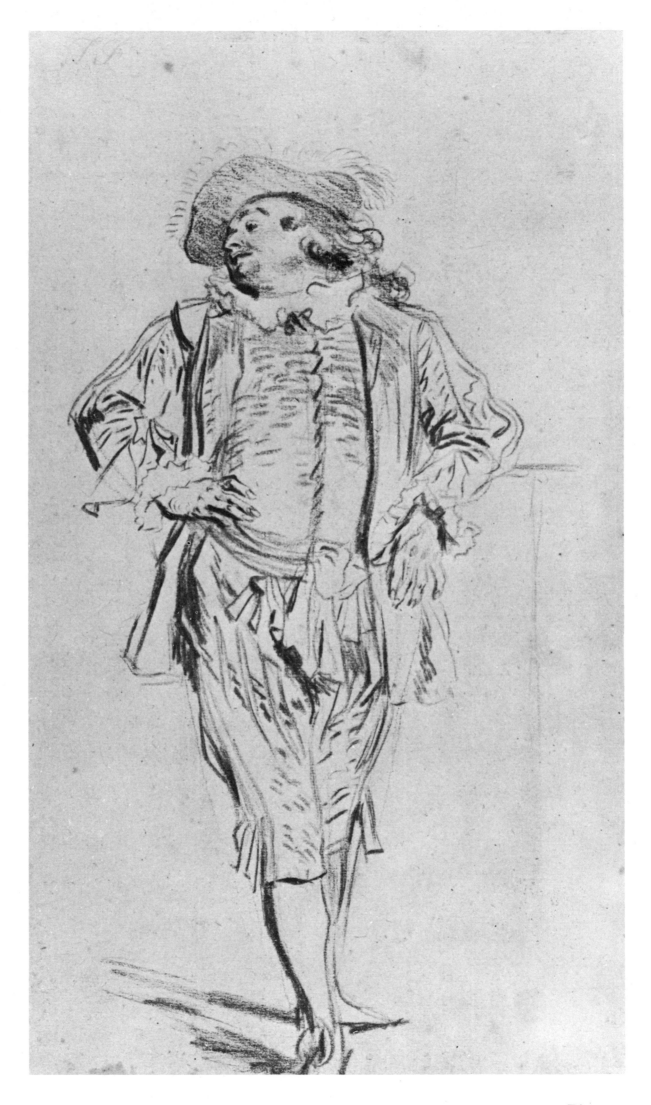

Plate 99

Plate 100

Savoie

Plate 101

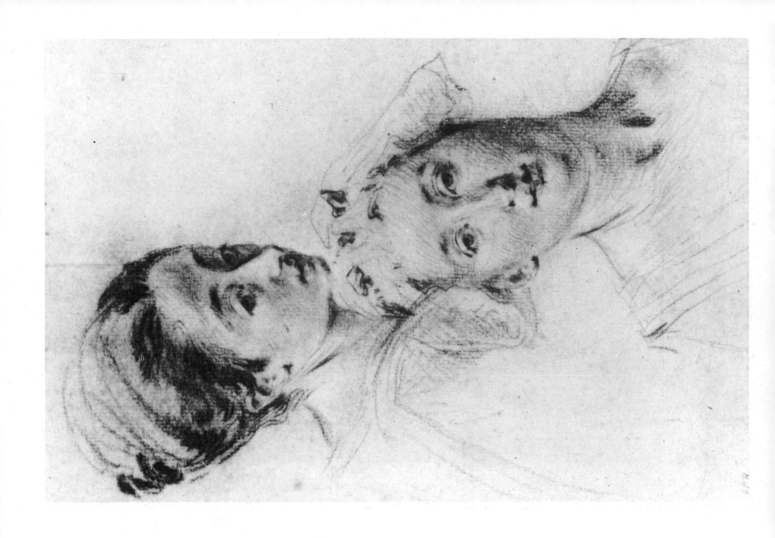

Plate 102

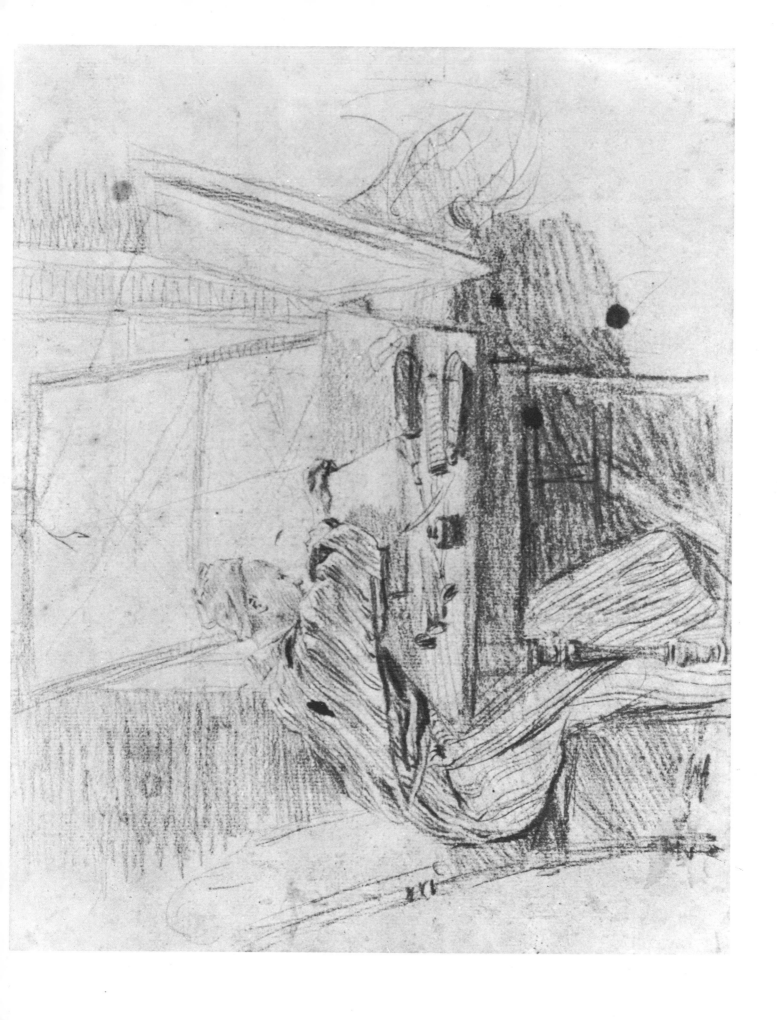

Plate 103

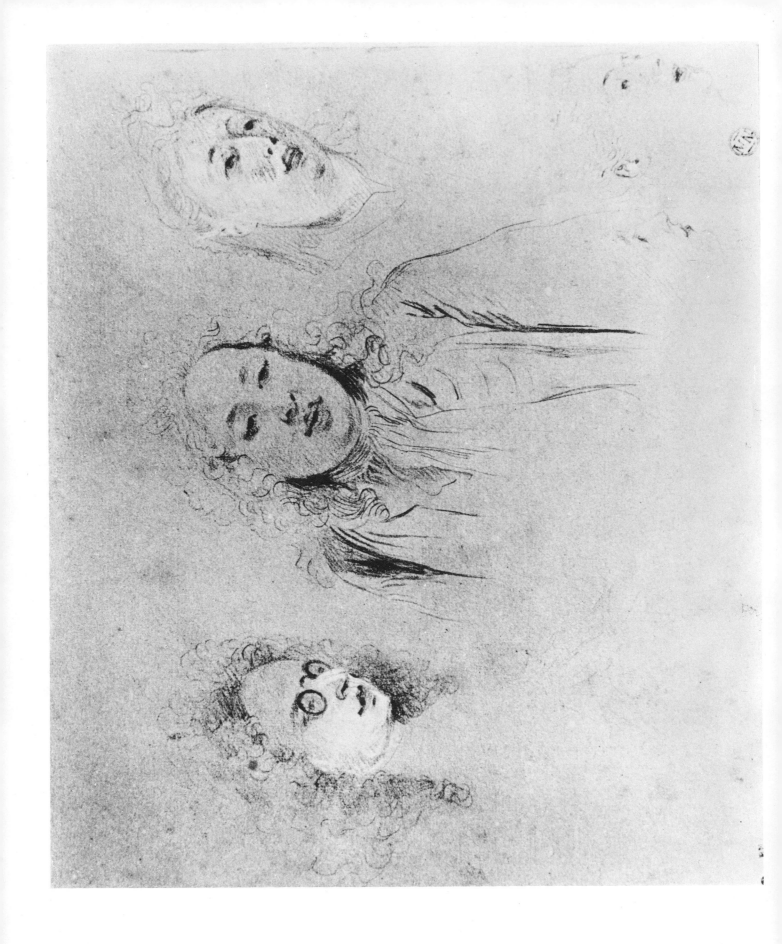

Plate 104

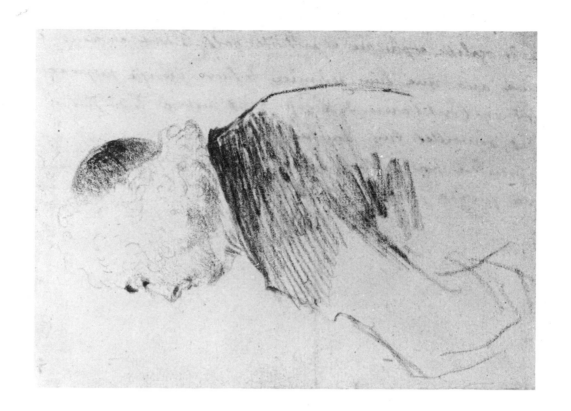

Plate 105

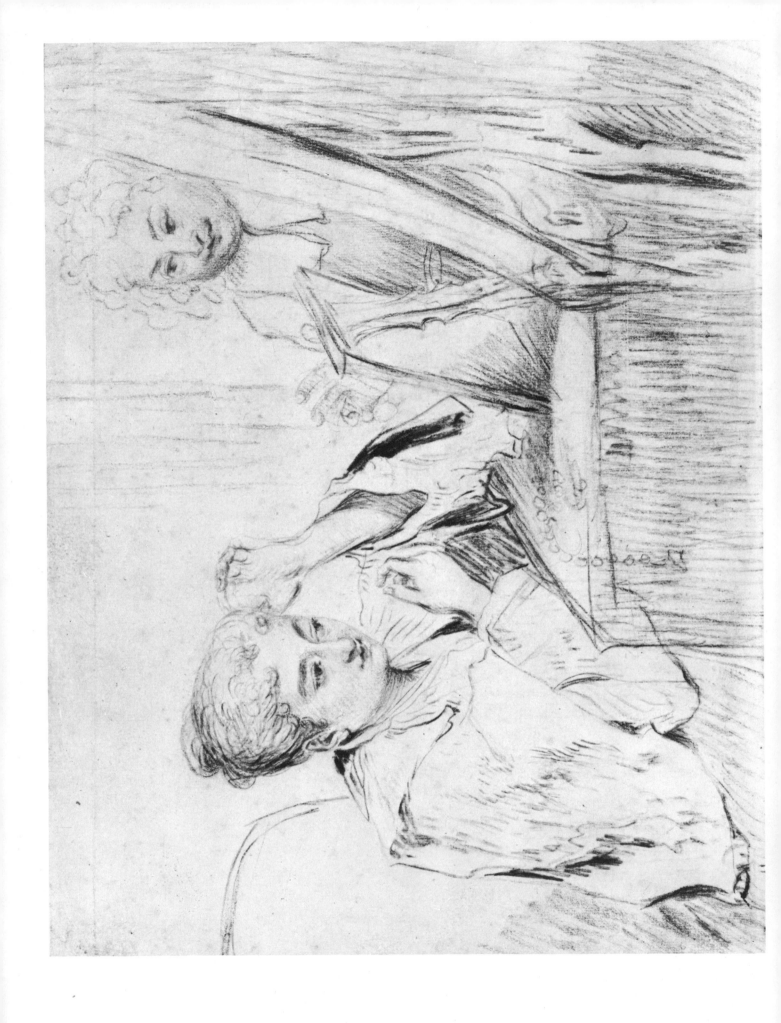

Plate 106

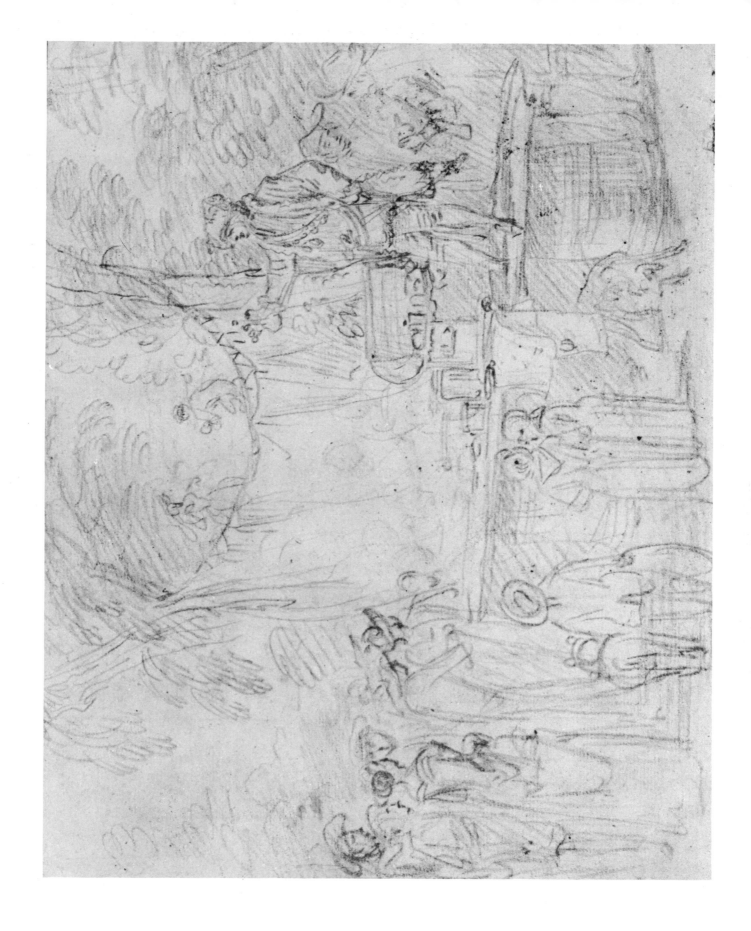

Plate 107

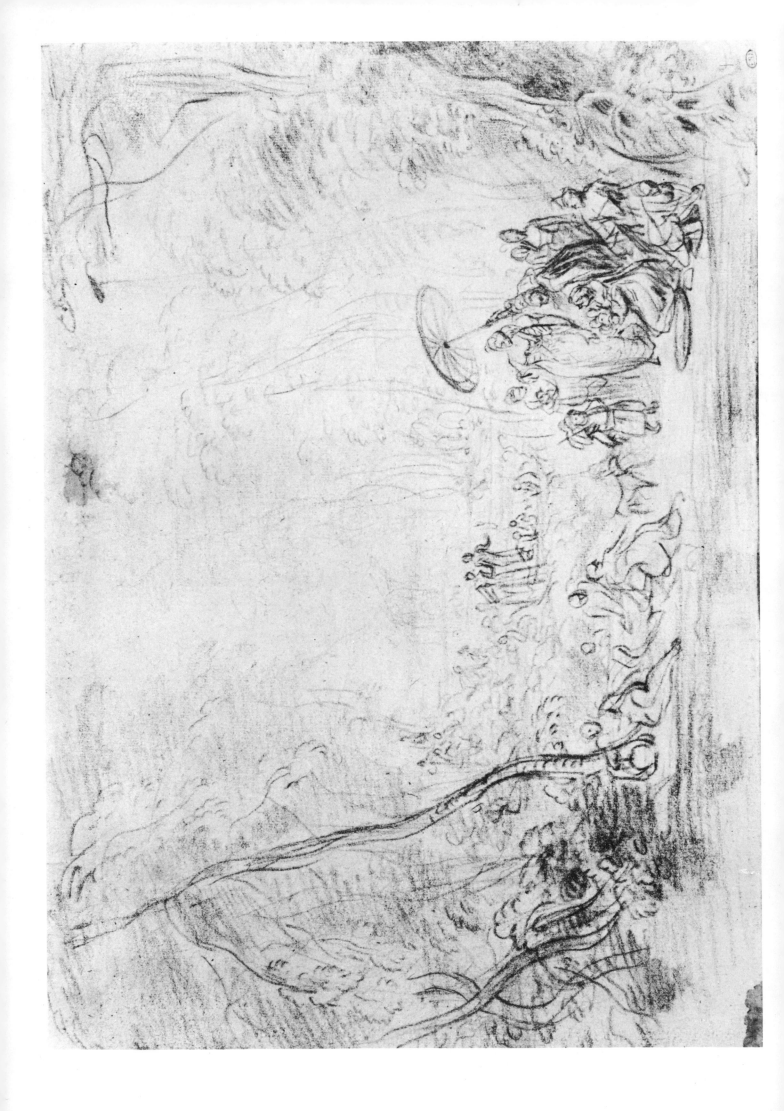

Plate 108

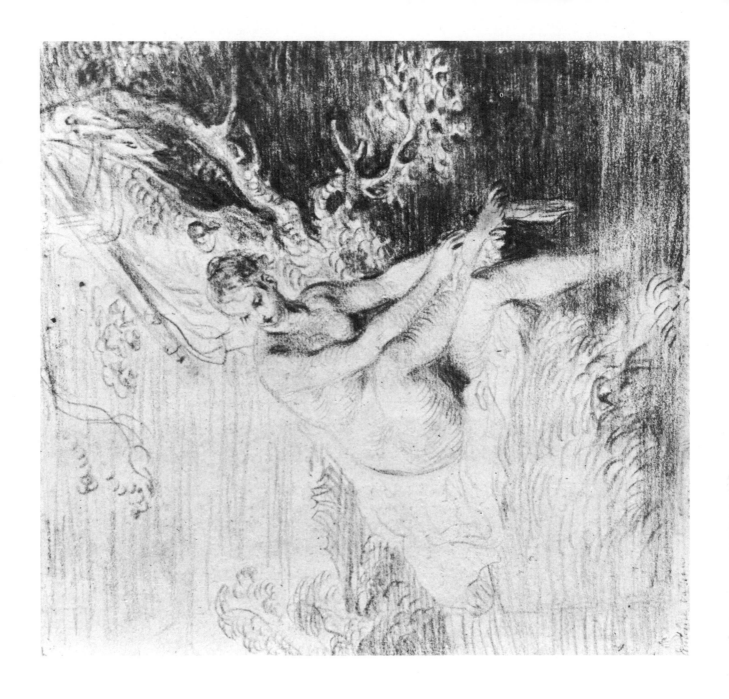

Plate 109

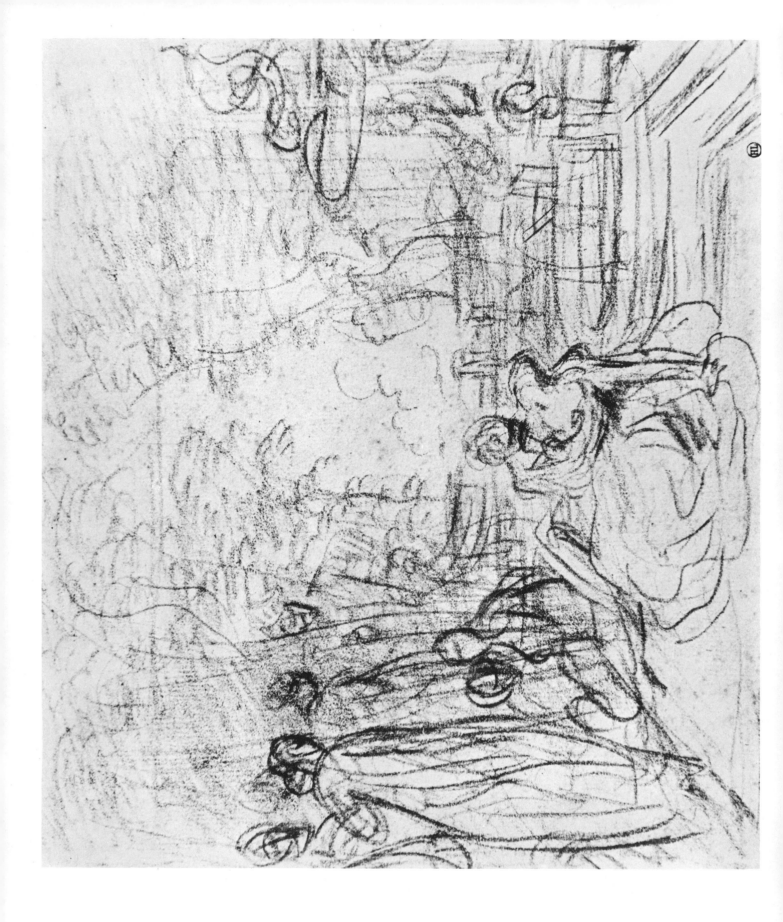

Plate 110

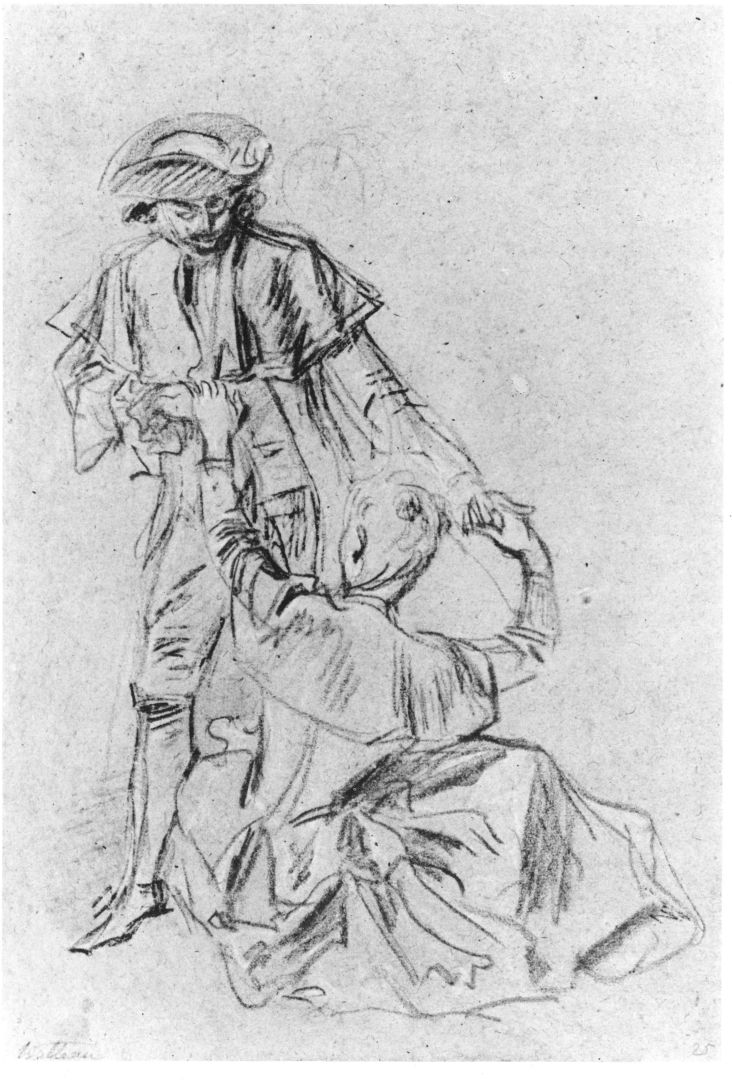

Plate III

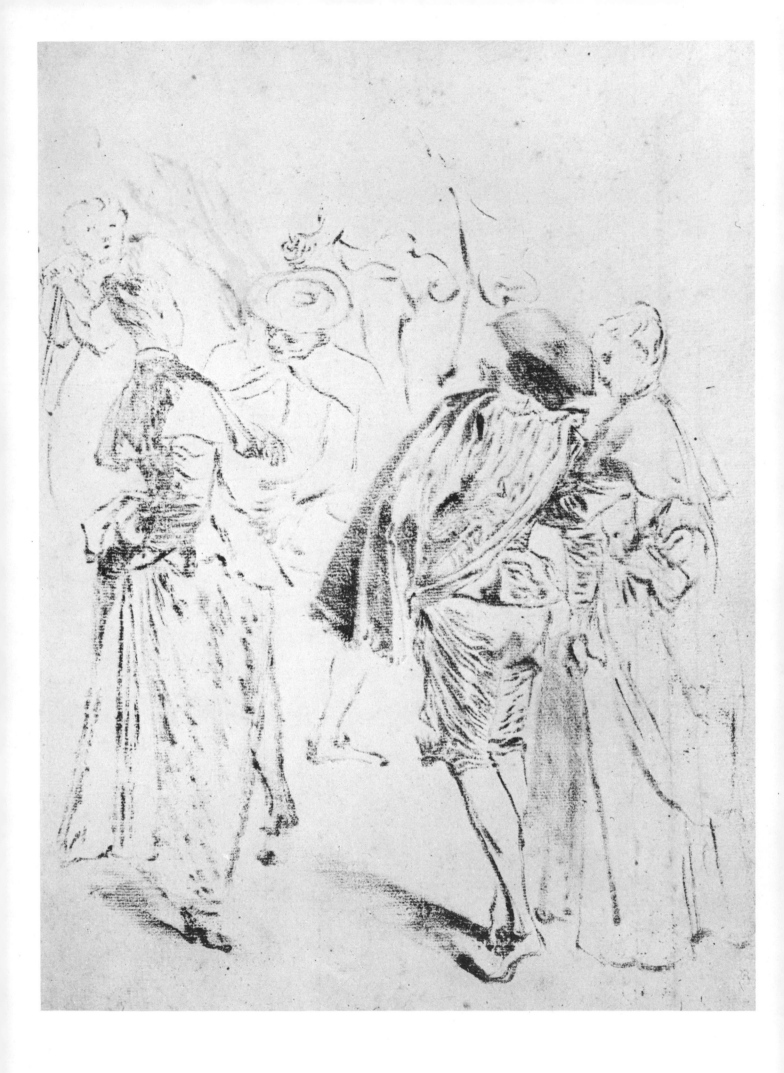

Plate 112

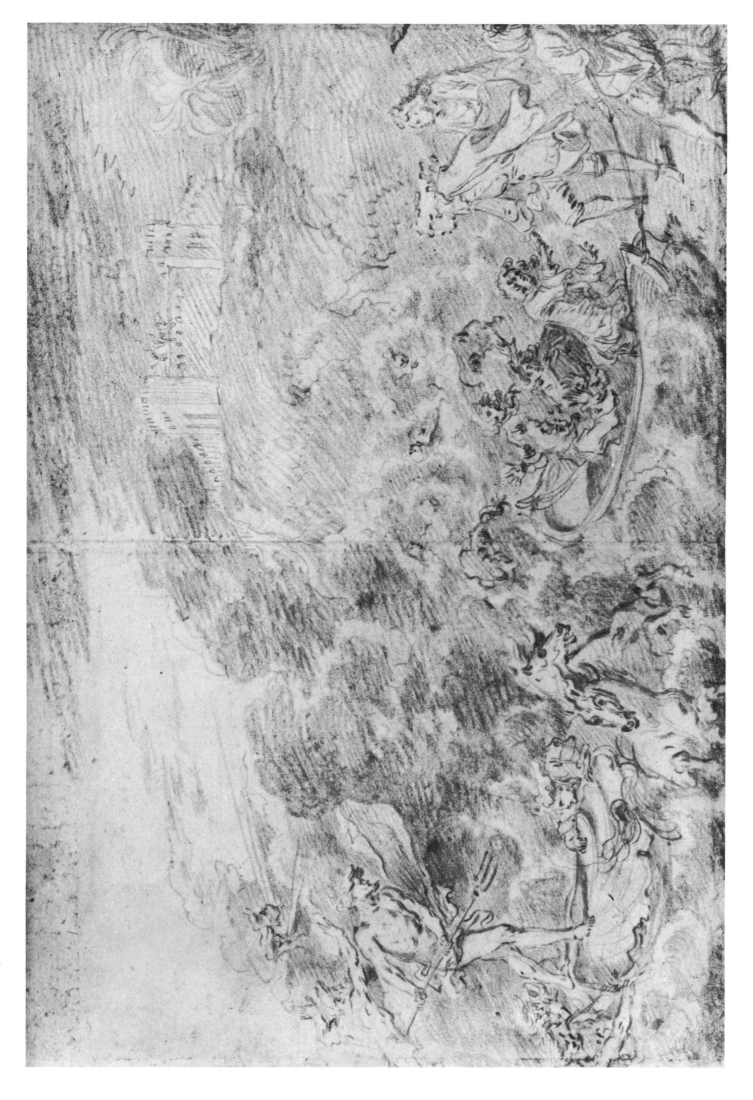

Plate 113

Plate 114

Plate 115

Plate 116

Plate 117

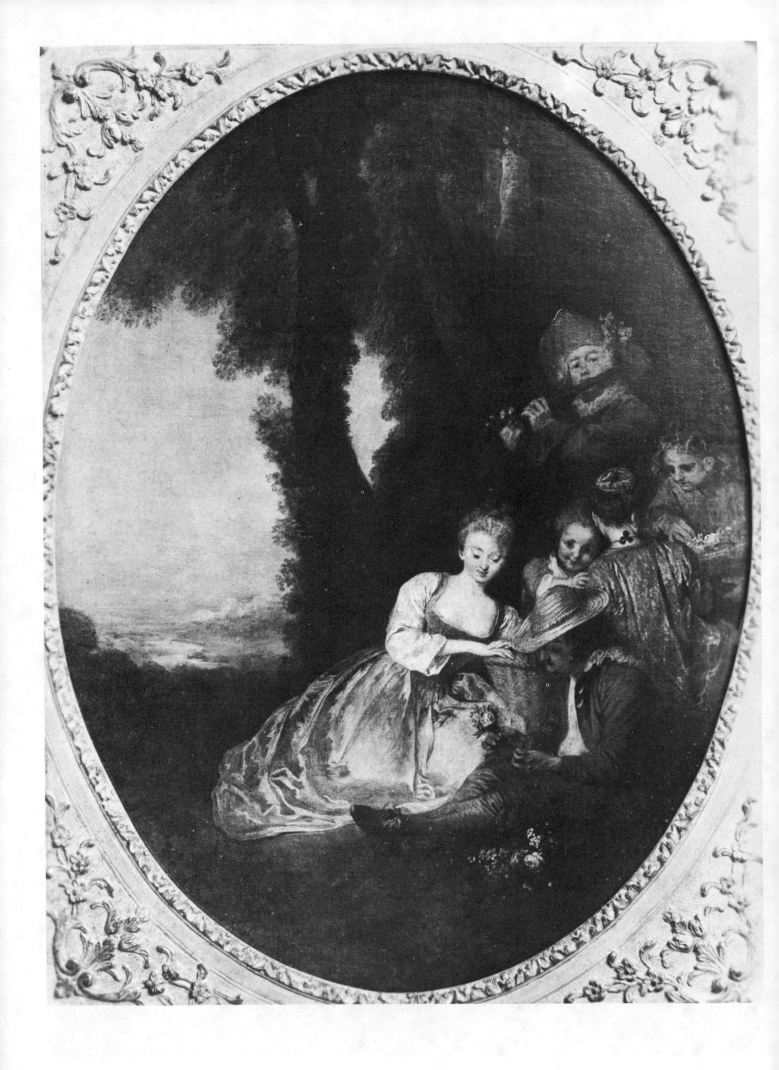

Plate 118

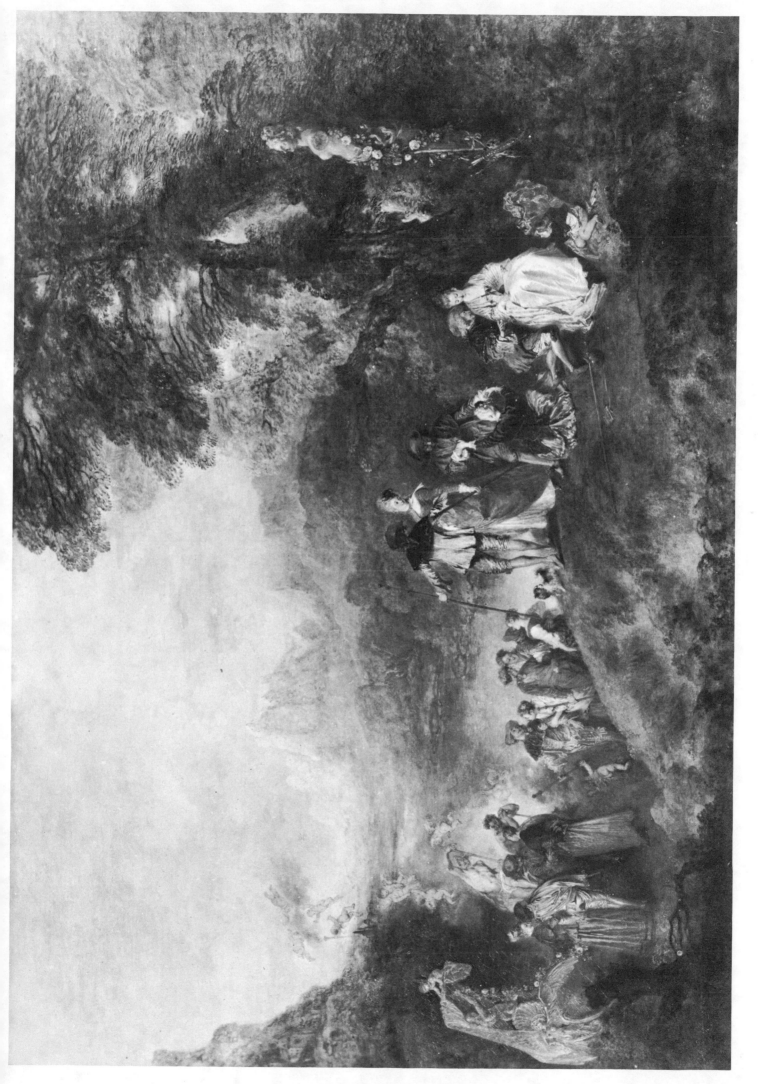

Plate 119

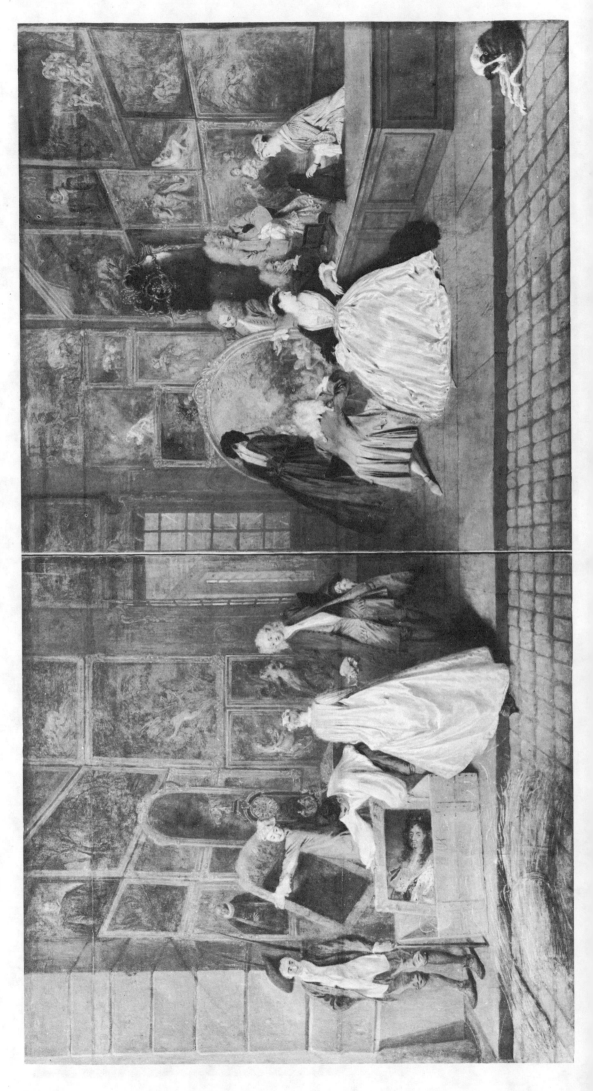

Plate 120

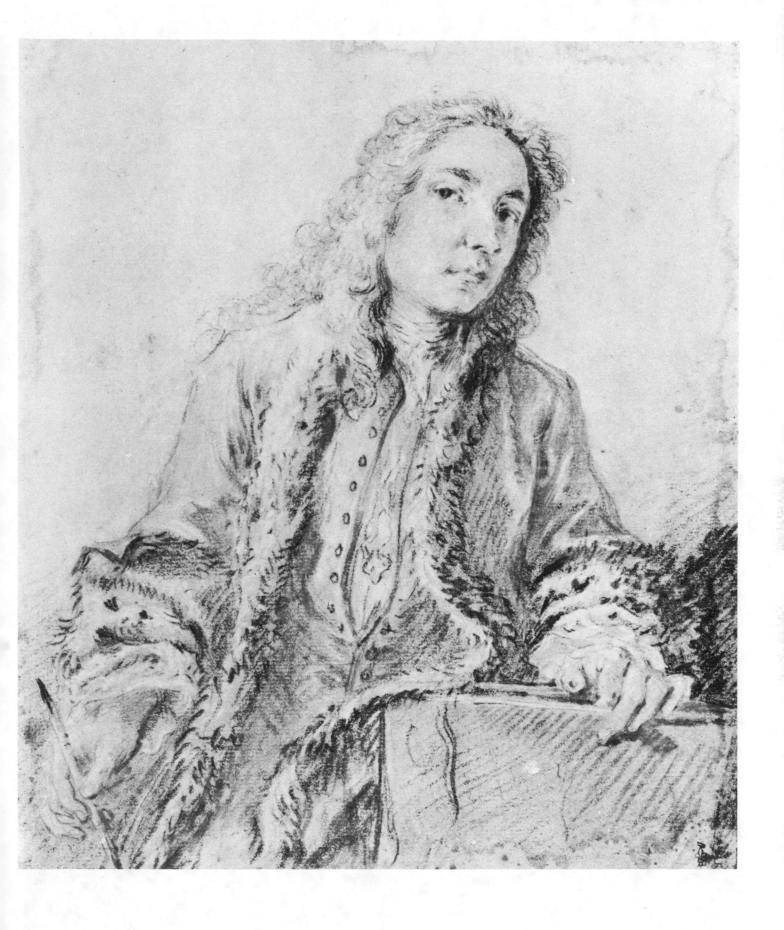

Plate 121

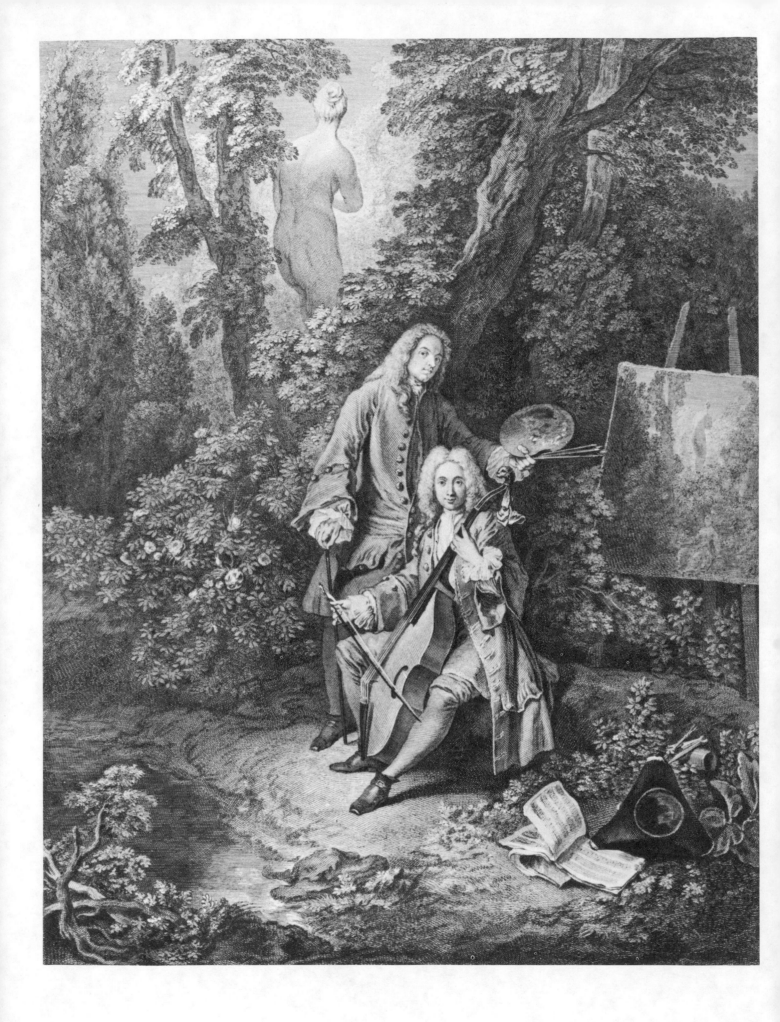

Plate 122

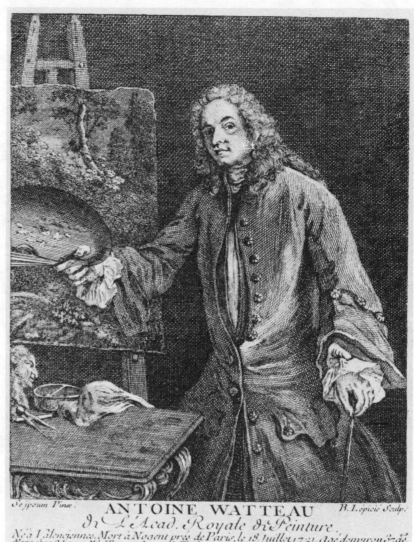

Se jpoum Pinx.

ANTOINE WATTEAU

B. Lepicie Sculp.

de L'Acad. Royale de Peinture.

Né à Valenciennes, Mort à Nogent prés de Paris, le 18 Juillet 1721. Agé d'environ 37 ans.
A Paris chez Odieuvre M.d d'Estampes quay de l'Ecole vis à vis le côté de la Samaritaine à la belle Image. C.P.R.

Plate 123

Plate 124

Plate 125

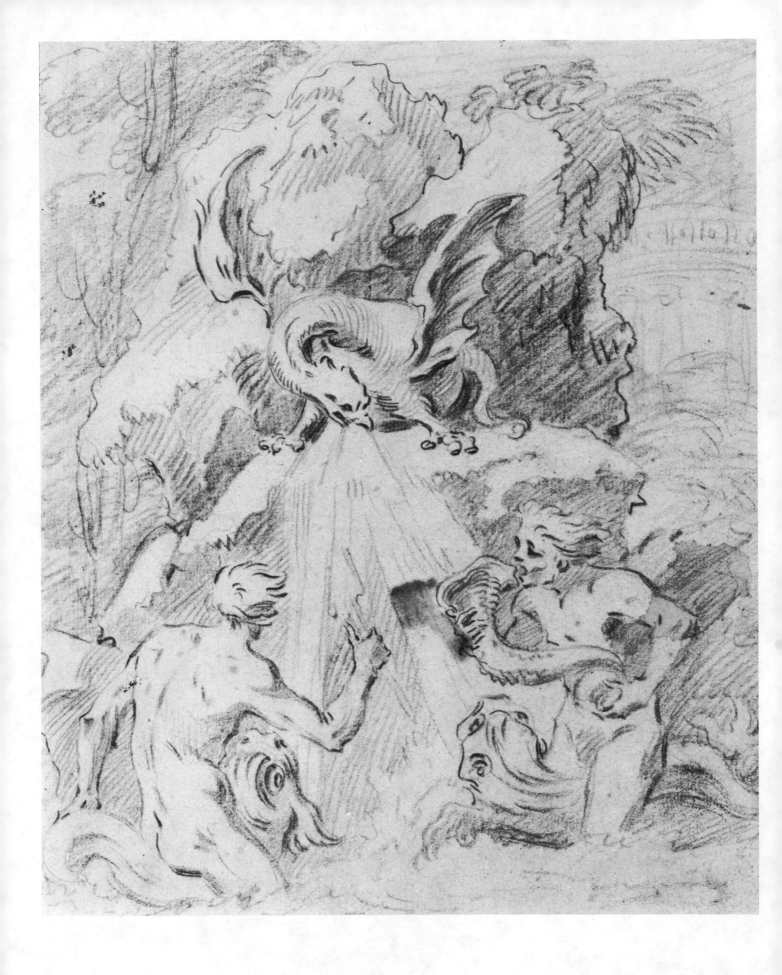

Plate 126

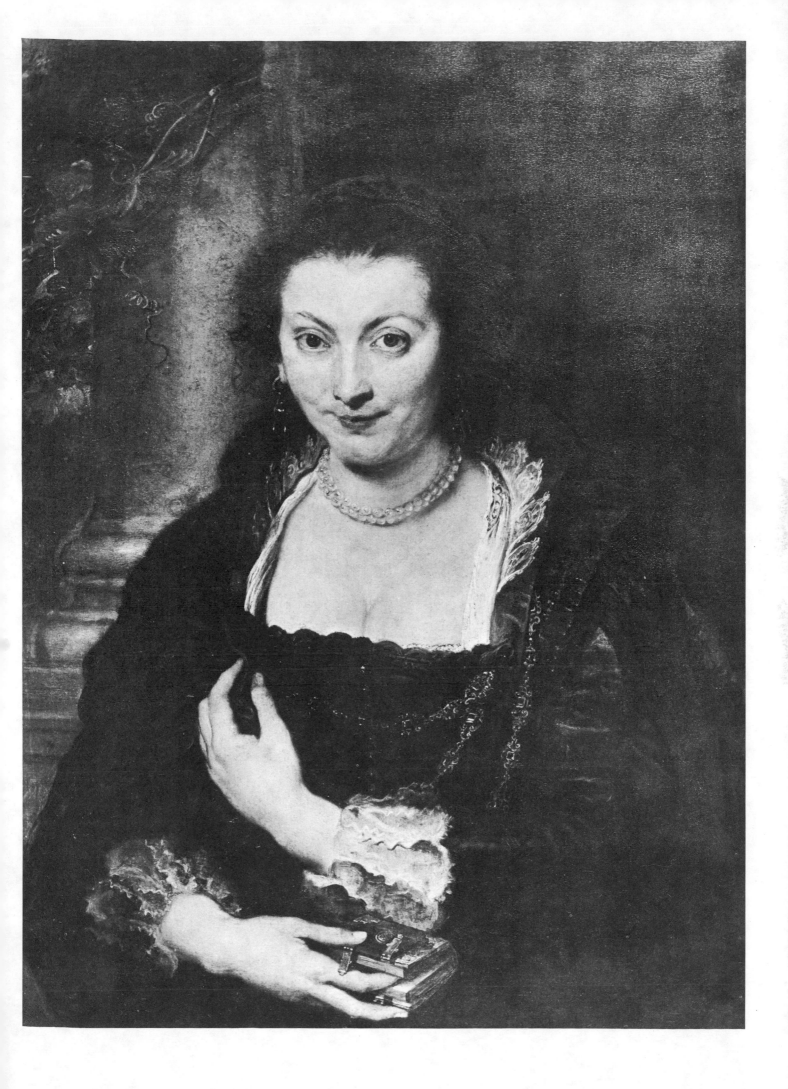

Plate 127

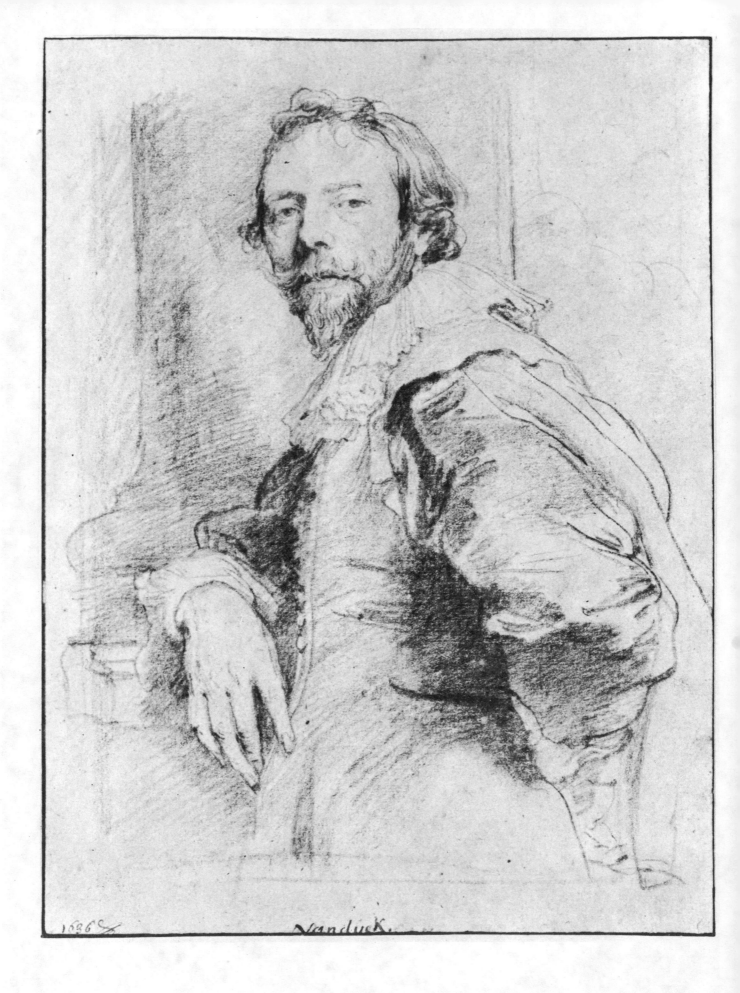

1686

Vanduck.

Plate 128

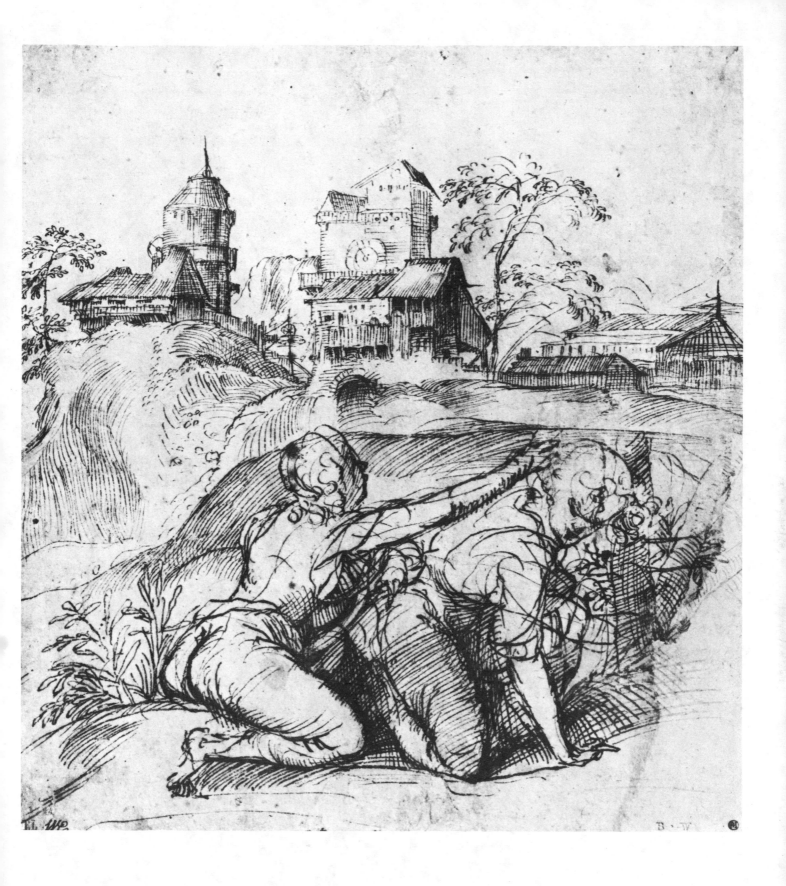

Plate 129

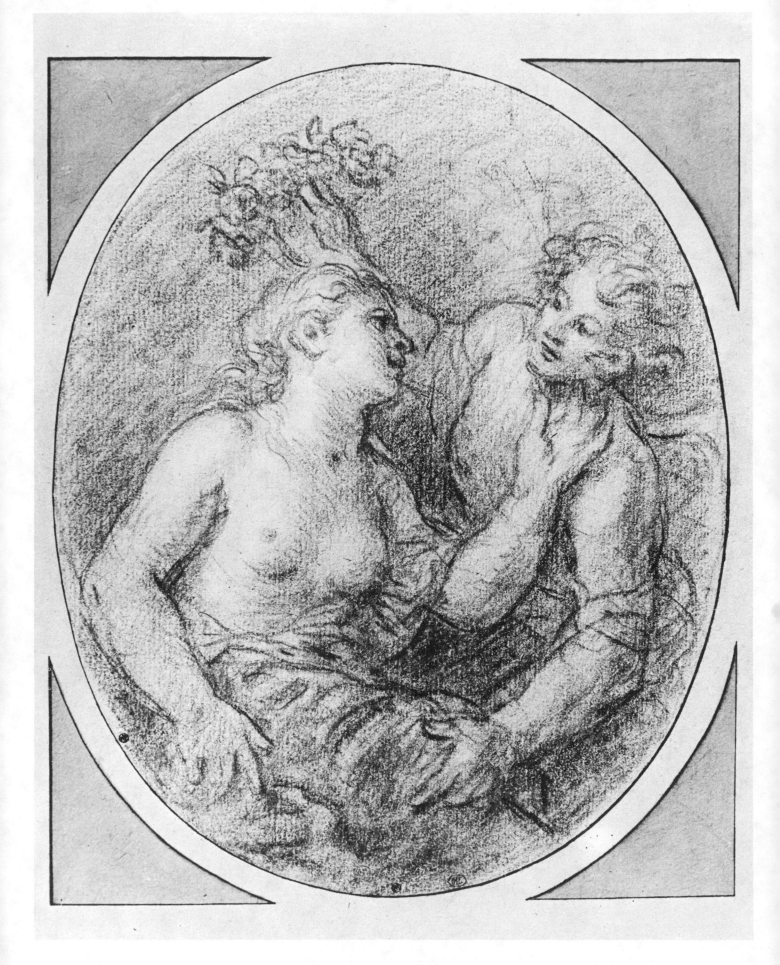

Plate 130

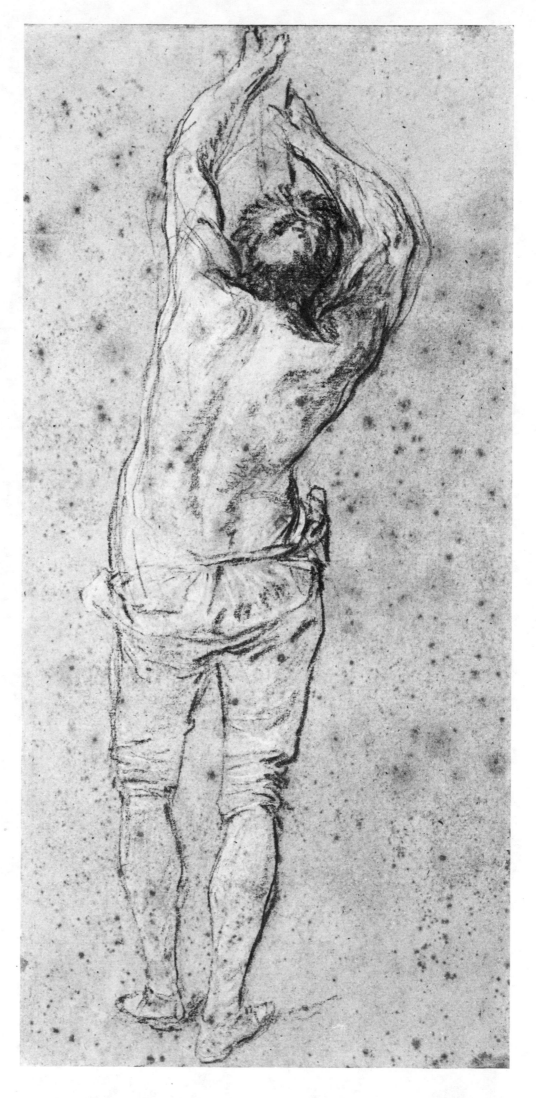

Plate 131

Plate 132